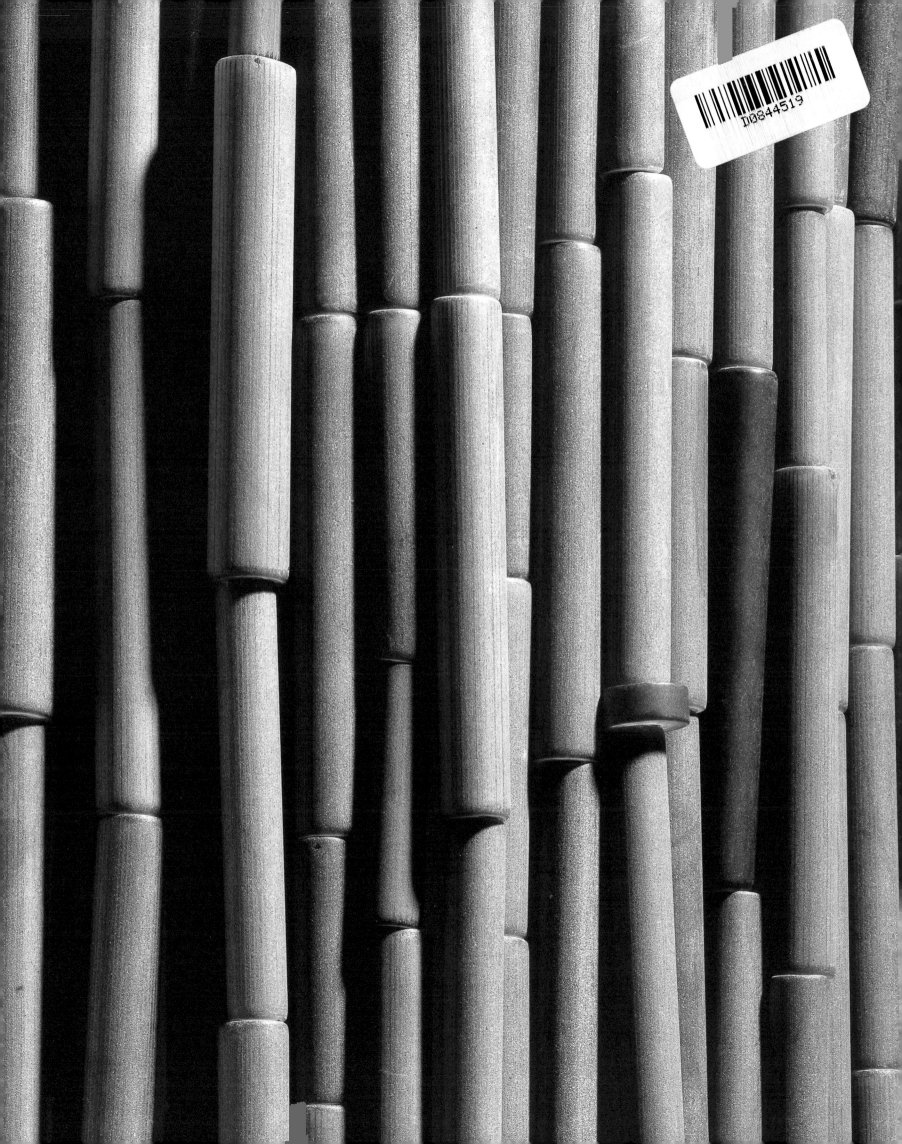

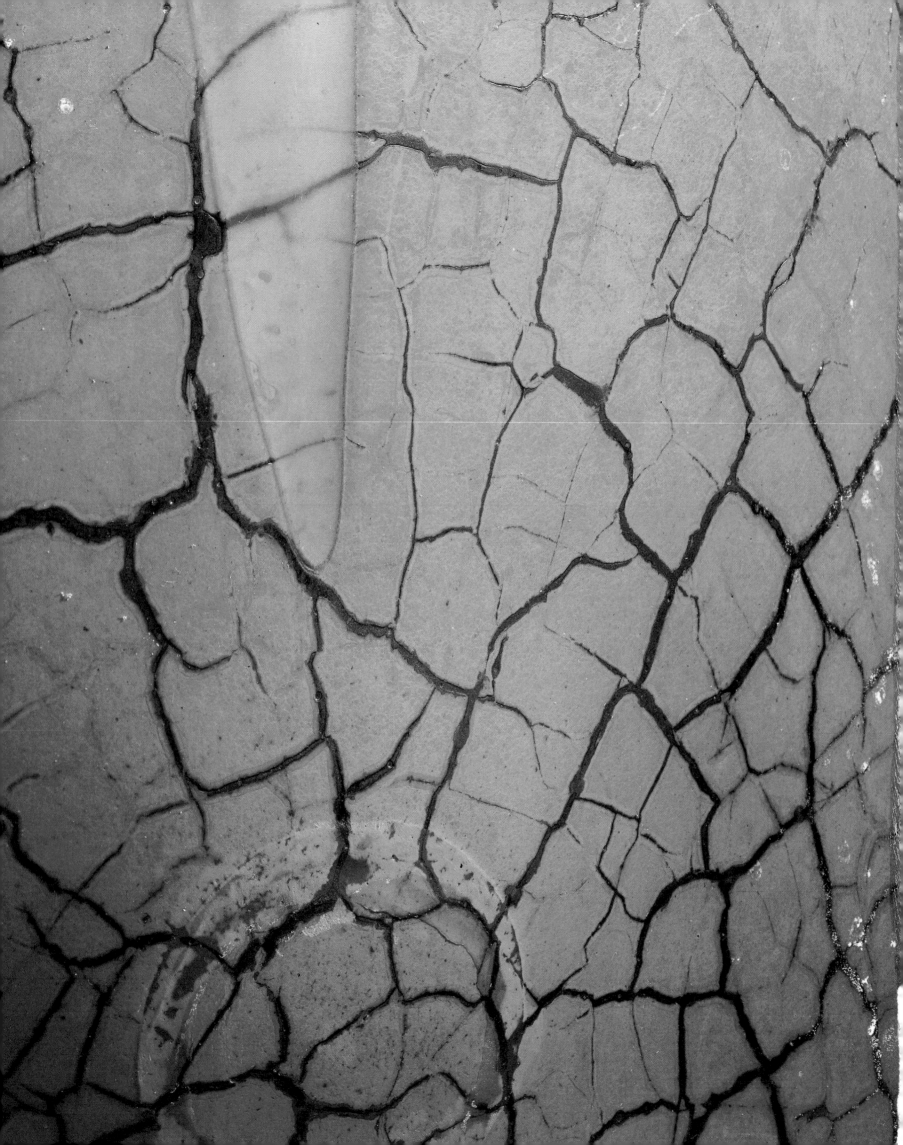

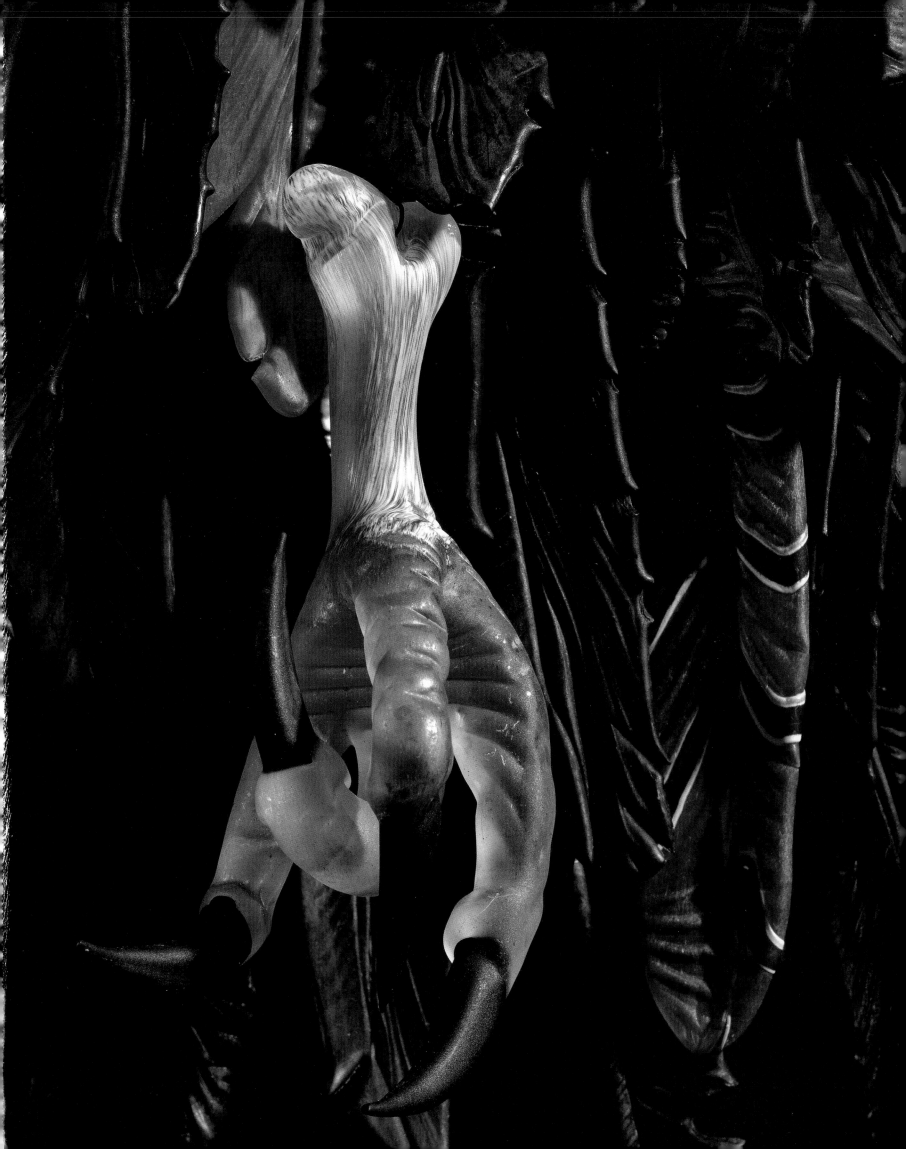

Man Adorns — In both the world we live in

and in the spirit we create and leave behind.

I dedicate this work to the spirits that have

adorned my life; with the passing of my

loving mother and my dear friend Italo, whose

deaths have given greater meaning to the

lives that surround and influence me. To my

family and friends, thank you. I honor the

spirit of man which has sought to recognize

and elevate this most mysterious world of

which we are a part.

—WILLIAM MORRIS

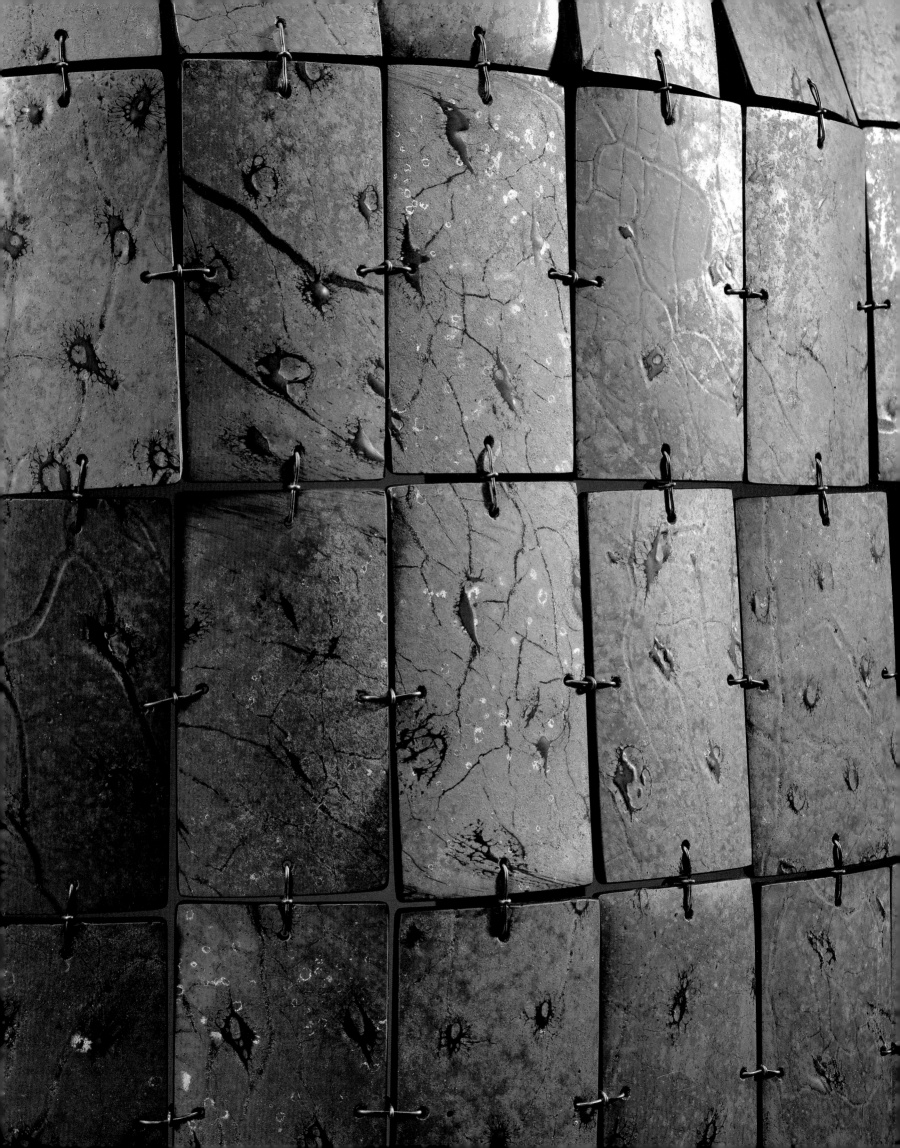

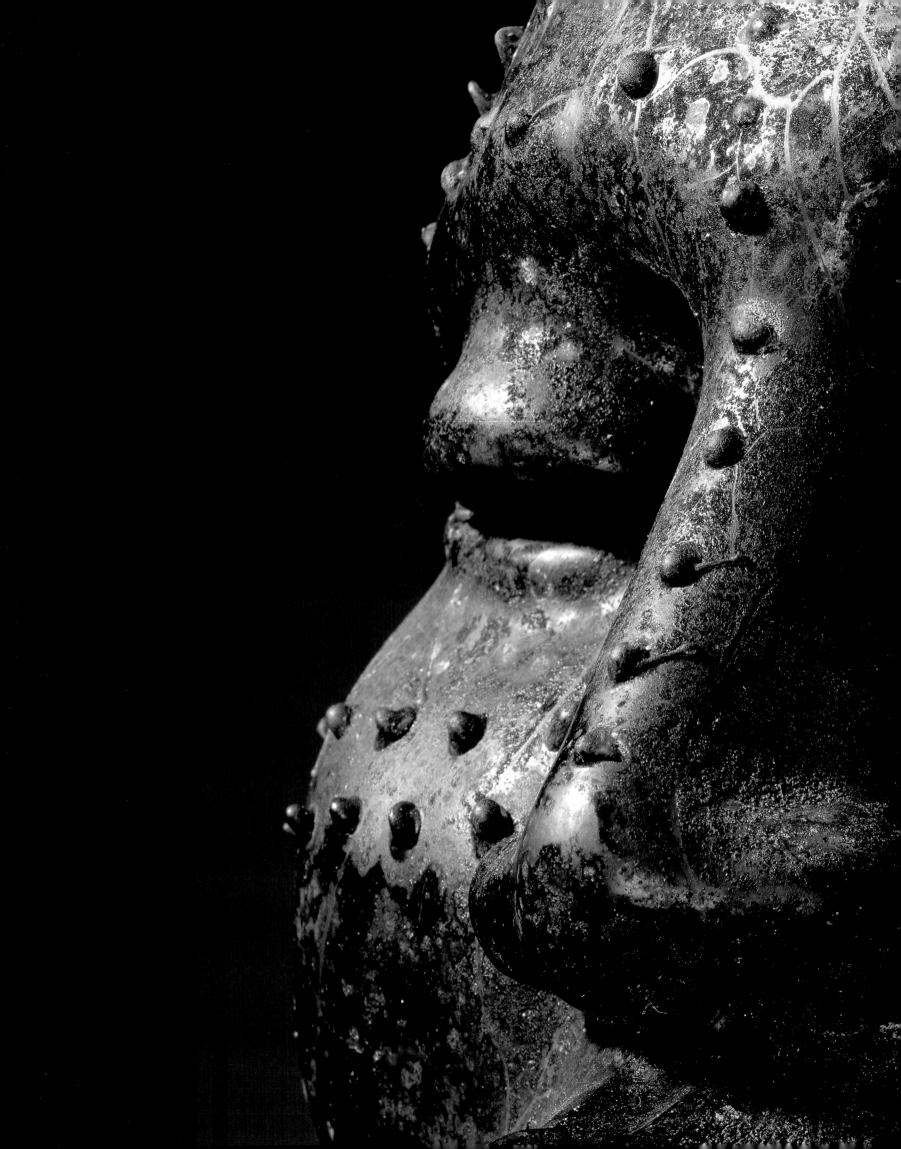

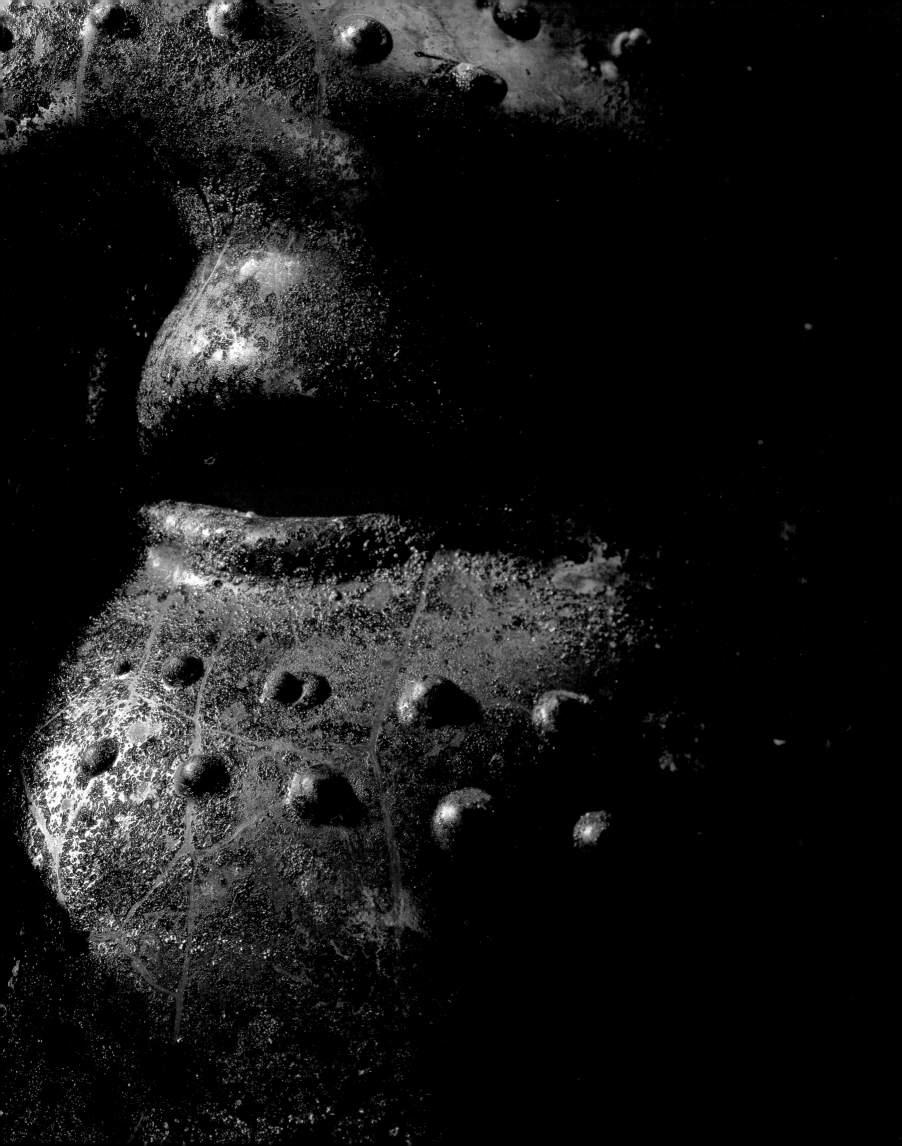

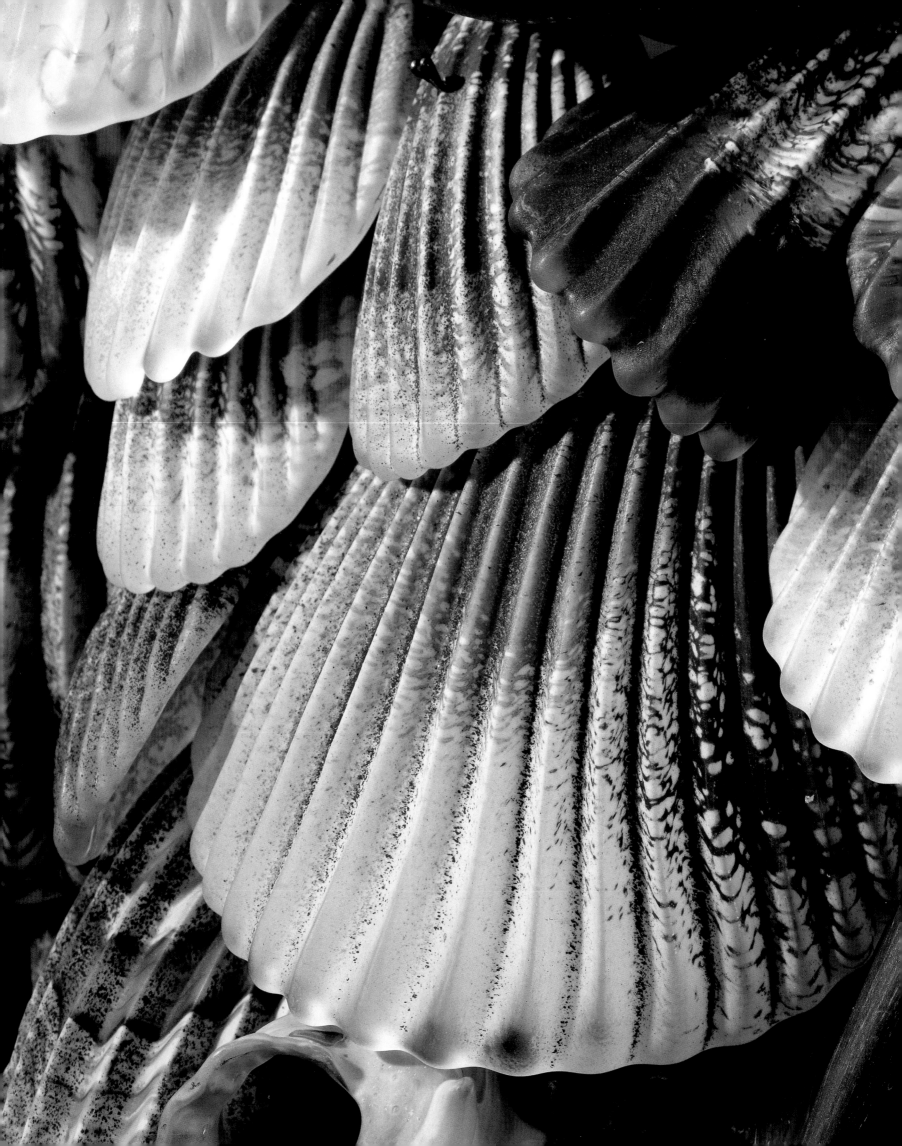

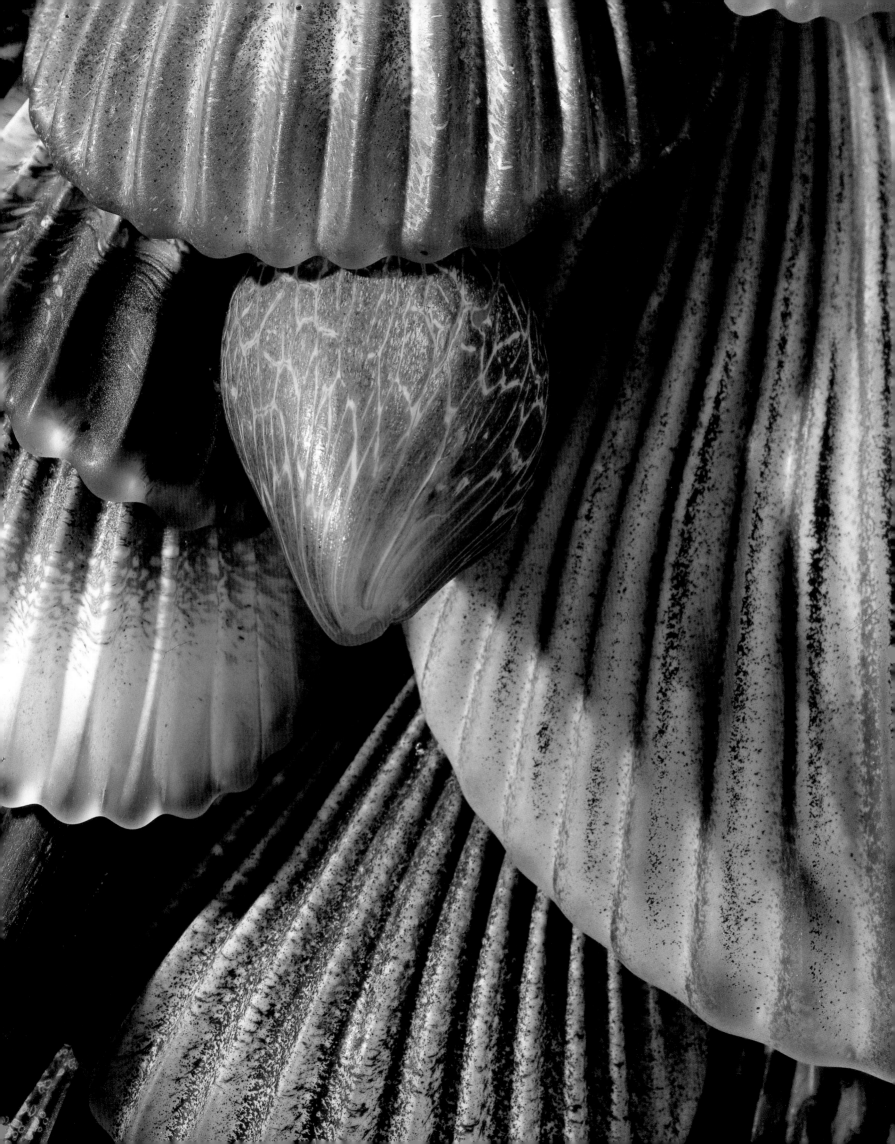

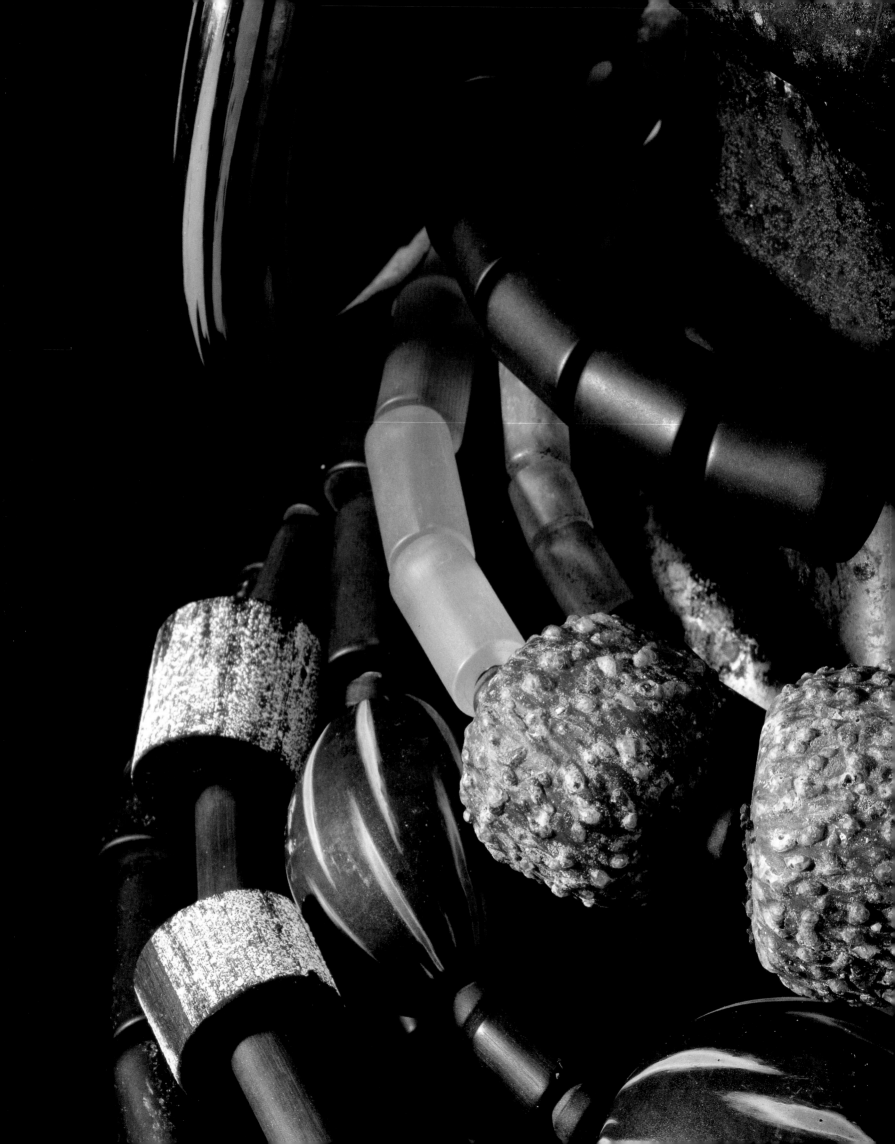

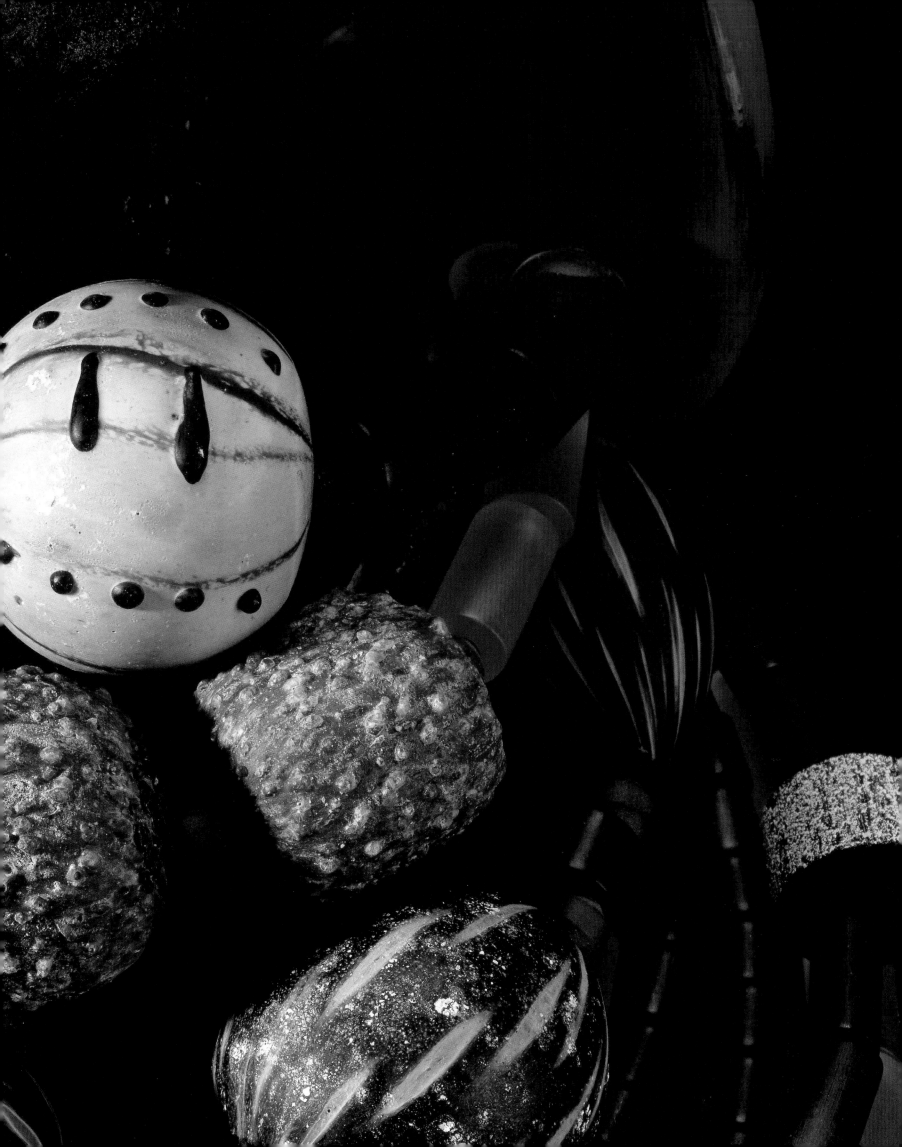

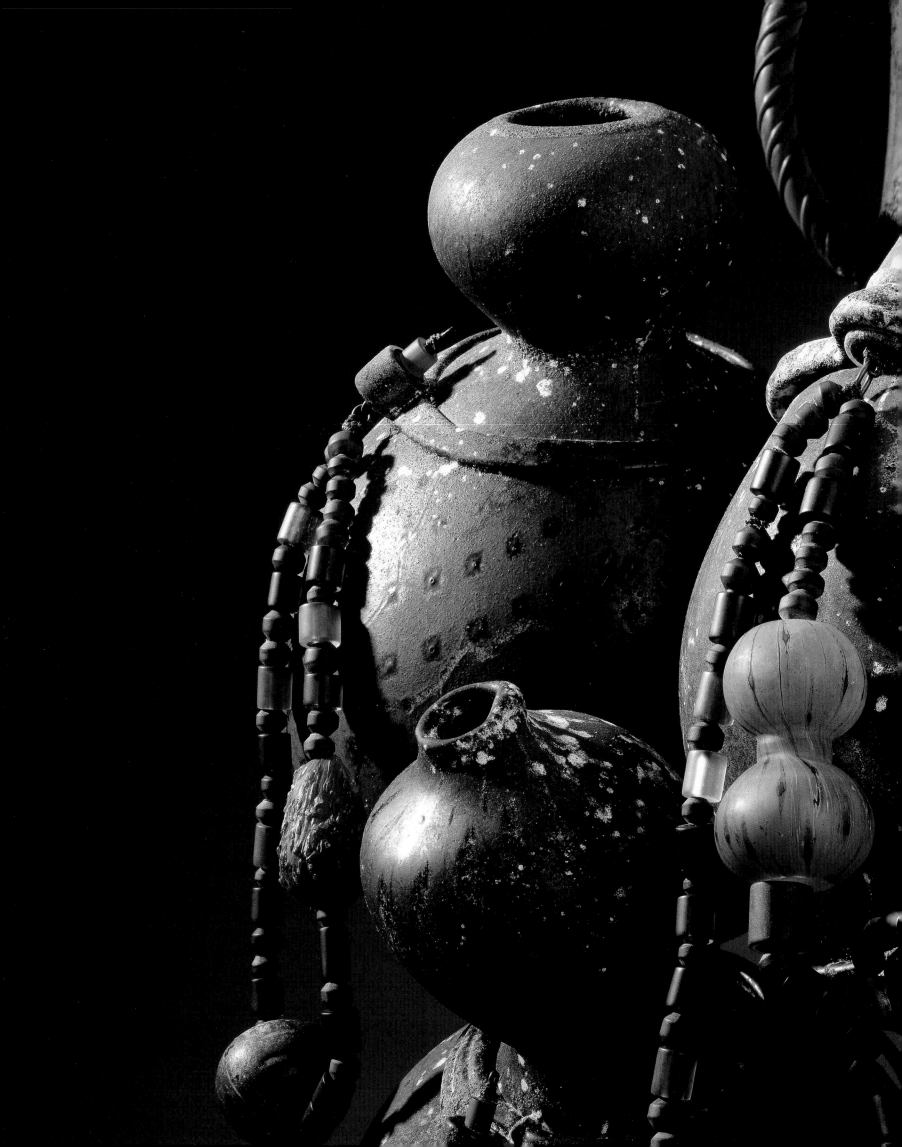

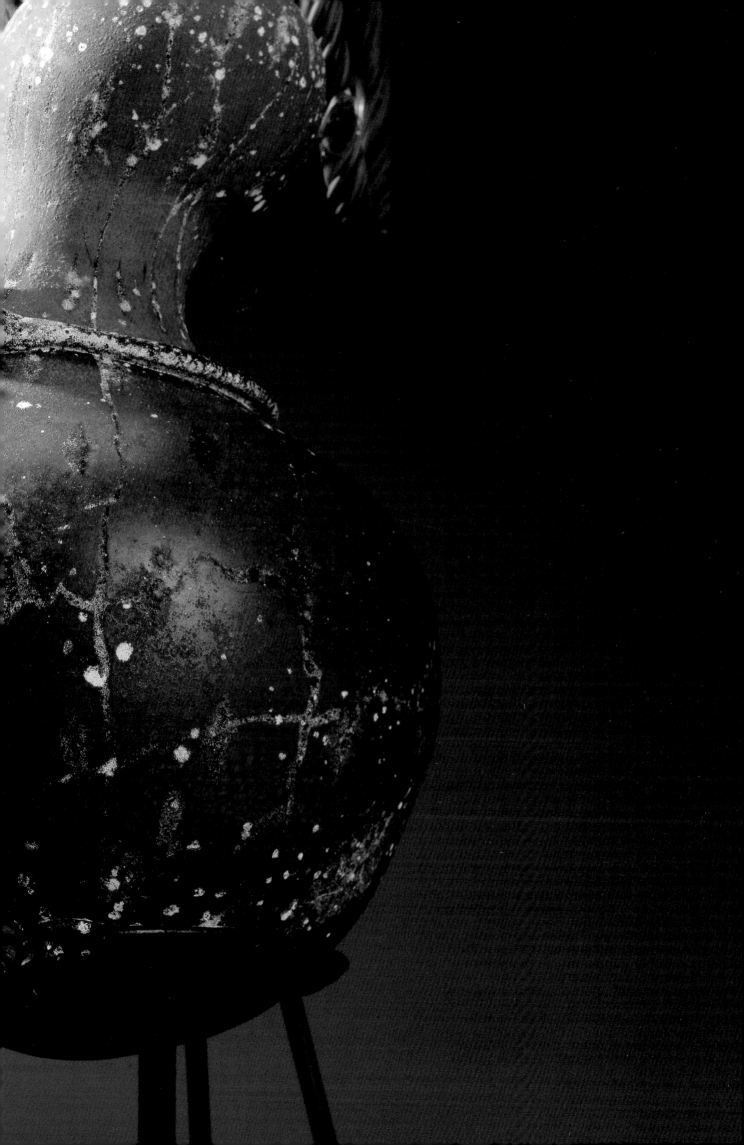

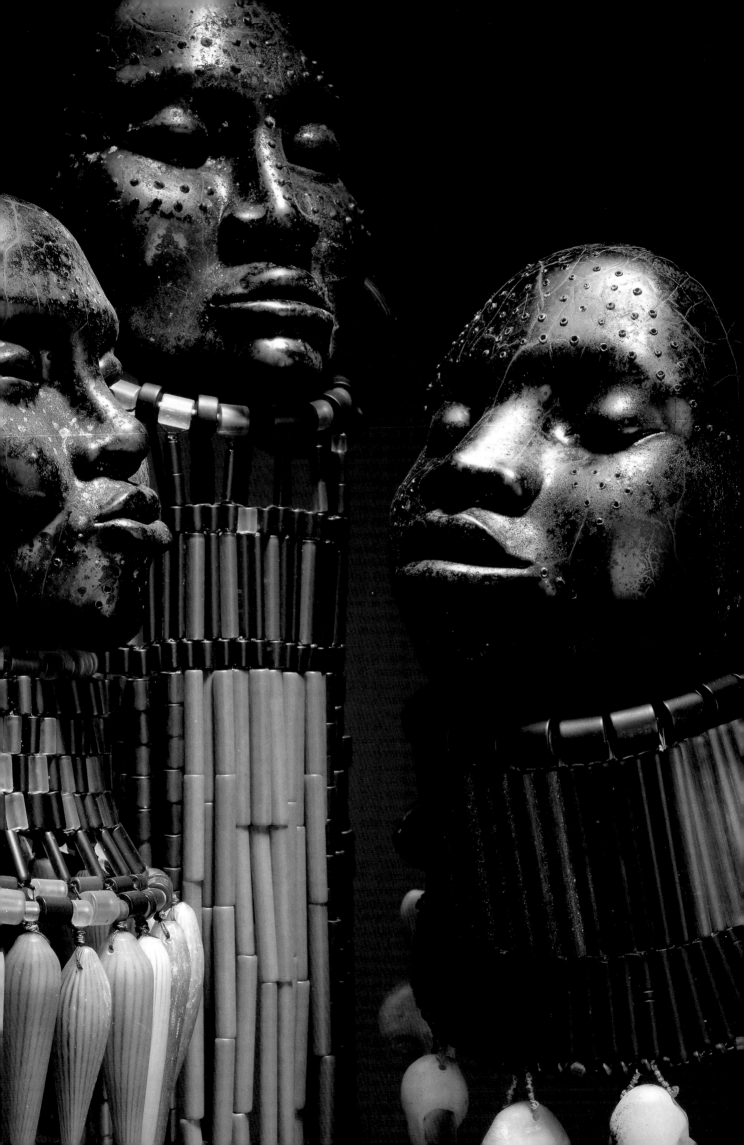

WILLIAM MORRIS

MAN ADORNED

by **BLAKE EDGAR** and **JAMES YOOD**

with a foreword by **BRUCE GUENTHER**

photographs by **ROBERT VINNEDGE**

MARQUAND BOOKS, INC.
Seattle

in association with
UNIVERSITY OF WASHINGTON PRESS
Seattle and London

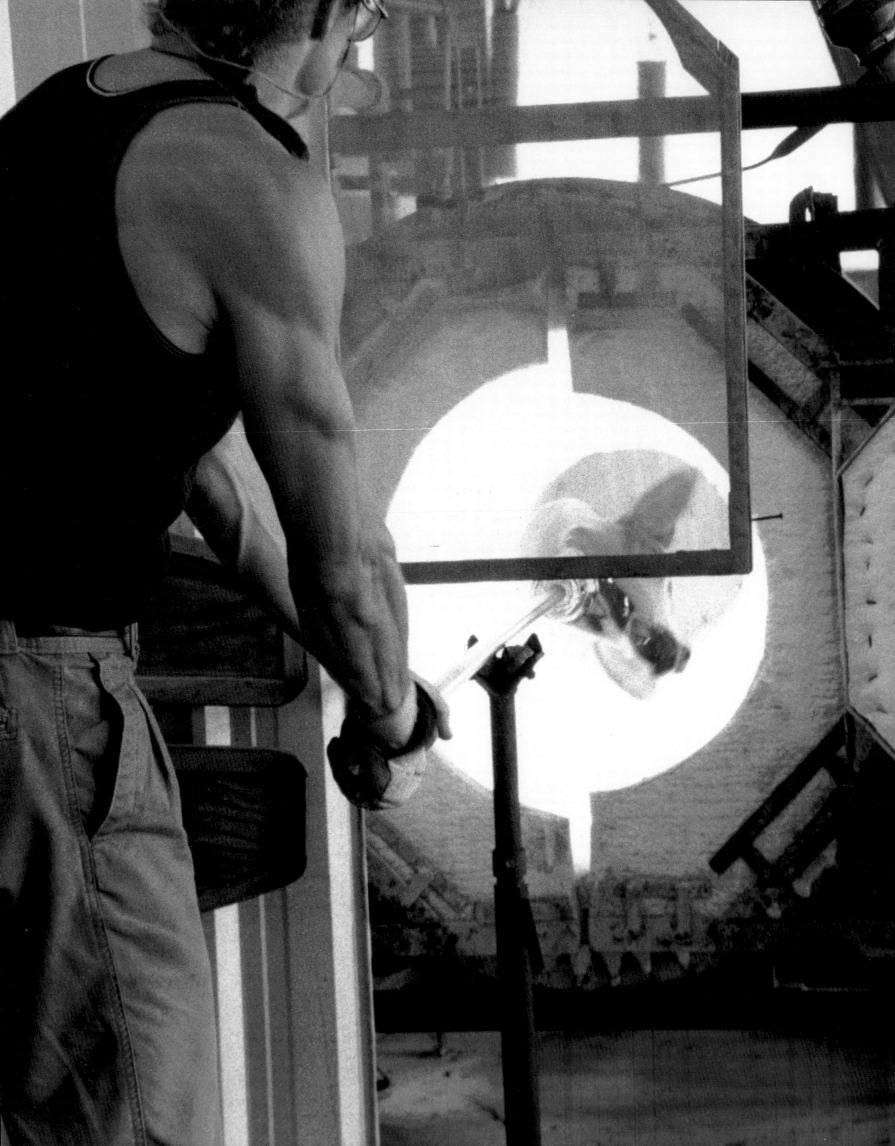

CONTENTS

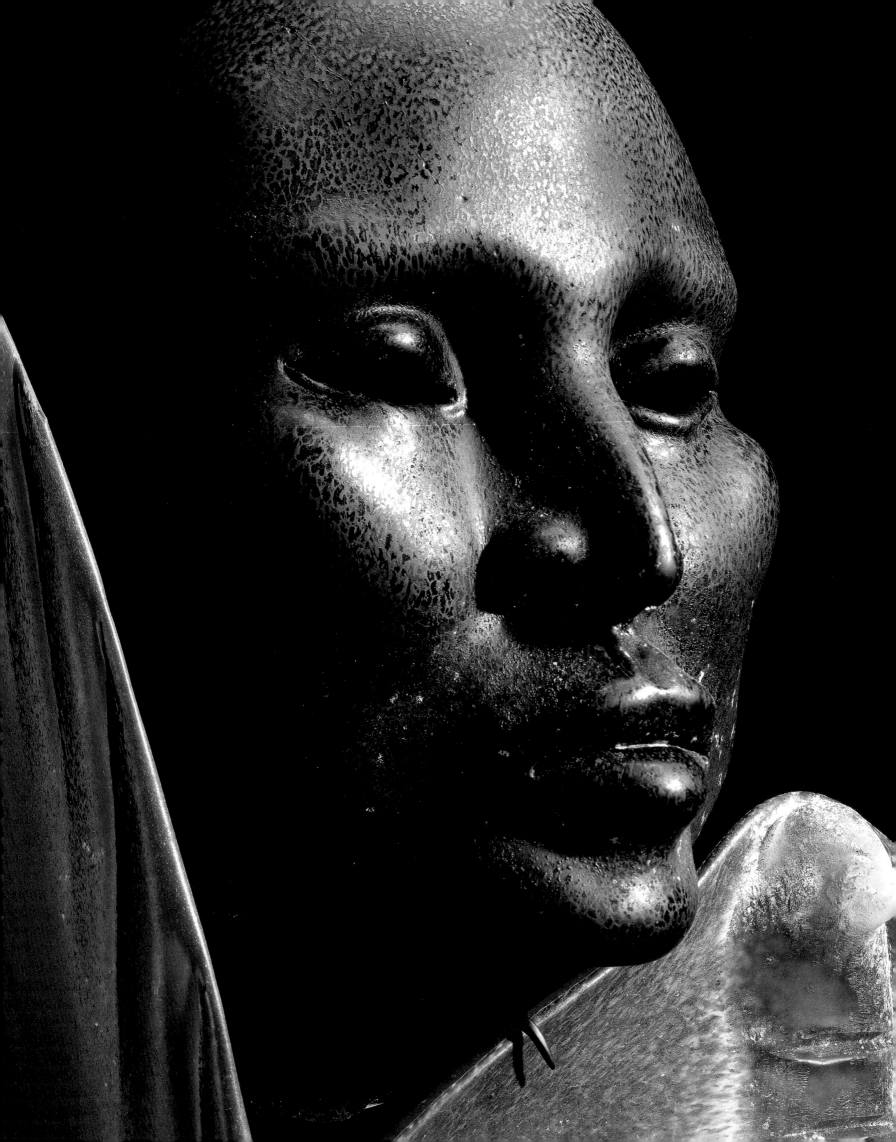

THE TRANSITIVE
ACT

HISTORY'S MEASURED FOOTFALL has today been all but halted—overwhelmed in the new millennium by the cacophonous digital presence of the World Wide Web, which conflates the traditional bonds and passages of time and geography into a global present. In a culture transformed by simulation and appropriation, we start each day by negotiating identity anew within the increasingly blurred boundaries of the self and the other. Cyberspace has effectively rendered visual literacy both universal and timeless, allowing individuals anywhere to sample experience down through history and across world culture in order to invent and reinvent themselves at will.

The body has become a part of language within this new globalization— a signifier of states of being shaped by affinity or fantasy. The temporal body is a field of dreams for every possible theatrical composite of ritual decoration that can be imagined. As we brand our bodies with tattoos drawn from world culture—from the bison of Lascaux to the now ubiquitous bar code of commerce—the boundaries between art and fashion, myth and reality, have likewise become indistinct. No longer designed to mark marriage, war, fertility, or death, each narcissistic act of appropriation further conflates art, history, and Disneyland into a seamless web. The world has become a coffee bar full of white suburban hip-hop boys and Maori-tattooed women bankers sipping cappuccinos.

It seems perfectly logical that within this rapidly evolving global paradigm, William Morris, one of the most prescient American glass artists, would find his attention engaged by the metaphor of the body and the enigma of the self. Morris's ability to mix disparate elements and sources, both temporal and mythic, in his exquisite glass sculptures, has now imagined the heroics of another age as talismanic figures across world culture. Powerfully modeled and brilliantly staged, the adorned figures recorded in these pages evoke for the viewer a child's fascination with the anthropological specimen and an adult's latent desire for the transcendent primordial. Through these provocative objects, Morris once again awakens in our collective unconscious a welter of associations that suggest both forgotten mystic rituals and the immediacy of the street culture of the new megalopolis.

Bruce Guenther

Curator of Modern and Contemporary Art
Portland (Oregon) Art Museum

"Man's origins in nature are expressed
through our physical structure.

Adornment illuminates ourselves to one
another and enhances our distinctions."

—WILLIAM MORRIS

FROM ARTIFACT TO ADORNMENT

Blake Edgar

TO ADORN IS HUMAN. Before people farmed or flew, or erected temples and skyscrapers, they created art. Decorations for body and clothing comprise some of the earliest art found among the cultural traces of prehistoric peoples. For the 50,000 or so years in which modern humans have behaved in readily recognizable ways, we have been fascinated by the luster and texture of bone, antler, ivory, shell, semiprecious stone, and other natural objects that could enhance our appearance. Adornment figured among the constellation of traits that signify the arrival of modern human behavior in the archaeological record—a key part of the cultural innovations that distinguish us from all our bipedal predecessors of the past several million years.

Body ornaments probably played an important role in establishing solidarity with fellow members of a social group and in identifying a particular group among neighbors and rivals. About the time they took a fancy to adorning themselves, modern people were expanding geographic horizons. They spread westward across Europe, embarked from Asia to reach Australia, and journeyed by land or sea to colonize North America. Populations grew, and ornaments must have held increasing value as symbols of kinship and friendship. Wherever they ventured, wherever they lived, modern people made art and adornments to accompany them in life and in death.

North of Moscow at the site of Sungir, for example, the graves of three people buried at least 22,000 years ago contained 13,000 carefully crafted ivory beads. Two adolescents buried head to head shared some 6,000 beads between them, which had once been sewn onto leather or fur garments—from cap, to coat, to pants, to moccasins. Twenty thousand years earlier in East Africa, people were grinding and piercing fragments of ostrich eggshell

into strands of beads that might have either beautified their bodies or served as a sort of cultural currency to cement reciprocal obligations among groups. Even earlier, people likely decorated their skins with ocher, hematite, and other natural pigments.

With *Man Adorned*, artist William Morris celebrates this ancient and universal human quality. At first glance, this series of glass sculptures signals a striking departure from Morris's oeuvre of canopic jars, animal vessels, assorted artifacts, and imaginative burial installations. His previous focus on objects inspired by the subsistence and ceremony of daily primitive life, such as tools for hunting or serving food, and on the relics that attended one during the afterlife, seems to have shifted to the living body itself. Animals dominated the earlier work, in which a human presence was implied by the products of human craftmanship or represented solely by skeletal remains. Now Morris depicts the people only imagined before. He has put flesh on the bones, and covered the bodies with costumes, jewelry, headdresses, and tattoos. These figures spring forth, full of vibrant life, in the present rather than recalling a distant past.

Upon further reflection, *Man Adorned* marks a natural, logical step in Morris's artistic evolution. He continues his exploration of the themes of origin and myth that permeate all his work. He has always interpreted episodes of the human saga, and each of these new figures stands as if ready to share his or her story—part of our collective story. Morris presents us with a multicultural mirror to probe our curiosity and expose our prejudices as we ponder who we are and from whence we have come.

Technically and conceptually, this series proved more challenging than any other attempted by Morris and his talented team of artists. The team even grew from its usual handful to a total of ten, the number of individuals needed to overcome obstacles and accomplish novel methods of working with a medium that continues to amaze Morris. From earlier efforts to capture the most salient traits of birds and mammals in glass, he learned how little he had really seen those animals before. He encountered a similar humility with the human face. "The face is like a landscape in flesh," says Morris, with unique topography to each person's nose, eyes, and cheeks. Capturing the subtlety of form and learning to relate to glass as human skin required Morris and his

team to fashion a new suite of tools and refine their techniques. Artisans were brought on board specifically to fabricate beads, feathers, and other details.

The series began after Morris proposed that the team experiment and see what inspired and guided the work. Morris had a vague notion of working with the human figure, but his first attempts—vertical versions of his burials with human skeletons—left him dissatisfied. He had never tried to re-create a human face in glass; his first attempt had an intriguing, primitive look. Soon Morris became a voyeur of faces, stopping people on the street to inquire about their family origins. To his surprise, many expressed little pride in the evolutionary legacies evident in their faces or on their skin. The team worked from photos and from models who posed in the studio. "Otherwise," says Morris, "they were all going to look like my crew members." Instead, the faces and artifacts evoke and sometimes blend elements of Africa, Asia, Oceania, and the Americas, tracing the global migrations of distant ancestors. As with recent animal figures, Morris aims less for realism than for an essence of ethnicity.

A blue-faced man with the dour visage of a Mayan lord sports elaborate geometric designs on his cheeks and forehead, like the intricate tattoos of a Maori warrior. Maori chiefs could draw their unique facial tattoos from memory, and such drawings served as signatures. Polynesian tattoo artists held a revered, hereditary position in society for their skill at wielding a mallet and sharp combs and chisels of bone to incise the skin with a soot-and-water pigment. From the neck down, Morris's figure wears a protective tunic of rectangular plaques connected by copper wire, reminiscent of the full-body jade burial suits worn by Han dynasty Prince Liu Sheng and his wife, Dou Wan. Gold wire held together the 2,500 pieces of jade of each burial suit, which took expert Chinese artisans an estimated ten years to complete.

Delicately balancing a vessel atop her head, an elegant young woman inspired by the diverse agricultural tribes of the Nuba Mountains west of the Nile in Sudan bears an outrageous burden of calabashes for storing water and beer. Perhaps she's a recent bride, for young men typically make the calabashes as wedding gifts and decorate them with designs similar to those incised or painted on their own bodies. The woman's face bears the marks of scarification, a process that begins in childhood and continues on the neck, back,

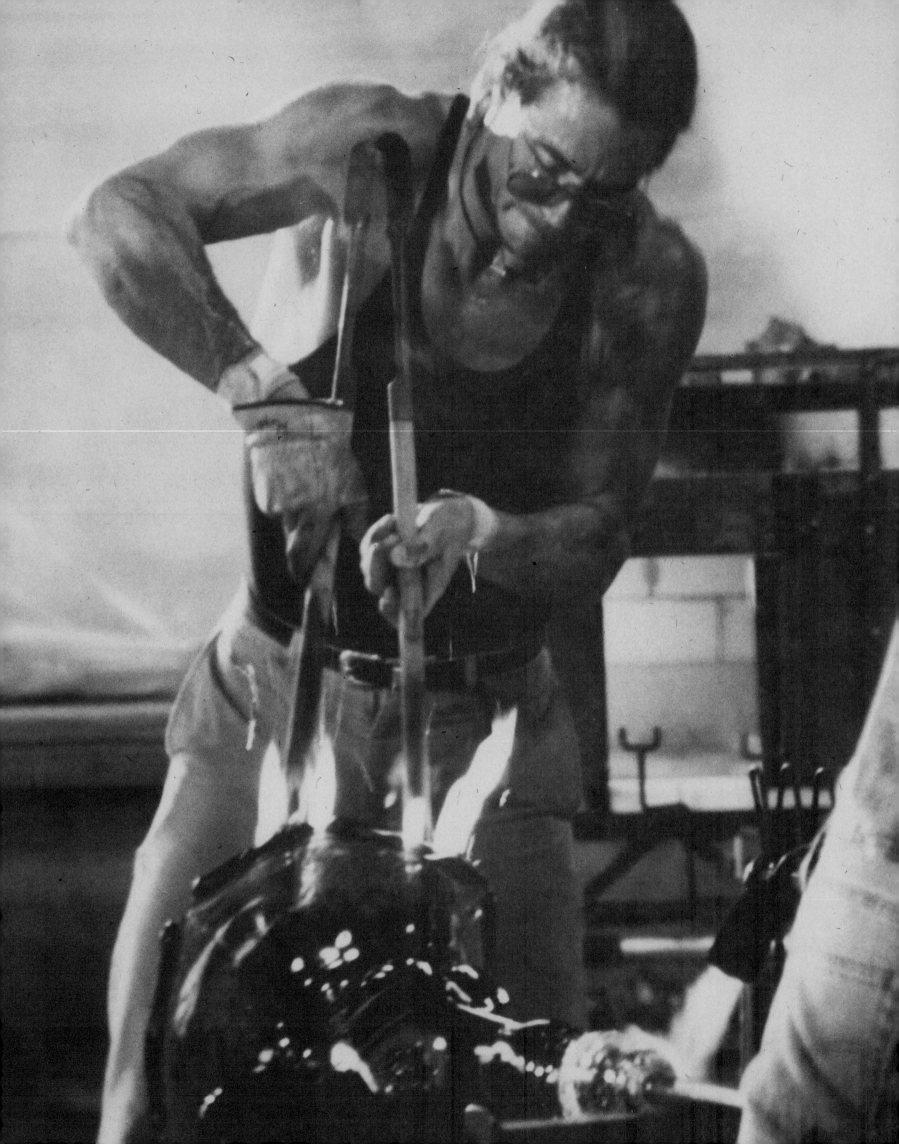

and torso, at significant transitions to womanhood and motherhood. Among the Southeastern Nuba, body art remains motivated by aesthetics, a way to celebrate a strong and healthy human form. Decoration must merely enhance anatomy and emphasize the body's beauty. The practice begins at birth, when red or yellow ocher is rubbed on a newborn's head.

Other figures in *Man Adorned* display a more mythical and mysterious appearance. The beakish nose and piercing gaze of the bird hunter match the eagle mask atop his head. Likewise, the shaman draped in black raptor feathers, talons, and skull sports avian facial features. Ivory hairpins in bizarre, bestial forms sprout Medusa-like from another head. One can imagine these people as the creators of those fantastical zoomorphic artifacts in Morris's earlier work.

Finally, gaze at the plain, unadorned faces of a young mother and child. Tied by the most immediate and sacred of bonds, this pair also represents us all. While we differ in our skin color, our hairstyles, the features of our faces, and our dress and customs, beneath the surface, any two humans plucked randomly from opposite ends of the earth would be virtually identical genetically. Fewer than ten genes regulate our range of skin color—anyone has the genetic capacity to become black, brown, or white. Opaque and translucent, glass provides an ideal medium to convey human homogeneity at this most fundamental level, and to shed light on our oneness.

HUMAN
TRACES

James Yood

WILLIAM MORRIS'S MOST RECENT BODY OF WORK is a fascinating immersion into the implications of a personalized historical ethnography. Within its breadth, he recalls peoples and civilizations that have disappeared from the face of the earth or are at imminent risk of doing so, and he offers us both a sobering gesture to loss and a platform for trying to understand what he sees as the transcendent significance of these peoples and their cultures. In many ways, this constitutes both a continuation and an extension of themes that have always concerned Morris, especially his deep-seated curiosity about the intense interrelationship between humankind, nature, and history. This is an artist whose work has always spoken eloquently and forcefully of a kind of spiritual resonance within the continuum of history, and of the magic in the intuitions sensed by our collective ancestors. His art holds that a profound way of understanding ourselves can be realized by an attentive consideration of our predecessors, and that what we are can be approached by a rethinking of where we've been.

For more than twenty years, in a career that has brought Morris to the very forefront of the modern Studio Glass movement, he has thought long and hard about these issues, and most often employed the metaphor of the animal to express his ruminations. (Although renditions of human skulls and bones and some pictographs of people have appeared in some of Morris's earlier work, particularly in sculptures and installations of the late 1980s, this new series of sculptures represents the first time he has overtly concentrated on the specific and individual human figure.) His extensive menagerie—including renditions of birds, bison, mammoths, horses, frogs, panthers, bulls, rhinos, gazelles, antelope, musk oxen, wolves, giraffes, impalas, deer, beetles, turtles,

and more—was, however, firmly tied to humankind through Morris's attention to cultural traditions in the forms and formats of their presentation.

Morris's subject matter was always less the sculptural reproduction of the specific animals themselves than the considered investigation of how certain civilizations over the course of human history have chosen to represent these creatures. His central concern has always been culture and its intersection with nature, offering a kind of communing with how earlier peoples have employed imagery of the animals that surrounded them to think about the aura of nature, of animals' and humans' interdependency with nature and its role as a source of magic and wonder. Historical models were plumbed by Morris, ranging from peoples and civilizations as diverse as prehistoric humankind, ancient Egyptian, Cycladic culture, Greek art, African art, Native American, and so much more, and with the infinity of variations and local geographic tendencies within each of these. But the trappings of temporal style were not as important to Morris as were the essences that these styles and peoples seemed to touch. His work has always been far less art historical revisitation than a pursuit of anthropological parallels. Morris's presentation of the torso or visage of an animal became a cultural link between our collective past and present, an homage to—but not a copy of—civilizations that in very interesting ways seemed more sensitive to and in harmony with the dictates of nature than contemporary humankind.

In a sense, Morris's most recent work begins to take us from ruminations about those civilizations to peering at some of the faces of the men and women who comprise them. His innate sympathy for moments in the history of the world when humans seemed to live more as a part of the mystery of nature, without experiencing the touristic disenfranchisement that might describe our current estrangement with the world around us, made him seek them out as individuals.

Glass, of course, functions as much as the bridge between these series of sculptures as does the conceptual concerns underpinning them, and Morris's skills as a superlative glassworker certainly deserve close attention. His technical skills are simply astounding; his ability here to make blown glass appear as bone, skin, bronze, leather, clay, metal, and more is so accomplished that it might appear effortless. It is, instead, the filtering of tremendous technique and a lifetime of experimentation, as Morris, effect by effect, has learned how to tweak and cajole molten glass into simulations of substances that seem far

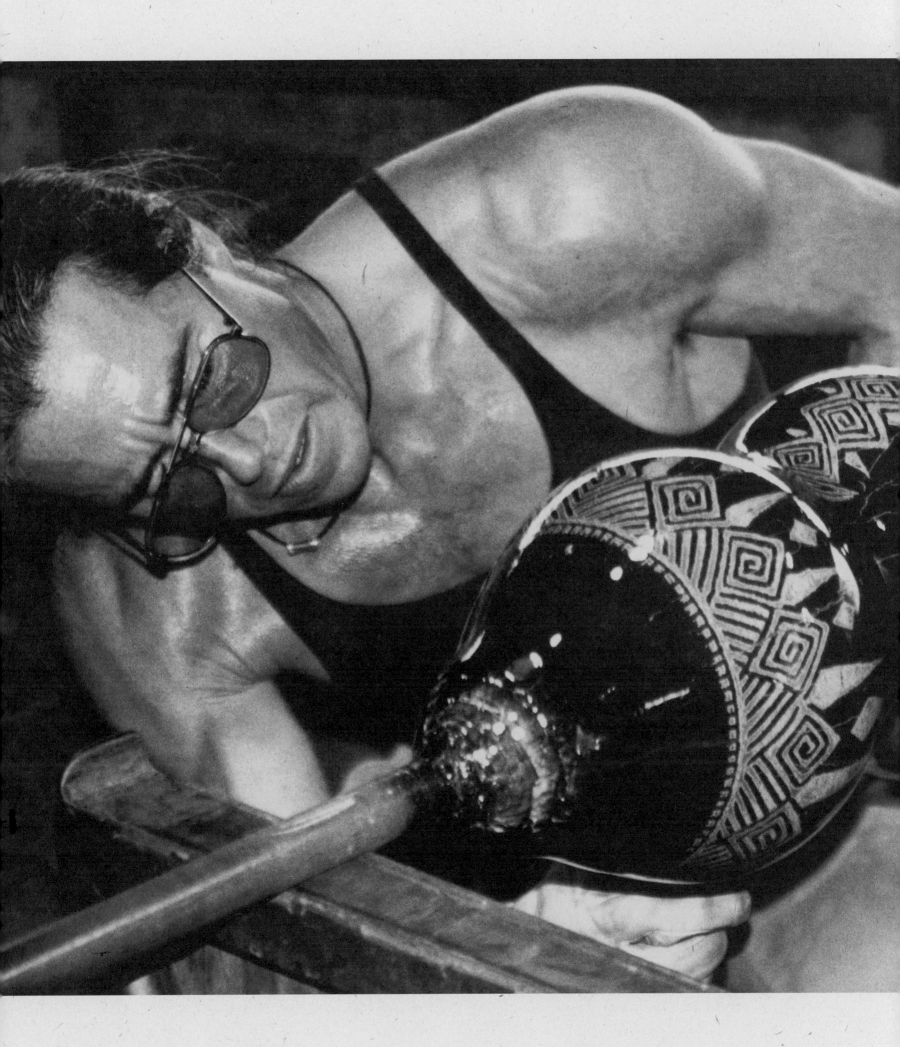

removed from glass's own inherent fragility and delicacy. Like some alchemist at the crucible, Morris and his team in his studio in Washington use the heart of the fire to seek and discover a magical transformation, to make his materials appear to transcend their physical and chemical properties, fully subsumed into what they describe. This process is all wonderful to witness, and the optical credibility of his sculpture provides no small part of its allure. But the significance of William Morris has never rested in his ability to make glass look like something it isn't; he does not want to fool the eye as much as he wants to inspire the soul, to touch us in a way that extends beyond our retinas toward a consideration of the deeper implications of our own humanity.

And here he exercises those skills in an almost palpable desire to look into the faces of individuals who somehow seemed more in sympathy with nature, with the fundamental processes of earth, than is contemporary humankind. Of course, these are not portraits in a specific sense; while Morris sometimes works from live models in his studio, he combines that experience with his imagination and the accumulation of his own varied and wide-ranging researches into ethnography and anthropology. The history of art provides some models and inspiration, and one also senses Morris's particularly careful examination of highly skilled artists such as Leni Riefenstahl and Edward S. Curtis who used photography as a tool of heightened cultural anthropology. Sometimes Morris surrounds his figures with an assortment of attributes that invite us to see the assemblage as some sort of a ritualistic installation surrounding a hunter, chieftain, or magic-giver. It is as if the accoutrements then accrue to some fetishistic end, that the various implements accompanying his figures aid us in considering issues of rank and stature. Often, though, the heads are shown singly, and are usually both formal and impassive. We look at them, but they do not look back, remaining impervious to our presence, masklike and aloof, serene and disembodied.

Among the many surprises in this body of work is that despite the tremendous geographical diversity suggested in Morris's characters, there is a kind of universality to their aggregate dignity and deportment. Morris has cast his net widely—Native American, African, Asian, Oceanic, Arabic, Arctic, Indo-European individuals and more are represented—and even when the culture from which his particular figures are drawn still exists, there is a sense that Morris is drawing them from a different moment of their ascendancy, when

their civilization was in full flower. Sometimes the emphasis seems to be on depicting individuals, and at other moments on depicting sculptures of individuals, but in either manifestation a certain formality of presentation is dominant, as if we could encounter these sculptures—sometimes themselves presented as fragments—in some museum dedicated to surveying aspects of the ethnic range of humankind.

It becomes less specifically important, though, whether Morris's subject is a Native American Karok man from California and the Pacific Northwest (where Morris was raised, educated, and continues to live), or a Tungus woman from the plains of Russia, or a Rana Tharu woman from the mountains of Nepal, or a Peuhl man from Senegal. What is central to this inquiry is Morris's desire to demarcate these individuals as individually and collectively presenting a vital alternative to dominant contemporary culture as usually manifested in and through Caucasians. This last group seems conspicuous in its absence from this body of work. Morris has from the very beginning of his career been alert to exposing the shallow and arrogant description as "primitive" of those civilizations and peoples who appear to him to have had a much deeper understanding of their place on this planet than modern society might ever know.

This all becomes one branch of a highly active pursuit of the "other," the almost Arcadian search for a path toward freedom to be discovered somewhere, anywhere, outside the mainstream tradition of Western culture. It is part of the belief system that drew, say, Gauguin to Polynesia—the belief that somewhere else, somewhere far away, one could encounter a culture unencumbered by the fetid morass that seems to constitute contemporary existence. Sometimes Arcadia can be a place or a people, or found within the body of a coveted beloved, and sometimes it resides in the recesses of our unconscious. Sometimes drugs or drink can seem to be the way to take you there; sometimes Arcadia is seen as an innocent universe only to be populated by children and the insane. The overt search for it, though, is almost always about two sides of the same issue: a passionate meeting of discontent and desire that requires this quest to come into being.

In the case of William Morris, this discontent/desire seems to rest in his sense that there was once a time and a place and a range of cultures more in harmony with nature, with the rhythms of this planet, than anything he can

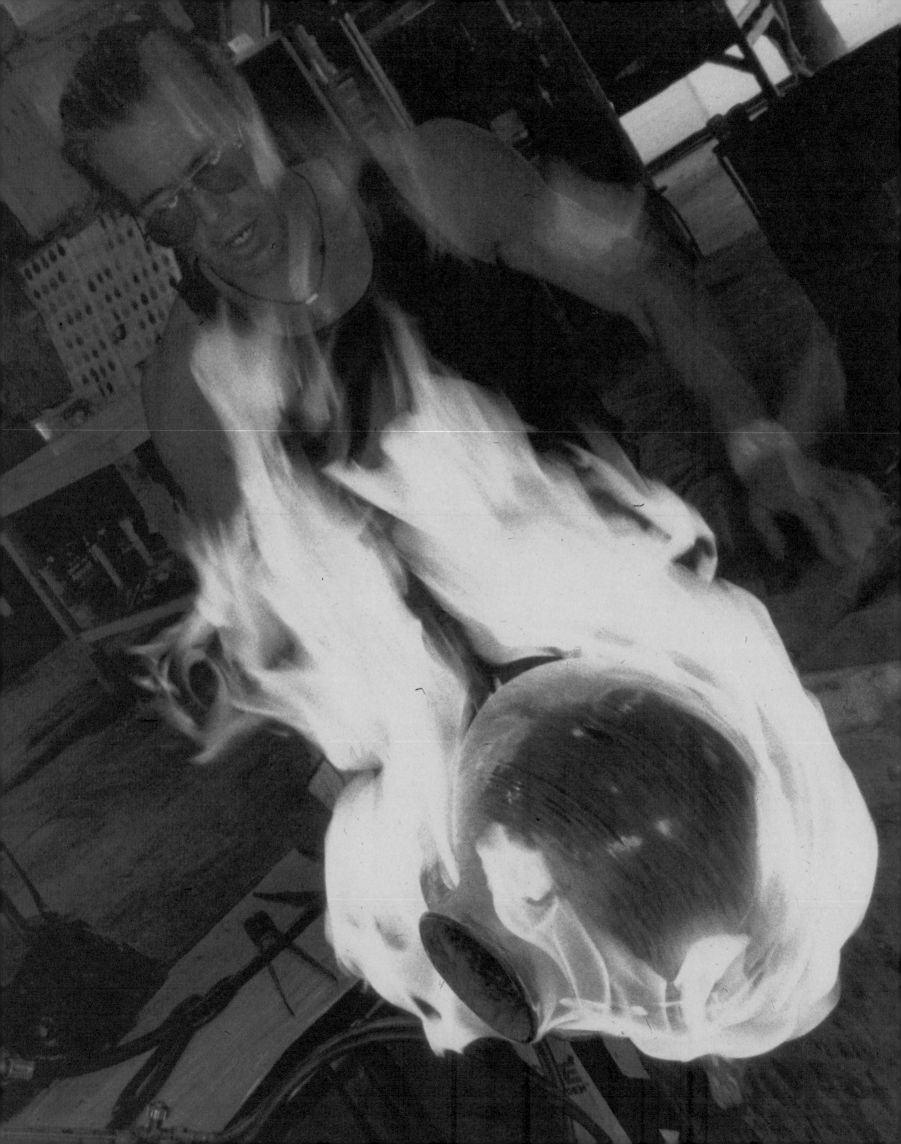

discover around him today. He seeks that time and place, and in his art he finds it, and offers it to us. He longs for those individuals who reflect his own love of nature and the wild, who somehow were living entities in an ecosystem of balance and harmony we have long left behind. Thinking about those people—their appearance, systems of adornment, and strategies of self-presentation—and inventorying them in determined and encyclopedic detail becomes a way of resurrecting the worldview that underpinned them. Morris seems to suspect that the world has been devolutionary, that we fall short compared to these predecessors, that modern myths of progress and the inexorable march of time might every day be taking us further from something very important. In the larger sense, it doesn't even matter that much whether Morris is literally right, whether the cultures he posits as more securely rooted in the tempo of the world were actually what he imagines they might have been. Morris presents us with a philosophical rather than an historical thesis: It never matters whether you find Arcadia, it only matters that you are looking for it.

Every glance at these figures can become more about what we are than about what they were. The search that this recent body of work indicates is, finally, ennobling to both maker and viewer, the conviction that the seemingly infinite range of participants in the human family are deeply and intimately connected to us, that just one leap into our collective unconscious might bring us face to face, together again. William Morris seems to argue that we can never lose what is embedded within us, and that if we were to uncover it, we might just reap the precious benefits of a deeper understanding of ourselves and of our place upon this earth.

PLATES

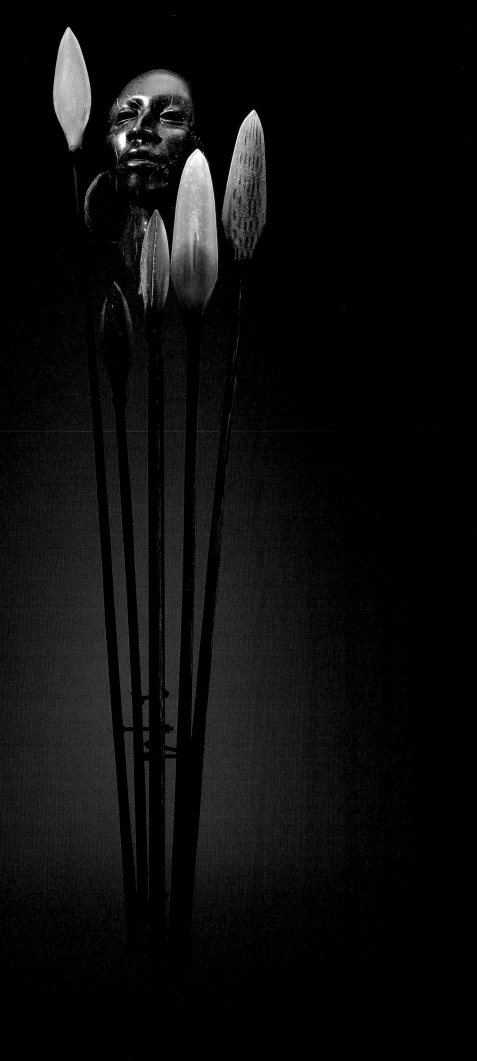

1

Hunter II

2001

80 × 19 × 14 in.

HI601.05.08

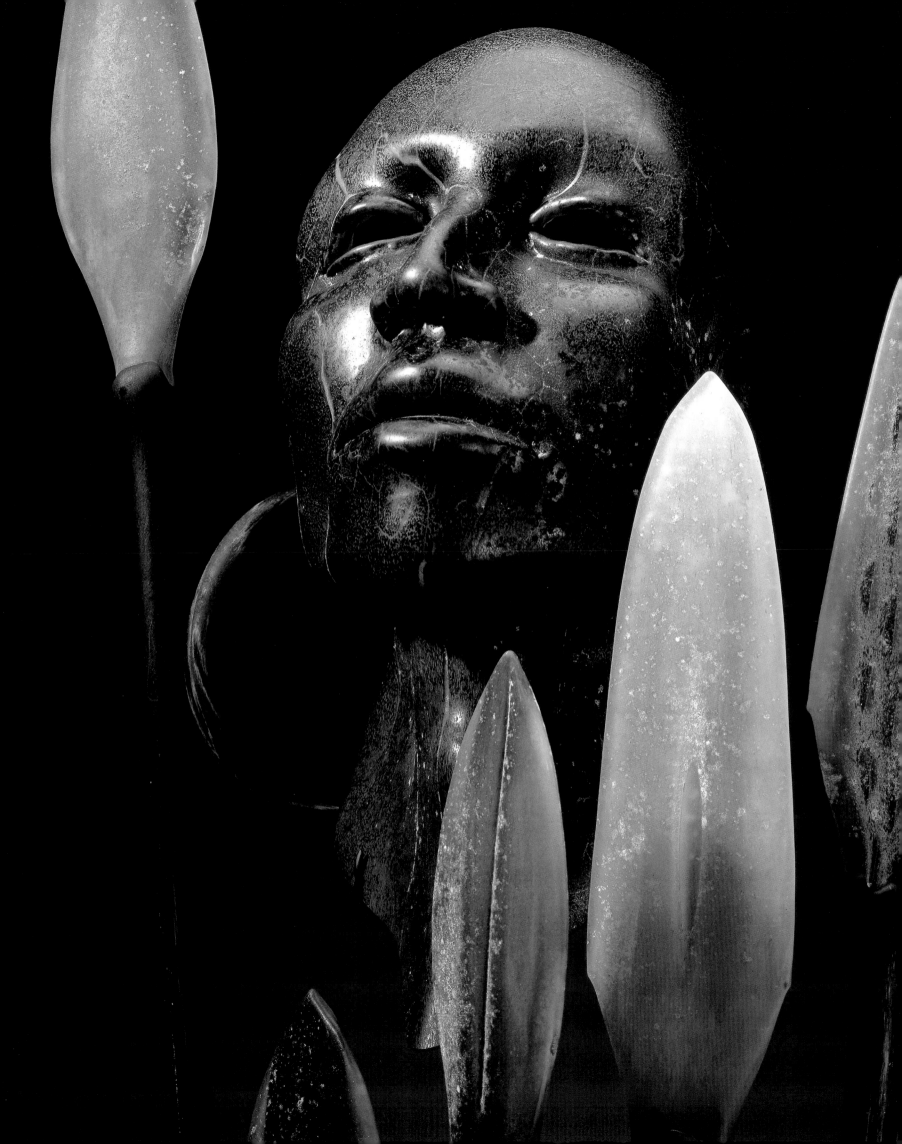

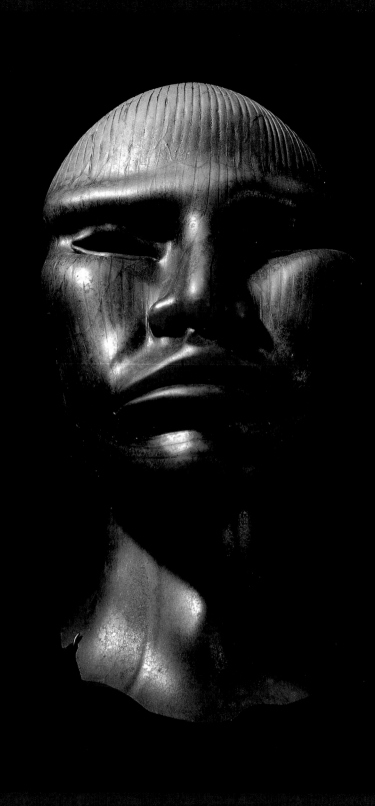

2

Rarotowgan Man

2001

25 × 7 × 8 in.

HA601.09.02

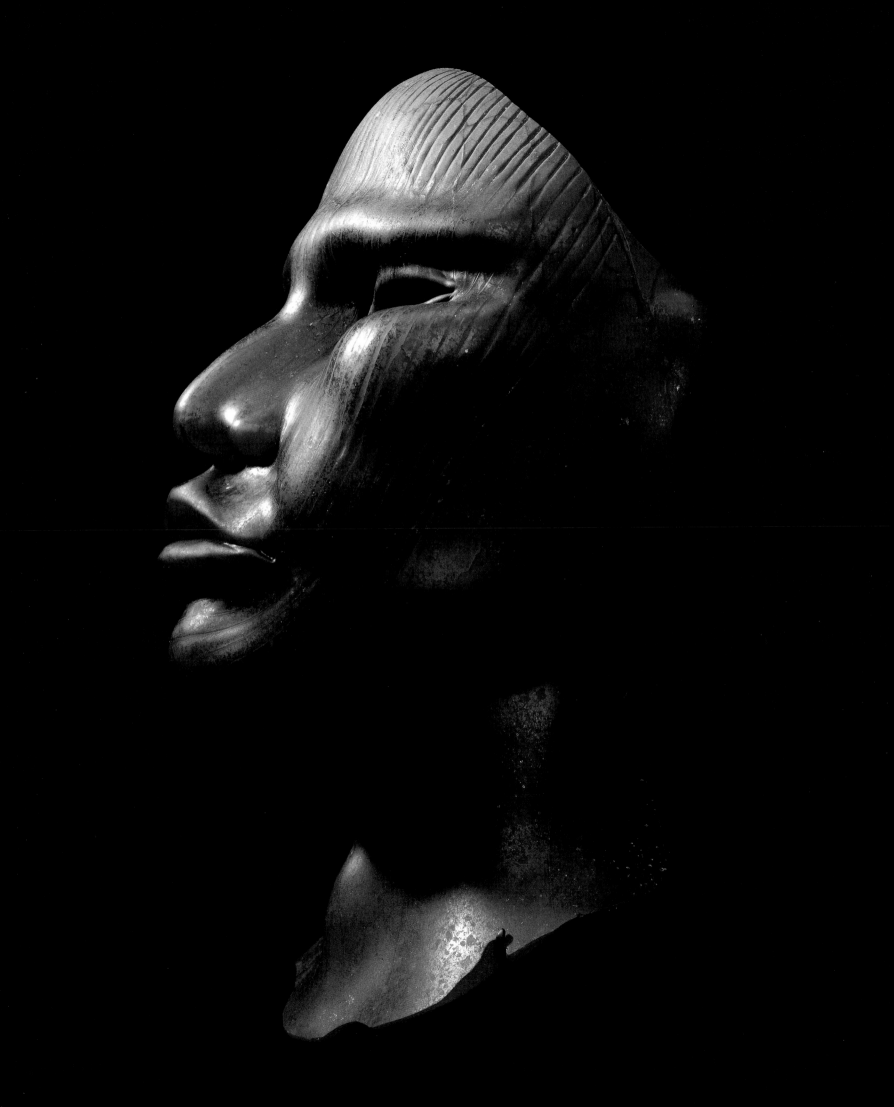

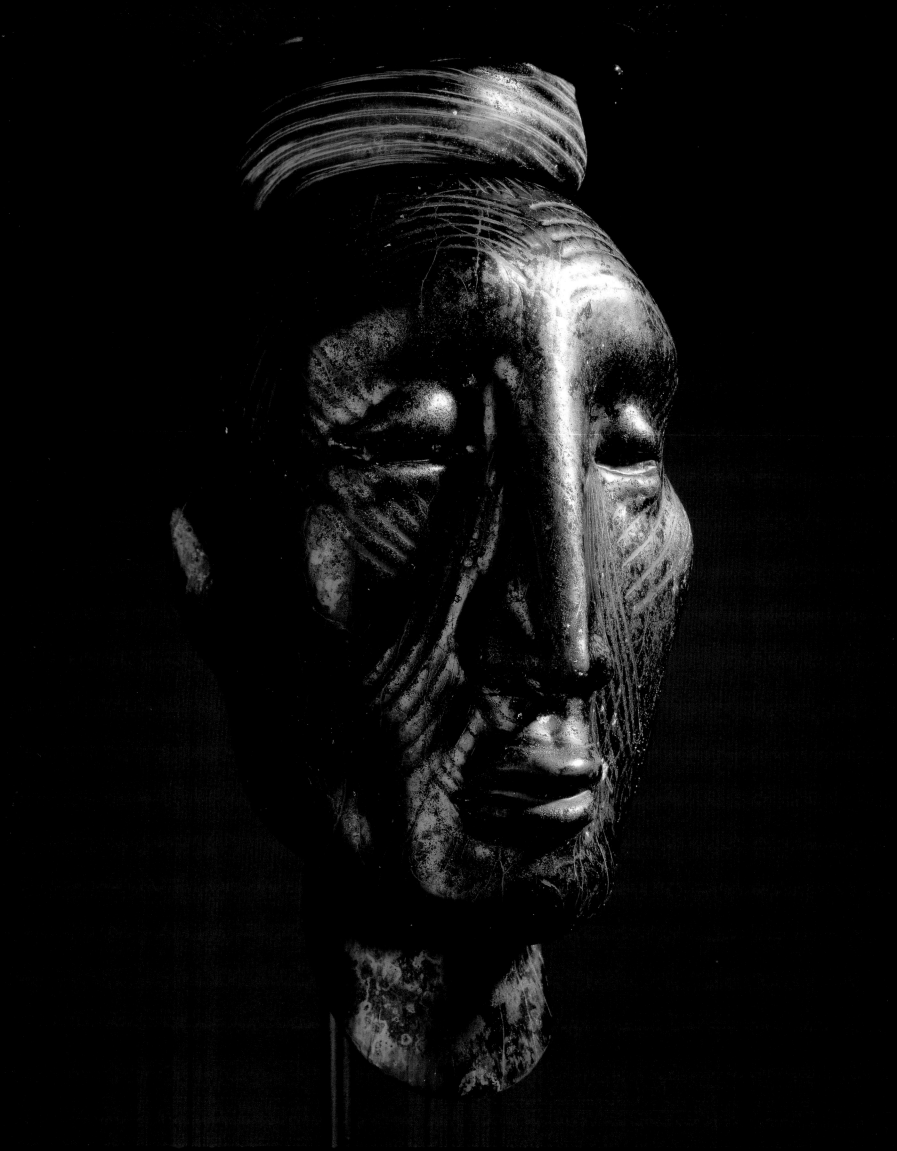

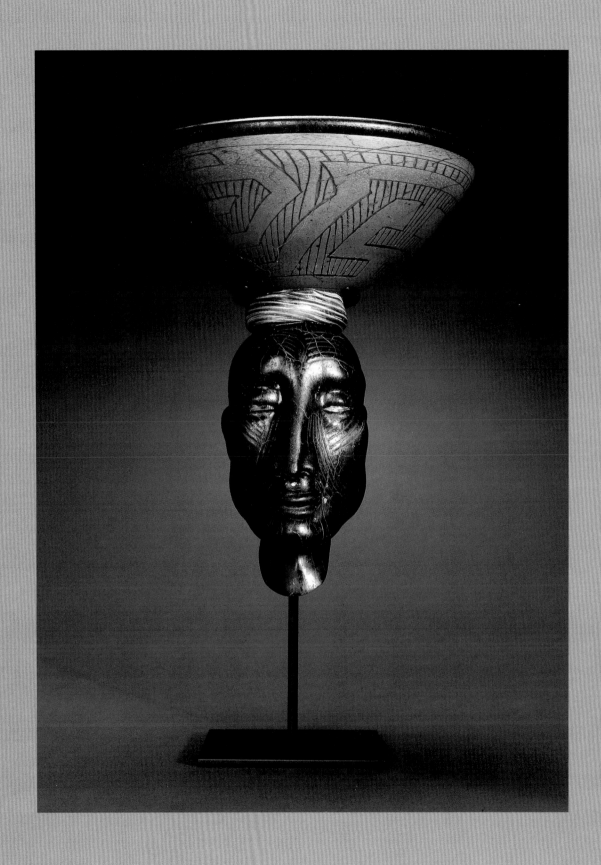

3

Mogollon Woman

2001

24 × 15 × 15 in.

HA601.18.02

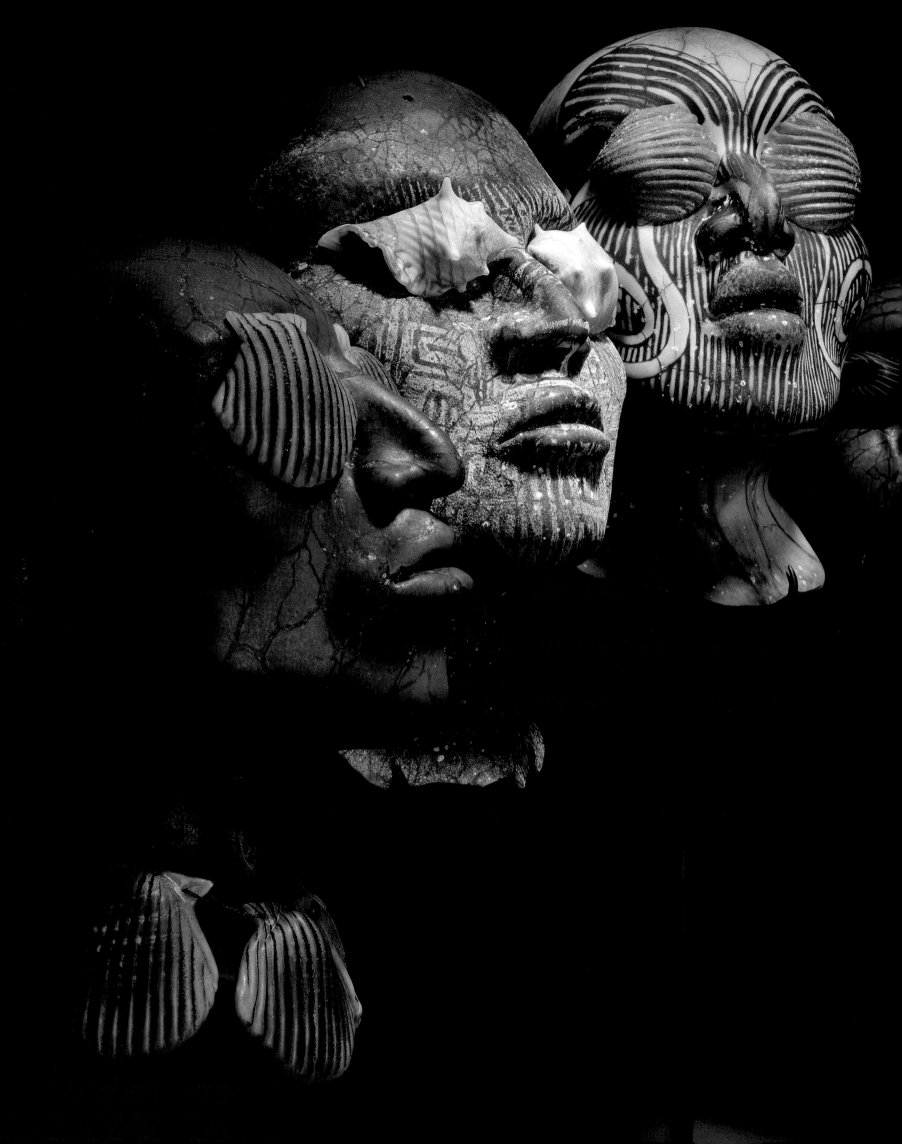

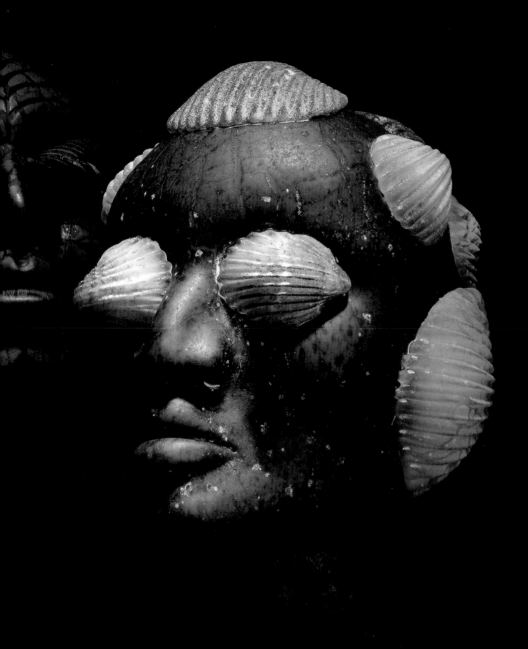

4

Teotihuacan Marquesas

2001
24 × 7 × 10 in. (largest)
18 × 8 × 9 in. (smallest)

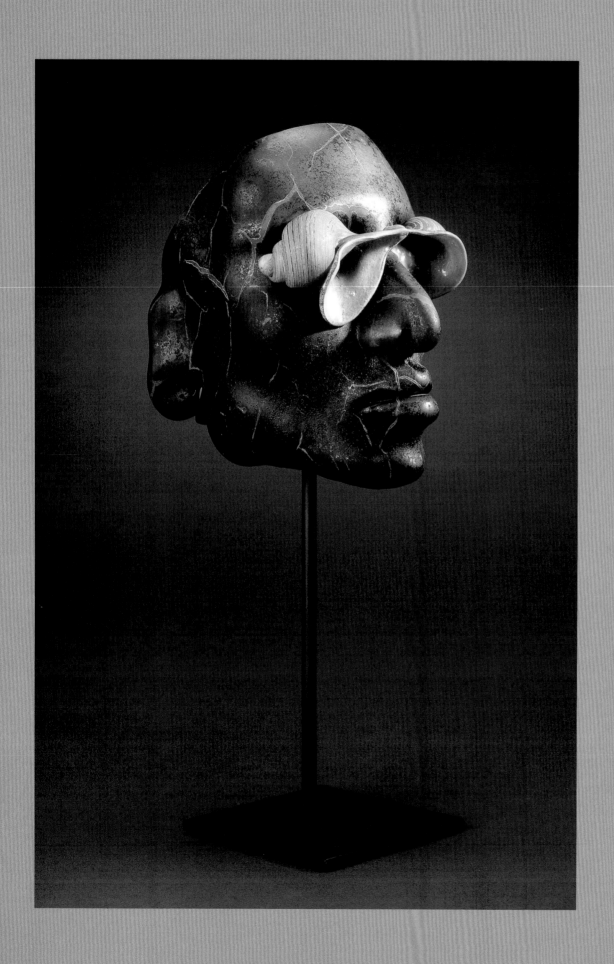

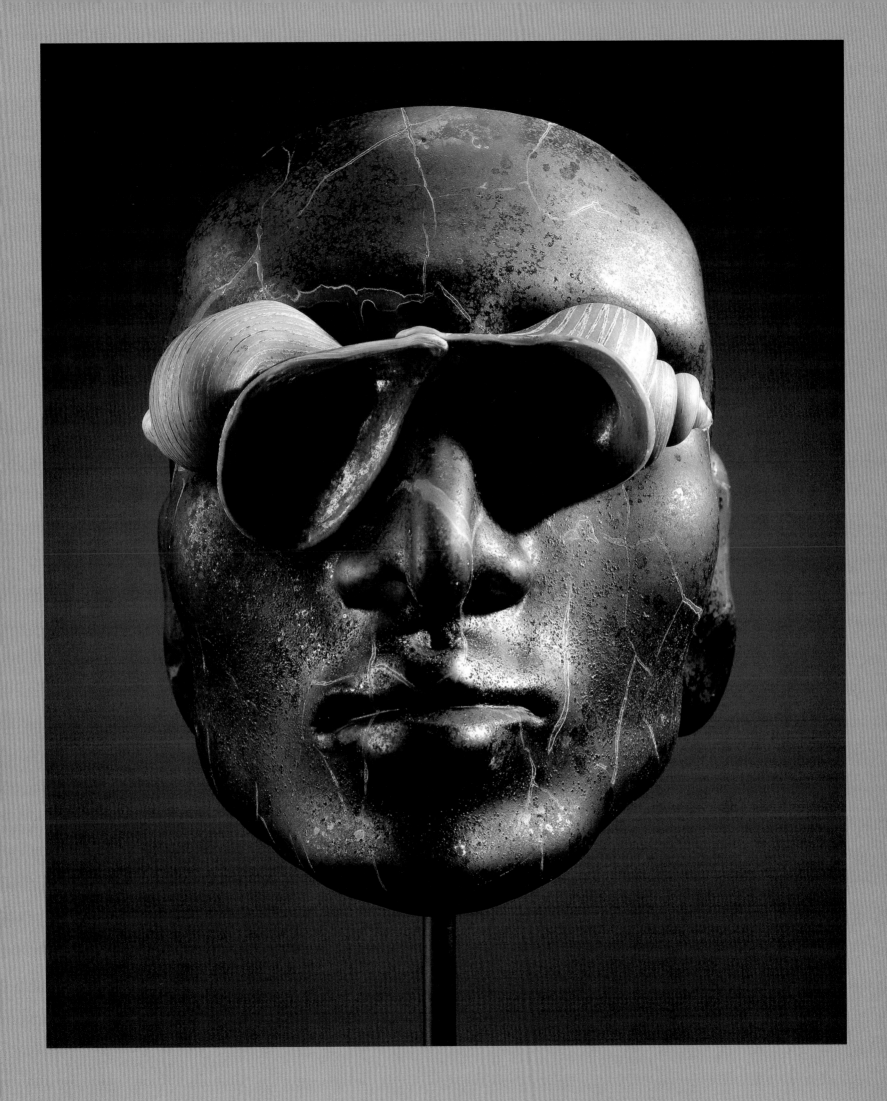

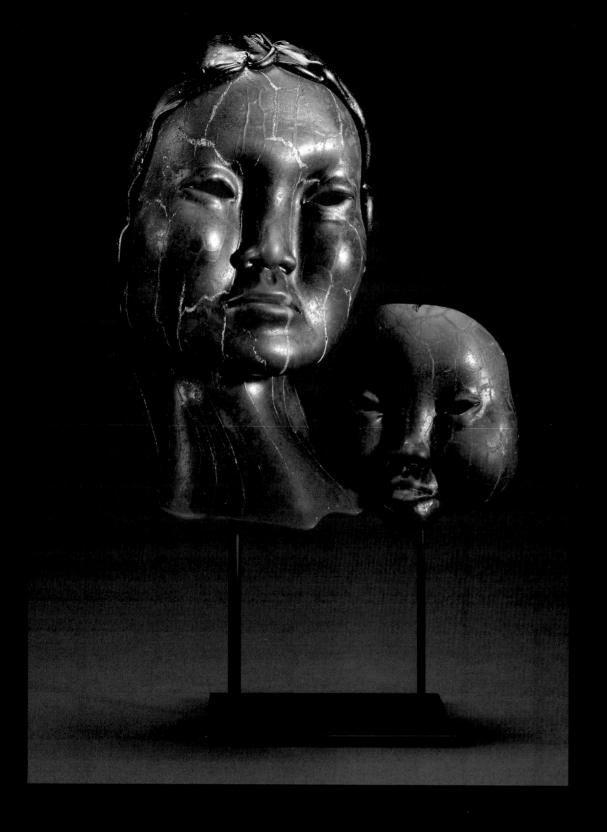

6

Inuit Woman & Child

2001

19 × 12 × 6 in.

HA301.08.03

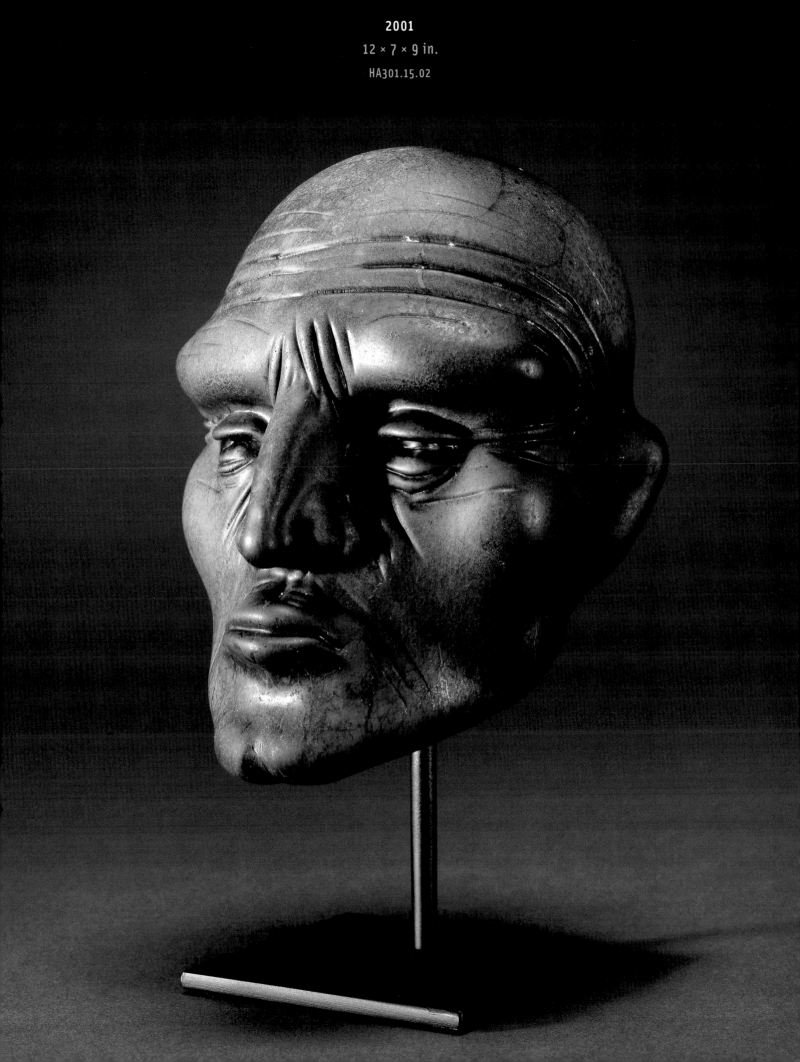

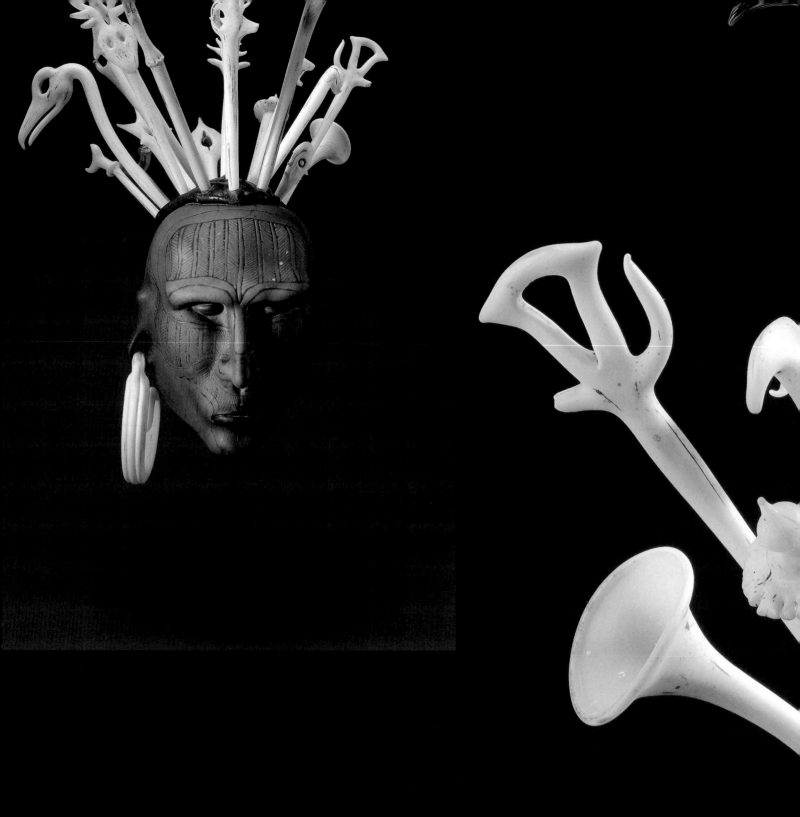

8

Zande Man

2001

26 × 16 × 16 in.

HA301.10.23

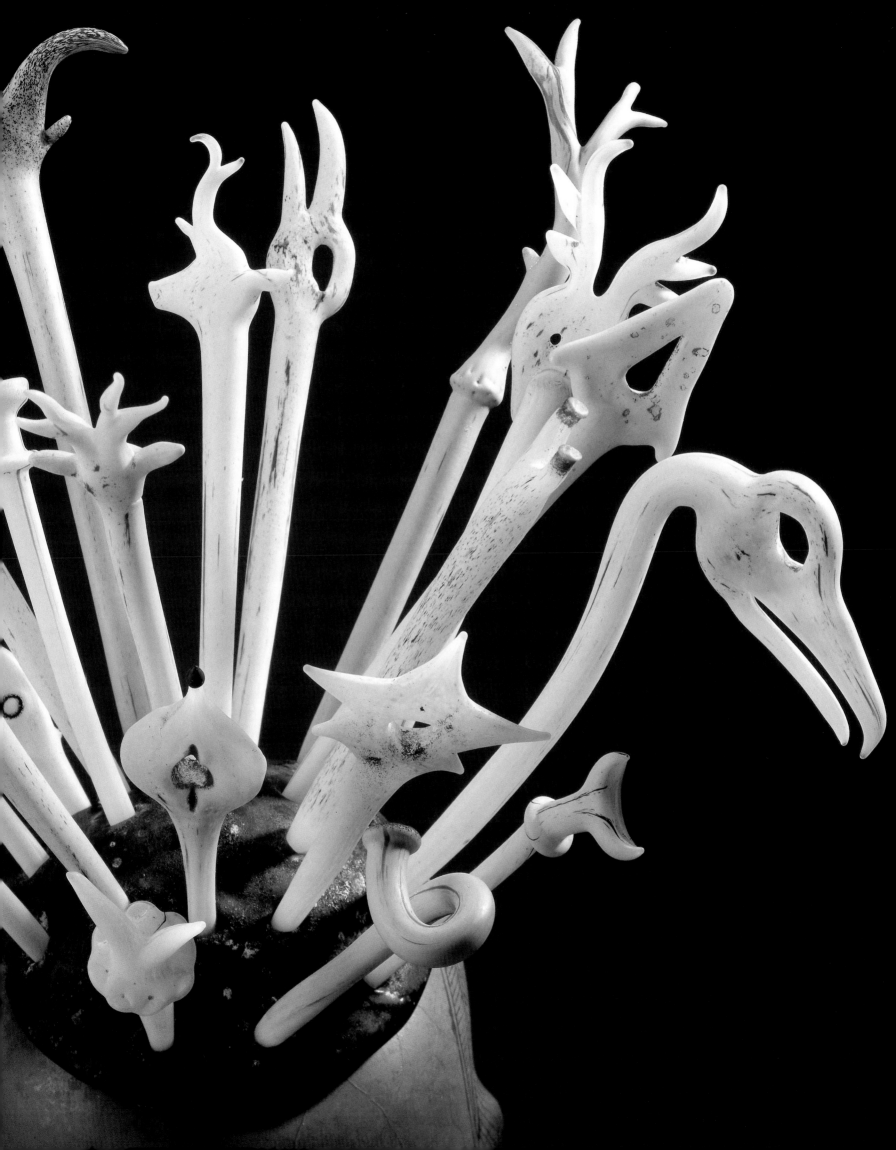

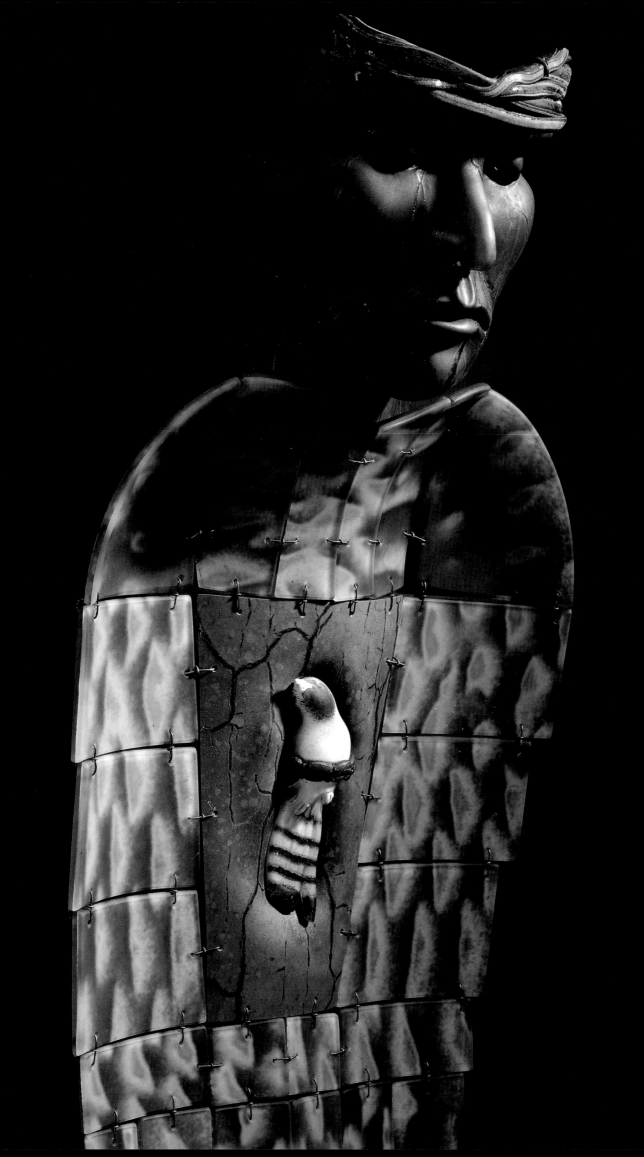

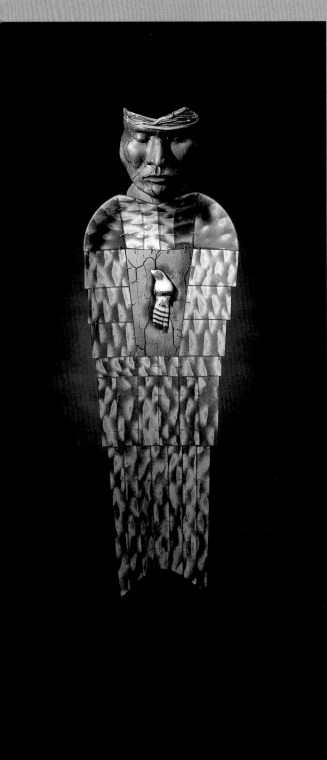
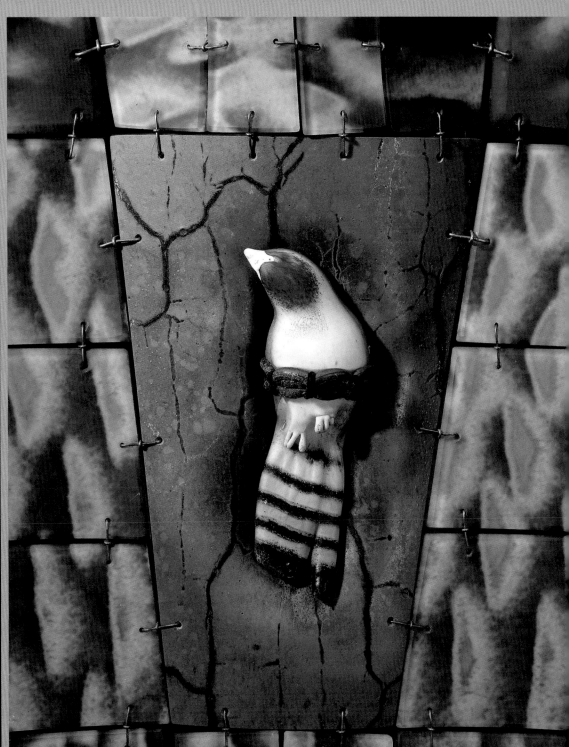

9

Hohokam Man

2001

75 × 15 × 15 in.

HI601.02.03

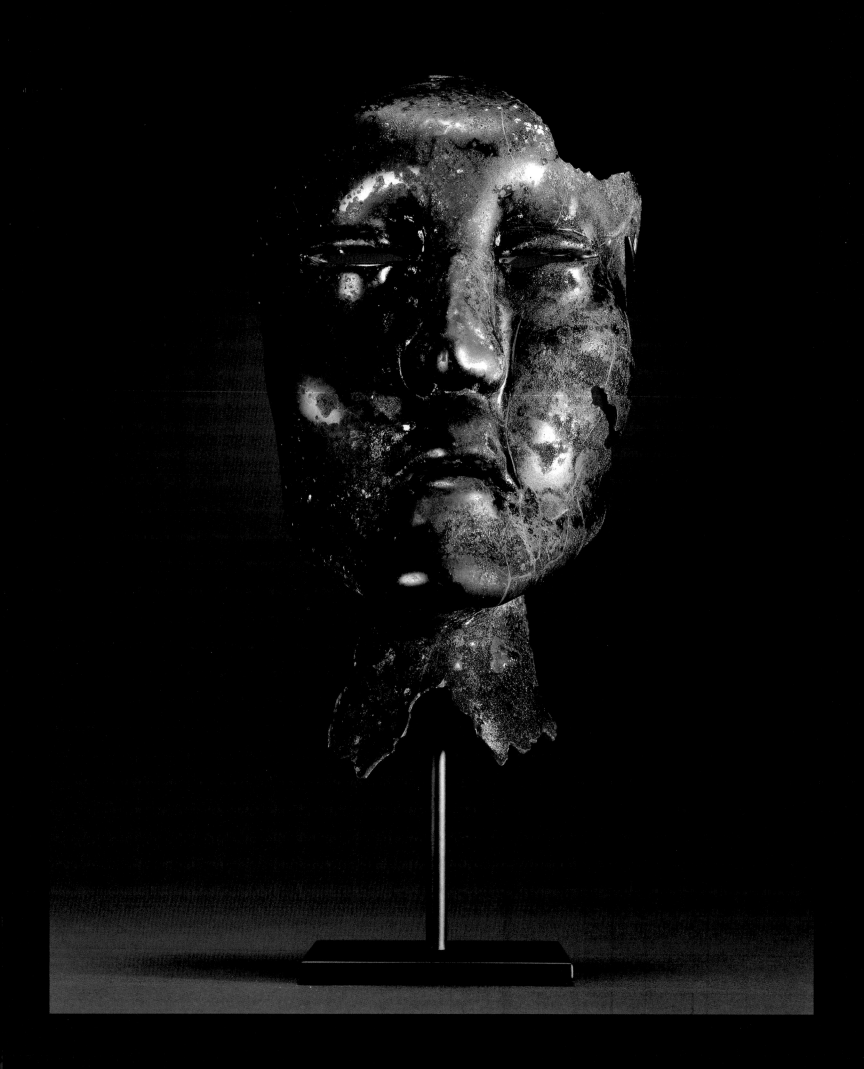

10

Joman Man

2001

13 × 6 × 5 in.

HA301.16.02

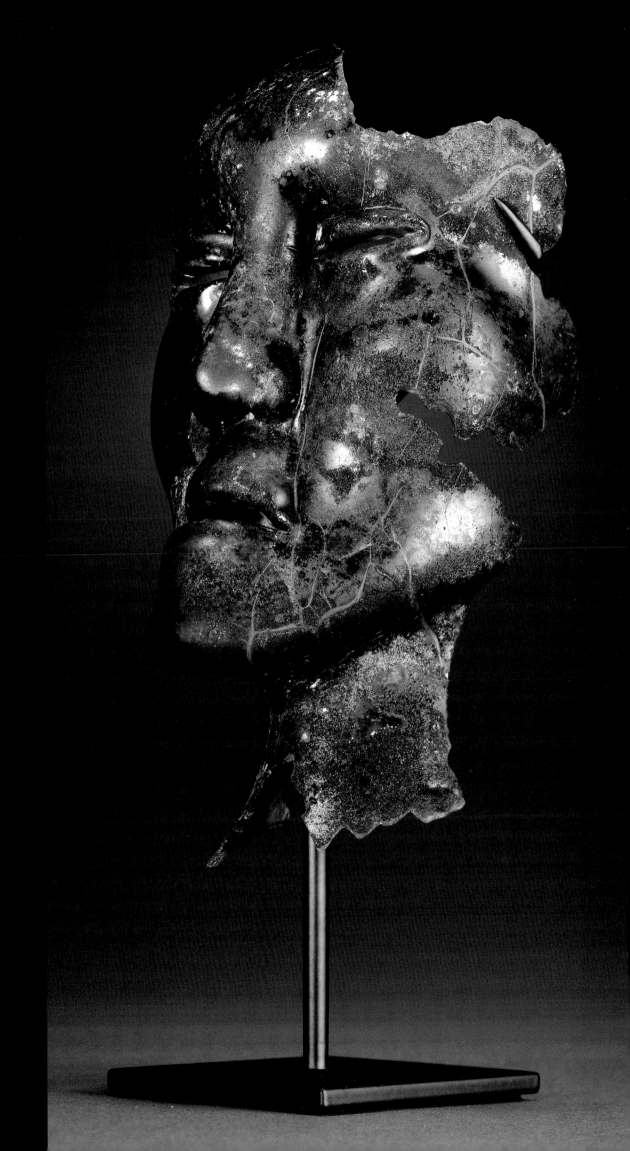

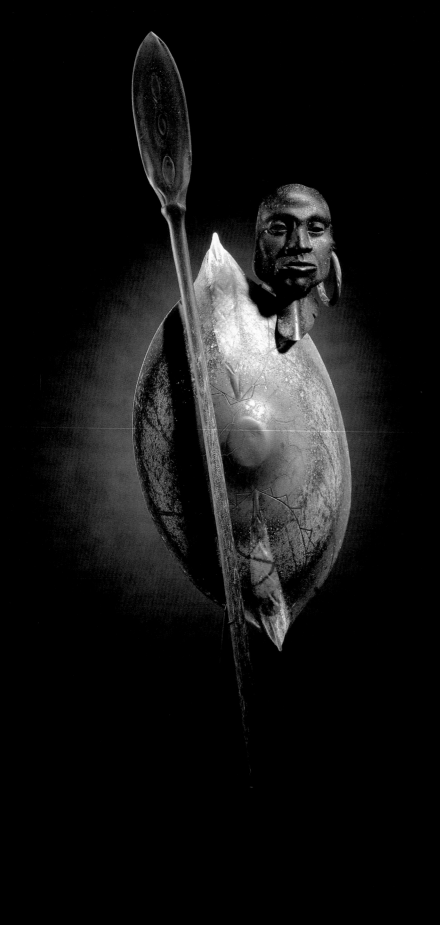

11

Warrior II

2001

81 × 25 × 15 in.

HI601.11.05

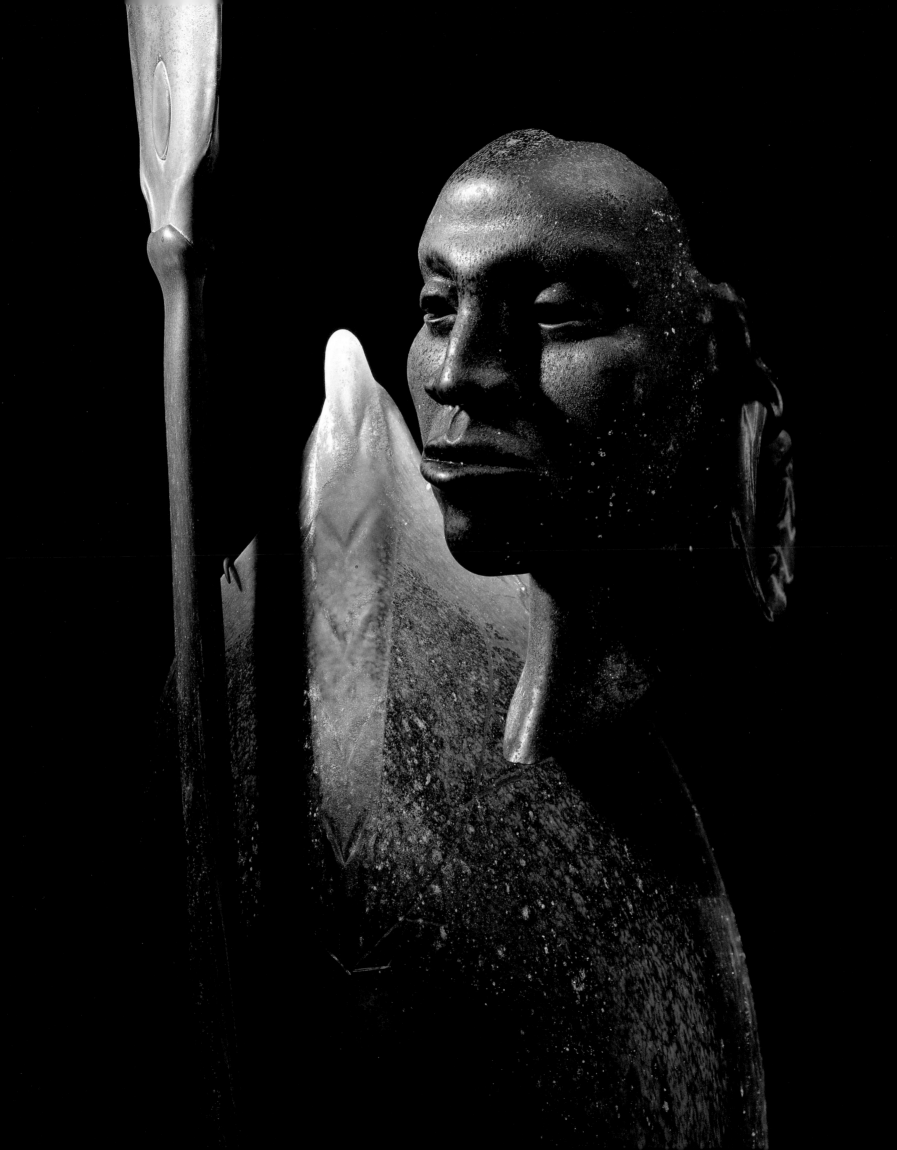

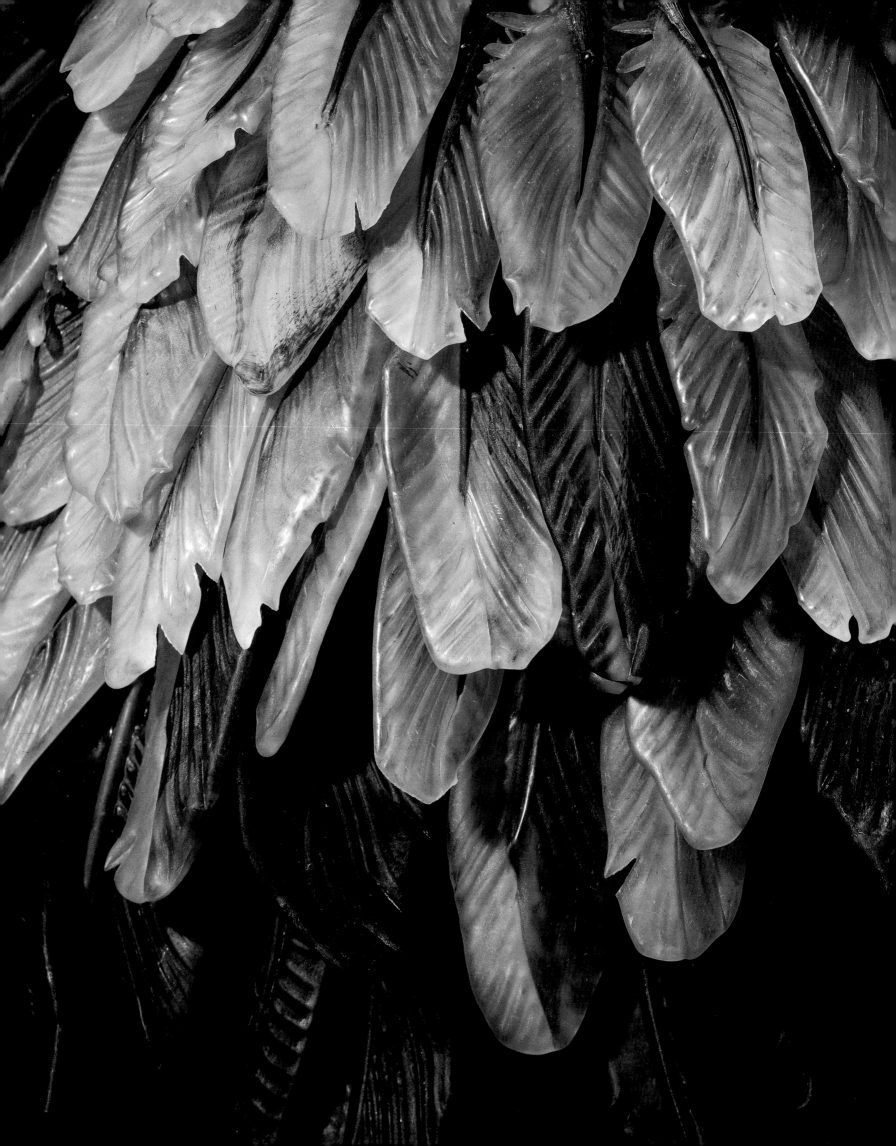

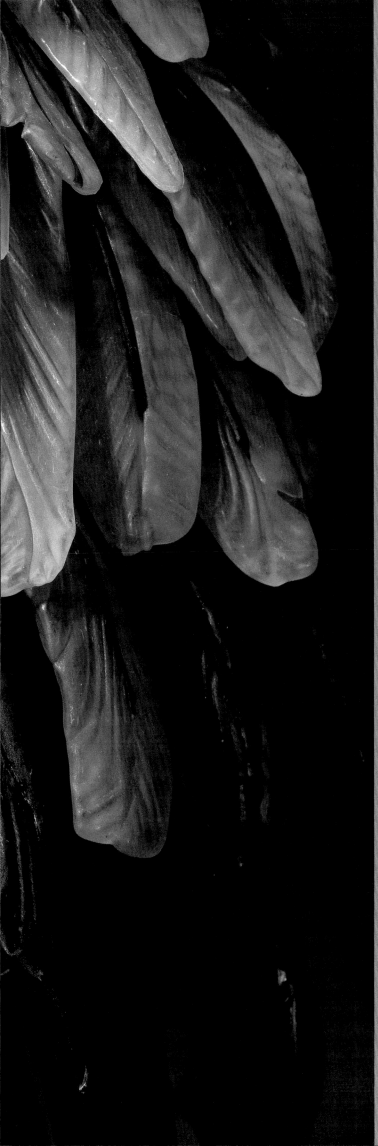

12
Maenge Singer
2001
30 × 16 × 11 in.
HA601.26.03

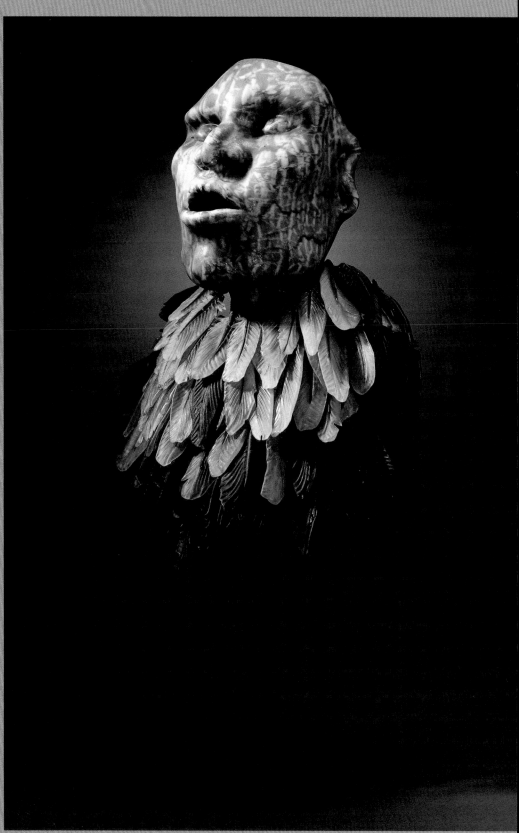

Maenge Singer
2001
30 × 16 × 11 in.
HA601.26.03

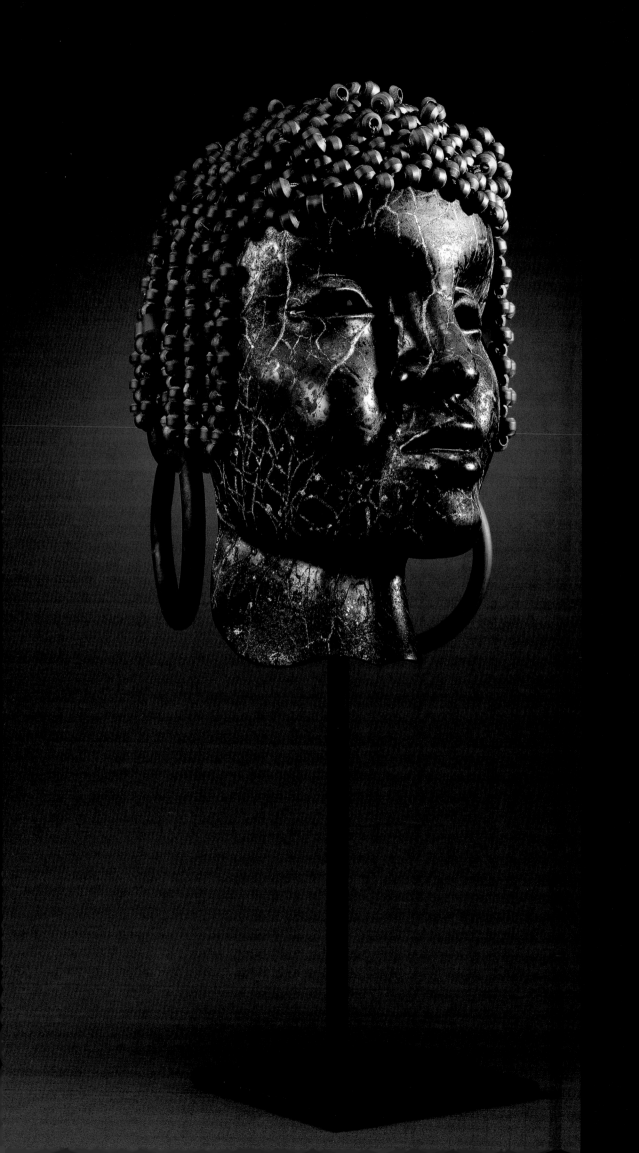

13

Kau Girl

2001

19 × 8 × 8 in.

HA601.02.05

14

Mongal Man

2001

25 × 9 × 10 in.

HA301.11.07

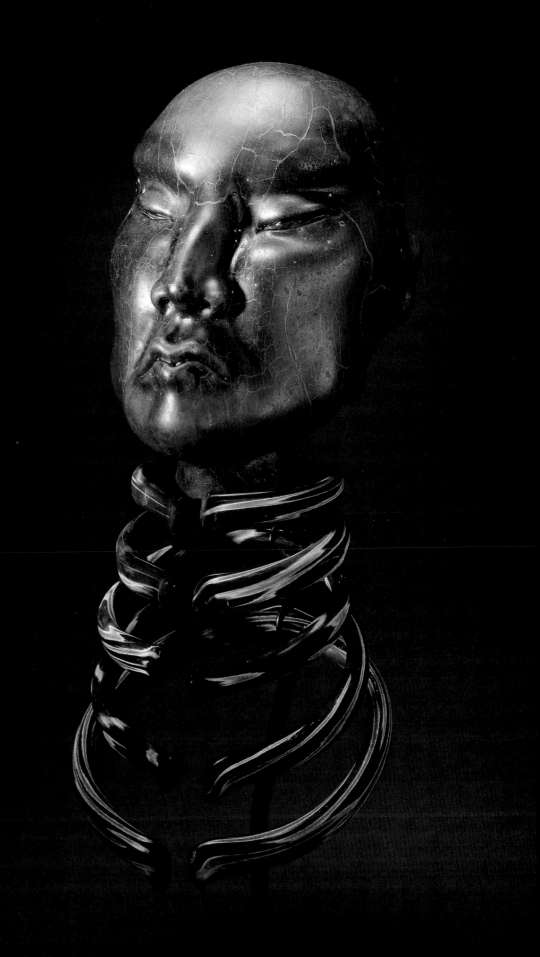

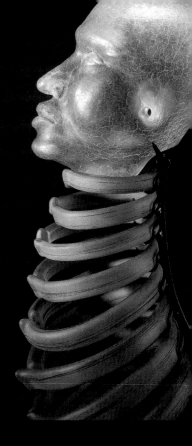

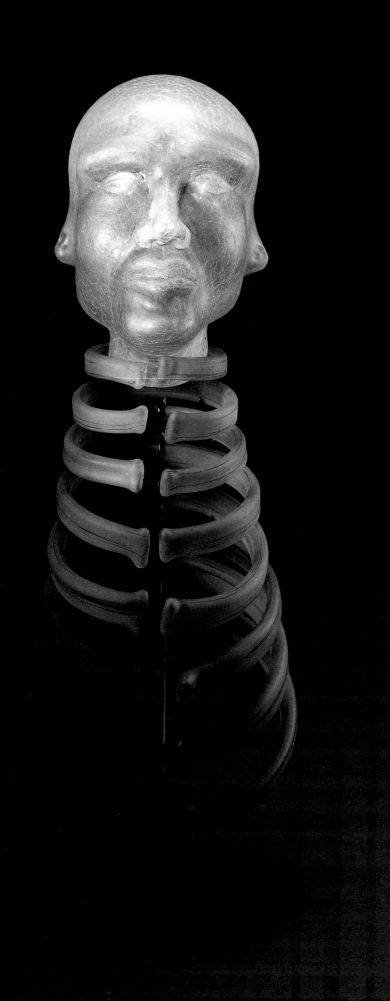

15

Maasai Woman

2001

24 × 9 × 9 in.

HA301 06 10

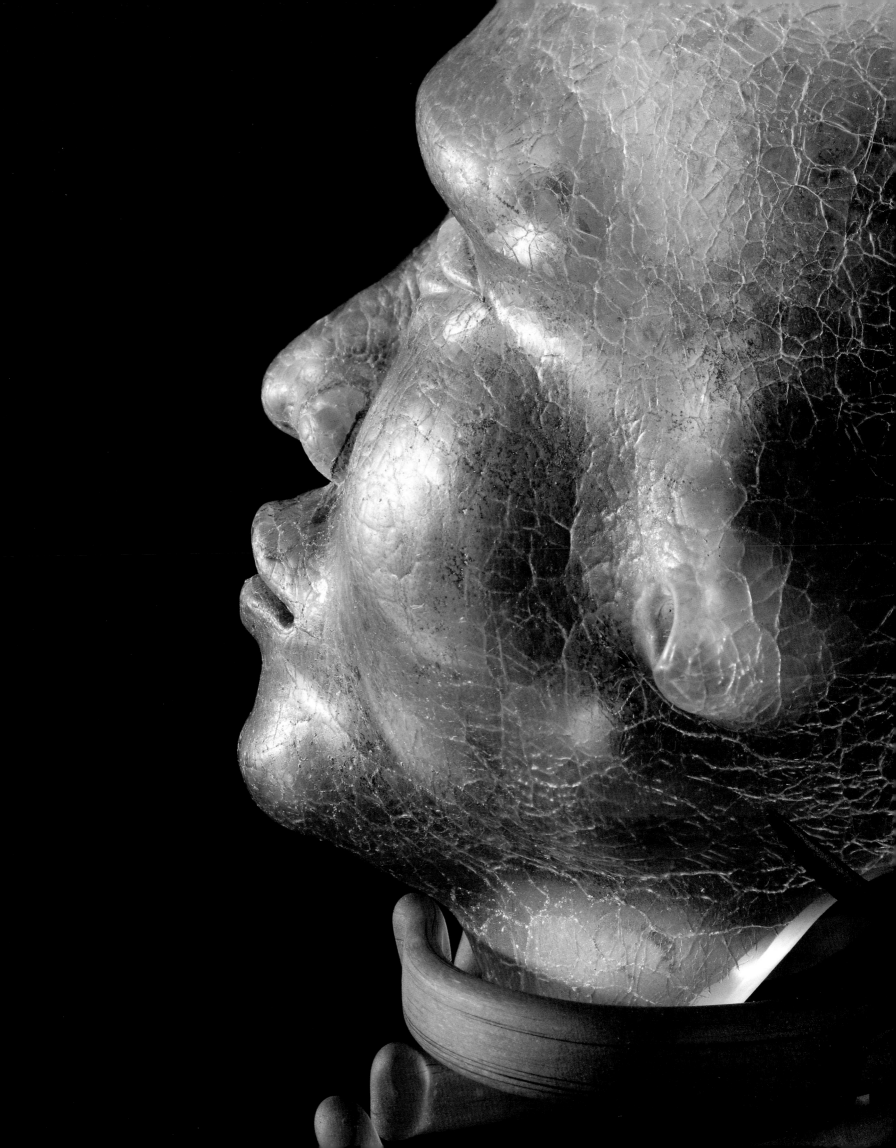

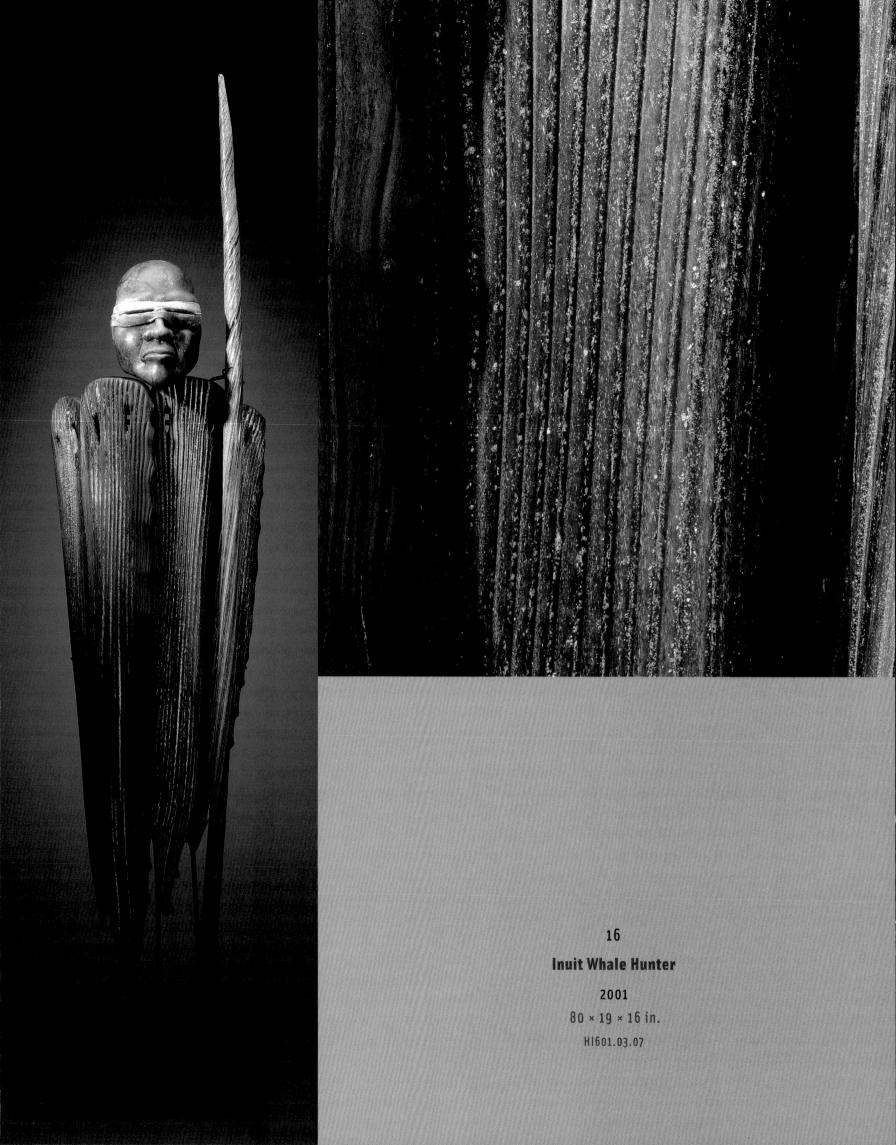

16

Inuit Whale Hunter

2001

80 × 19 × 16 in.

HI601.03.07

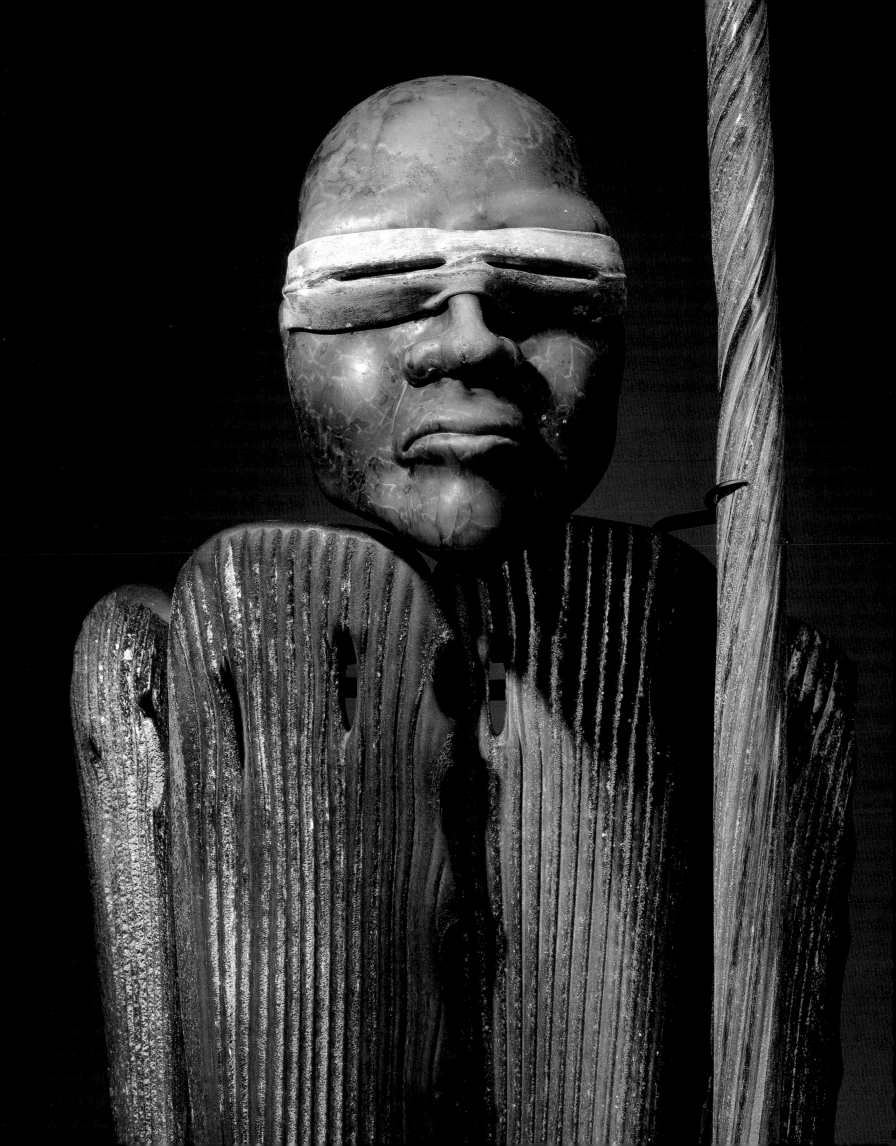

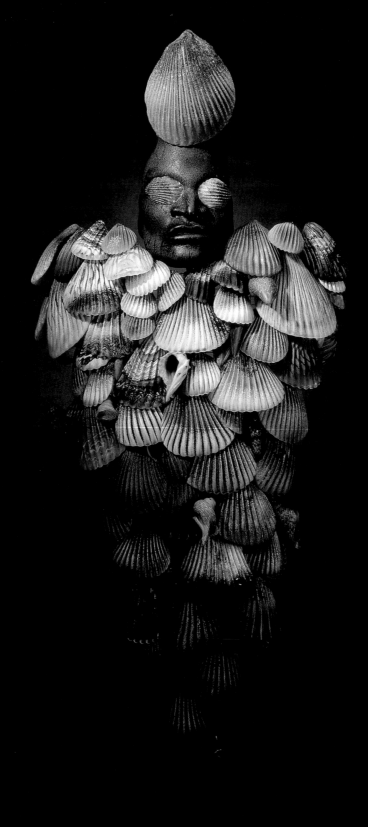

17

Colima Shaman

2001

66 × 22 × 15 in.

HI601.01.03

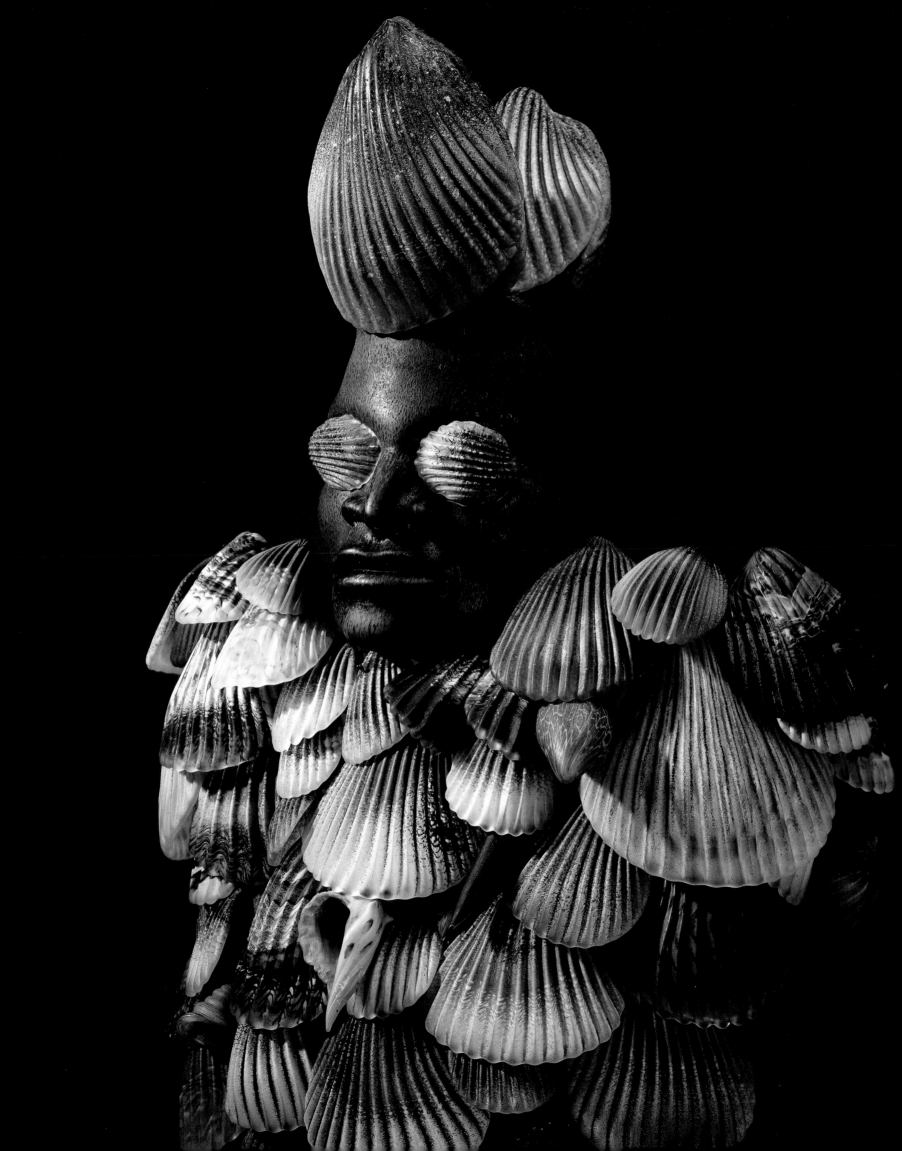

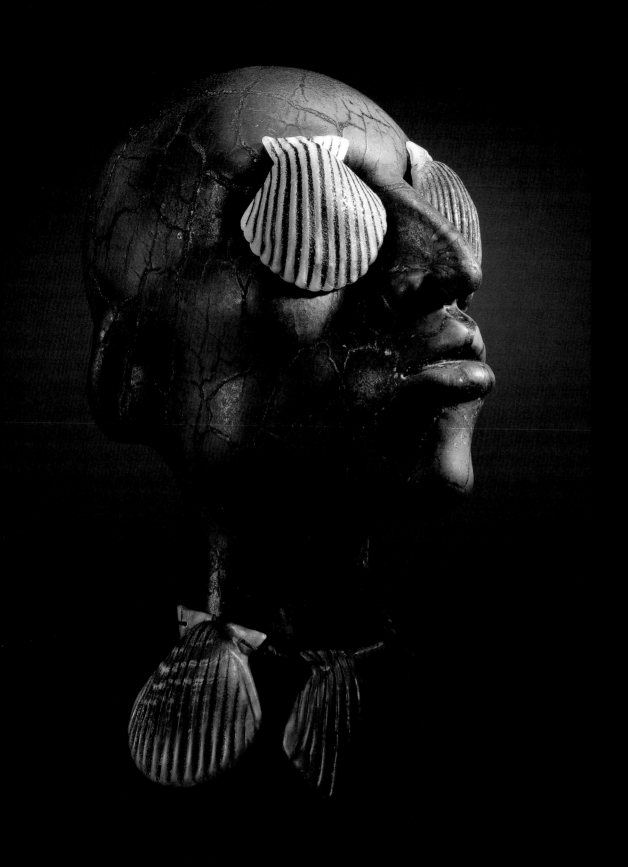

18

Chimu Diver

2001

18 × 8 × 9 in.

HA601.22.03

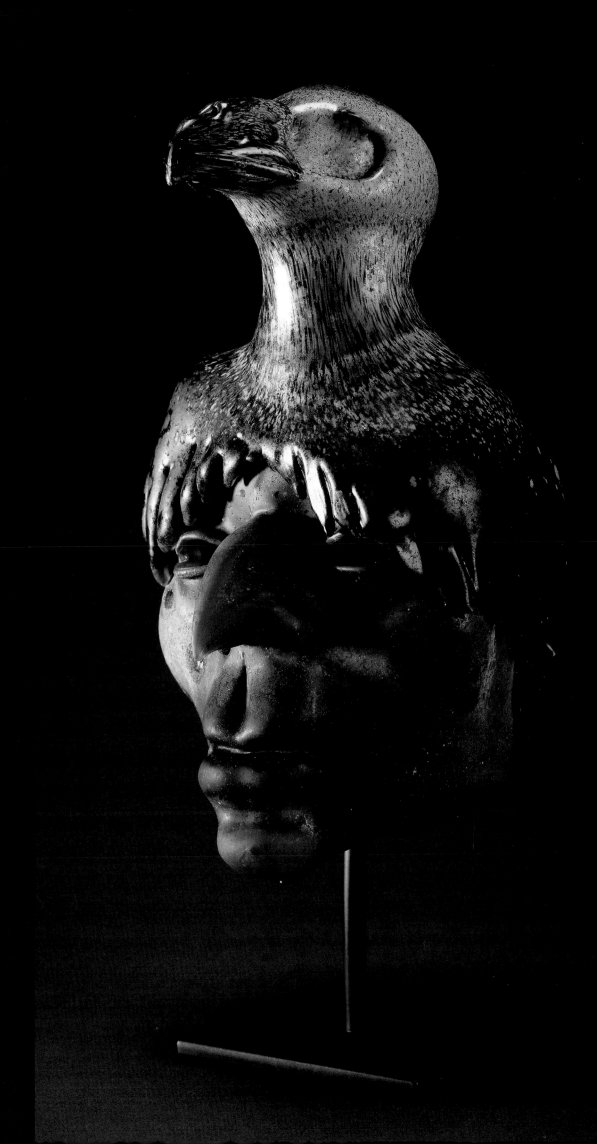

19
Untitled
2001
13 × 6 × 7 in.
HA301.05.02

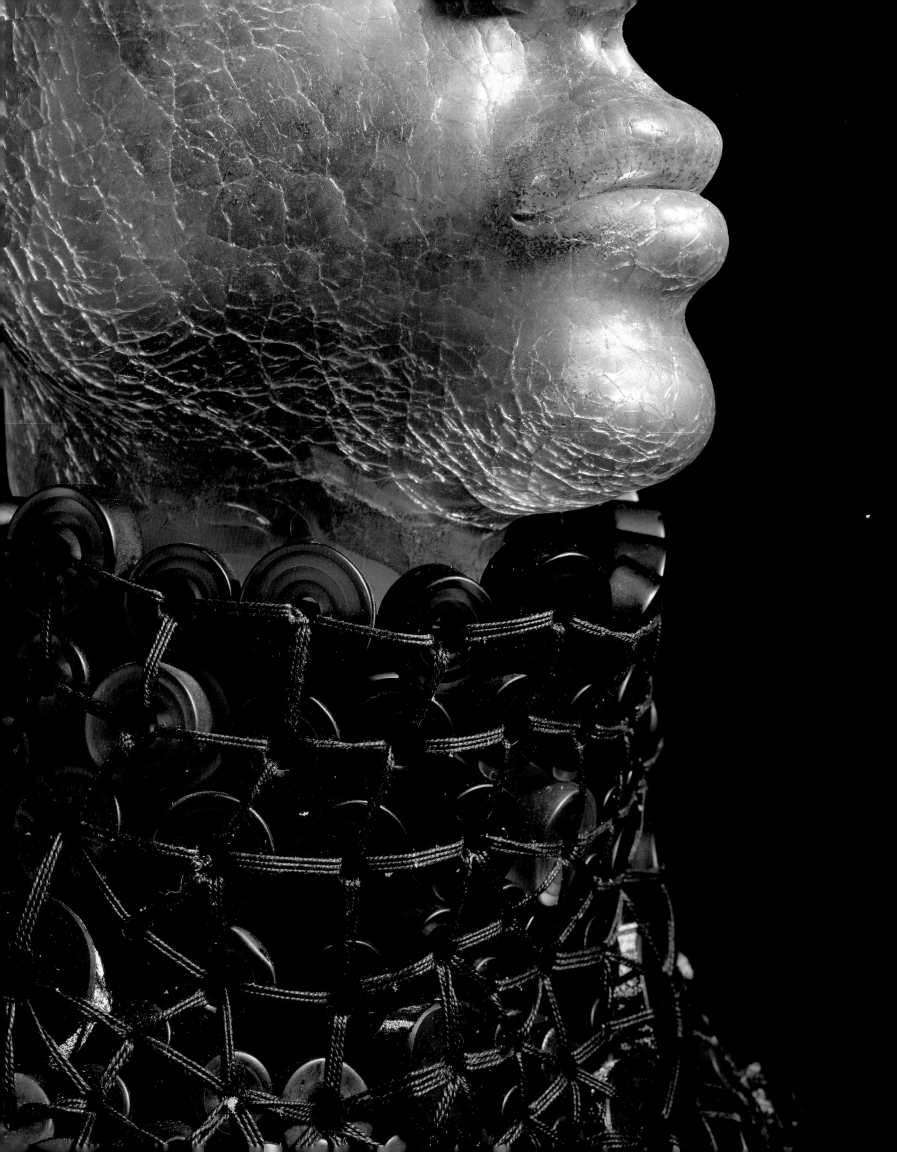

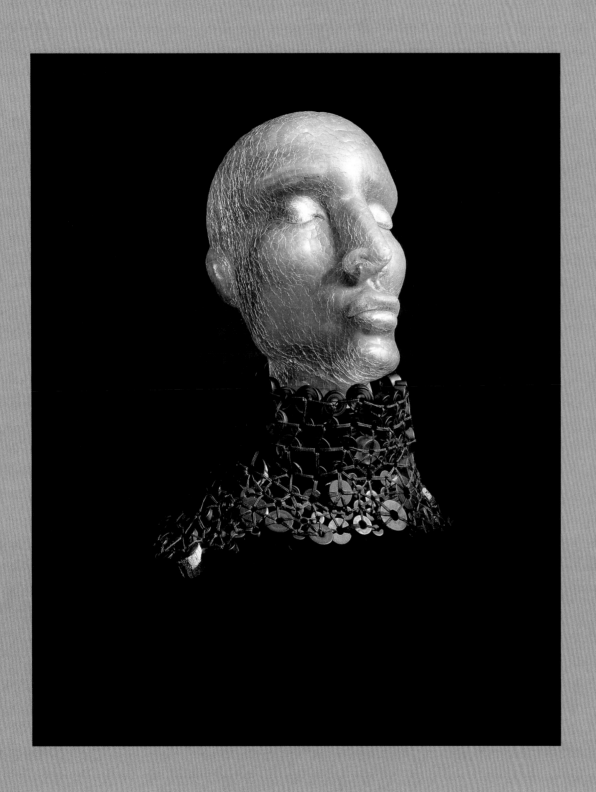

20

Berber Woman

2001

20 × 10 × 9 in.

HA601.14.03

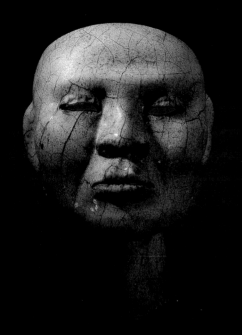 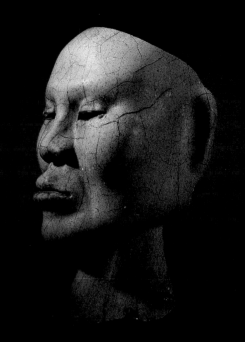

21

Tungus Woman

2001

15 × 7 × 6 in.

HA601.07.02

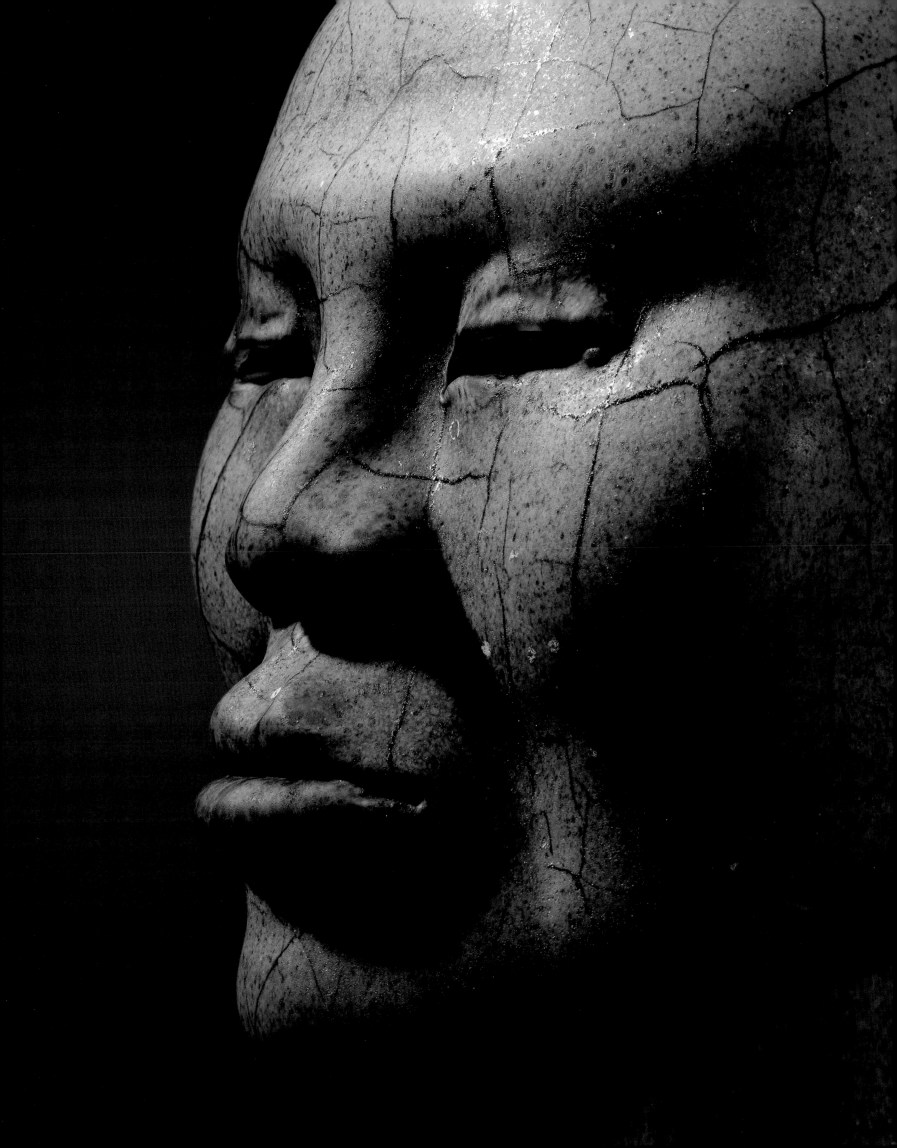

22
Chilkat Tlingit Man
2001
74 × 21 × 14 in.
HI301.02.05

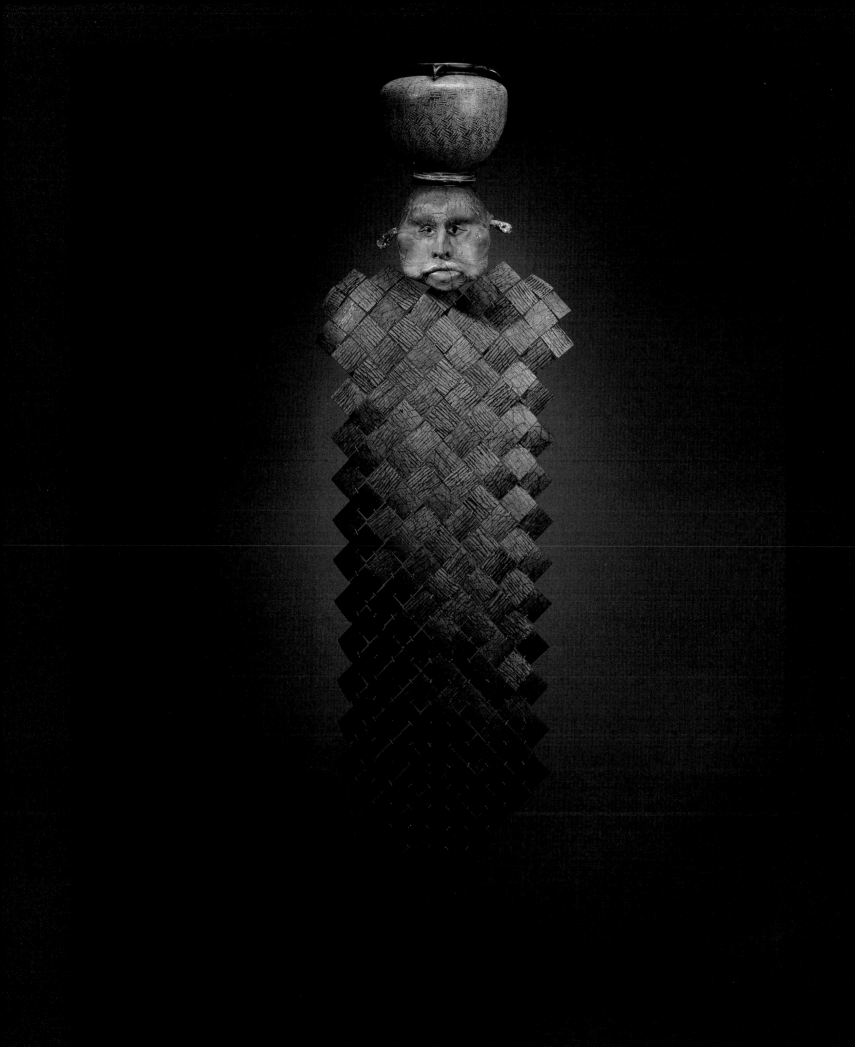

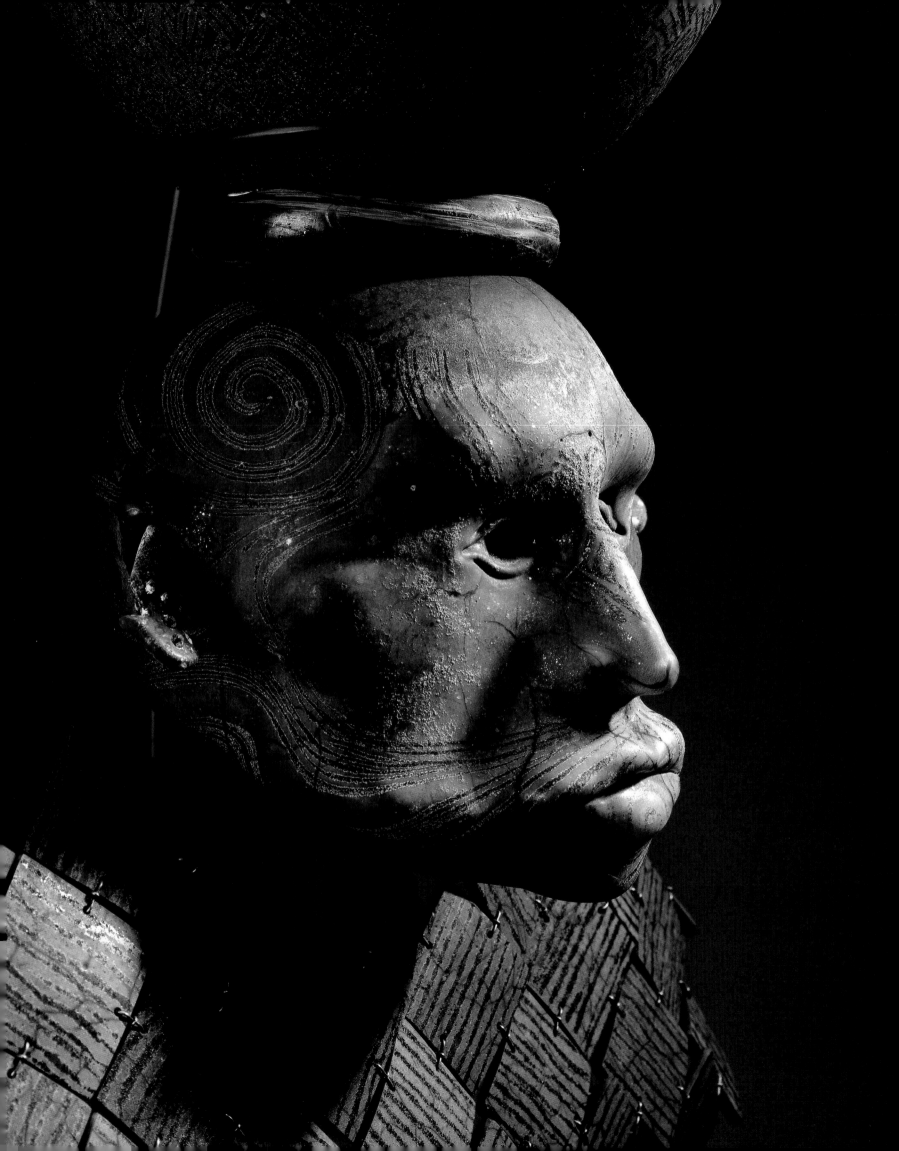

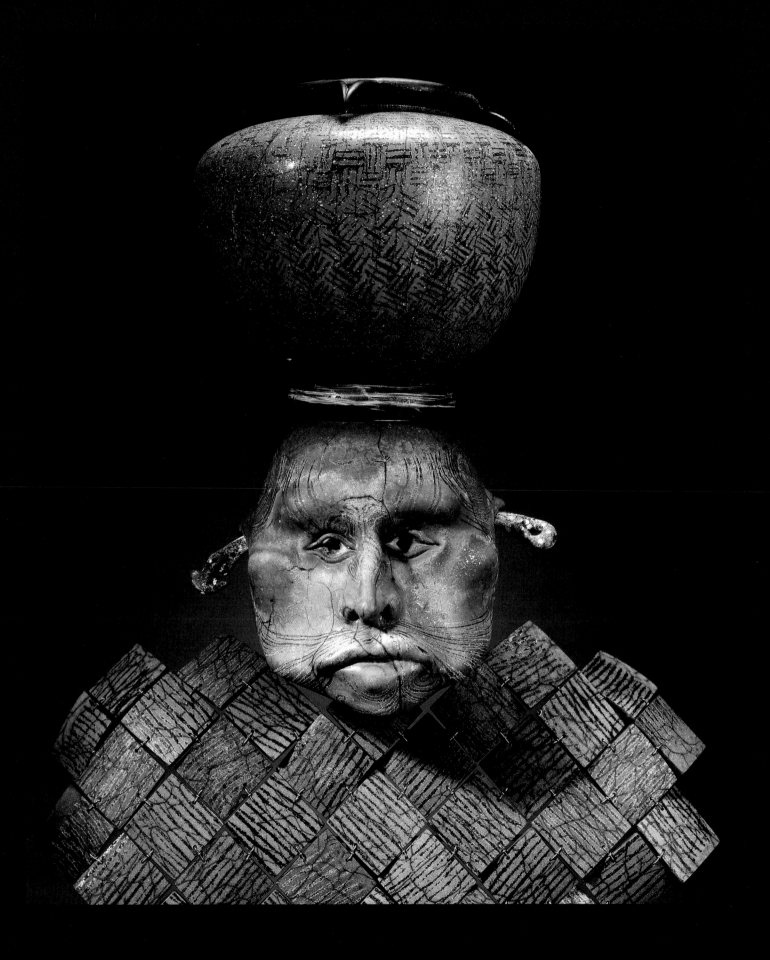

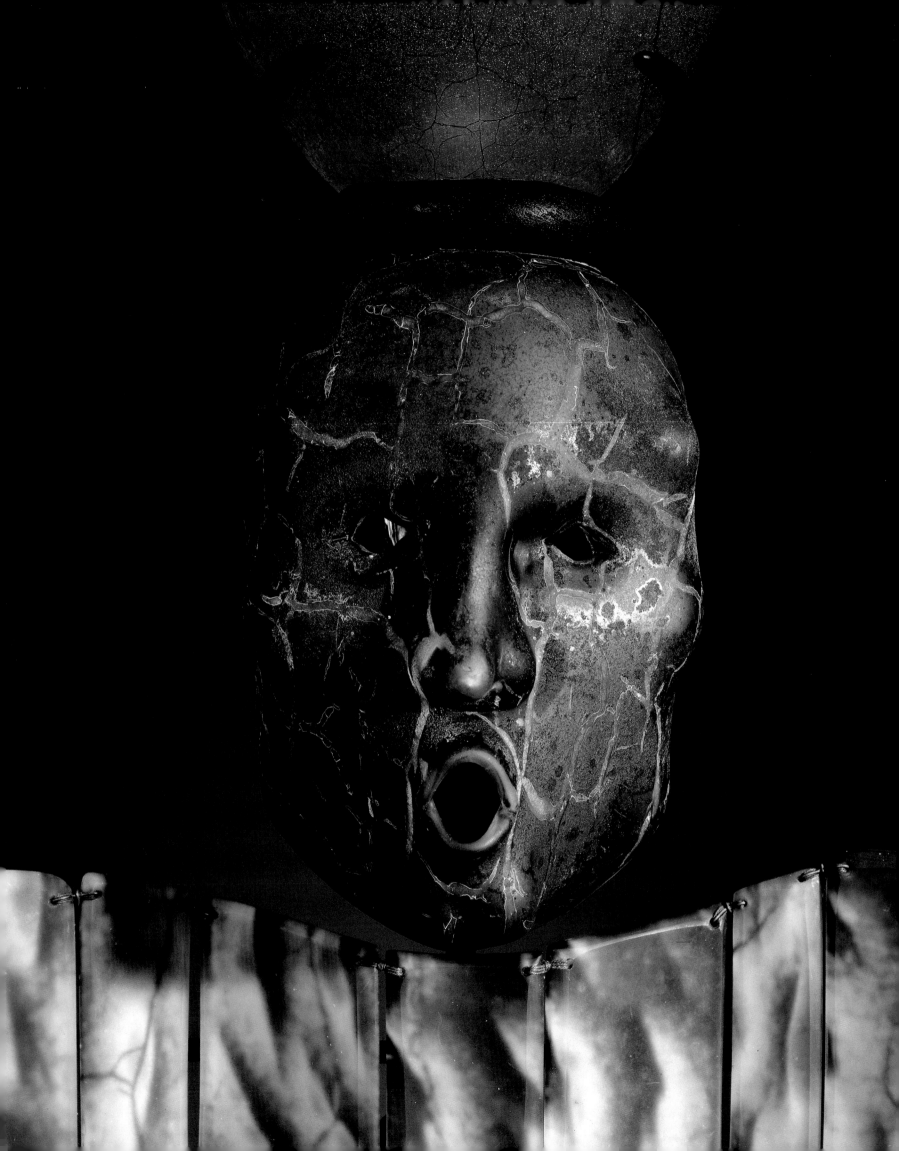

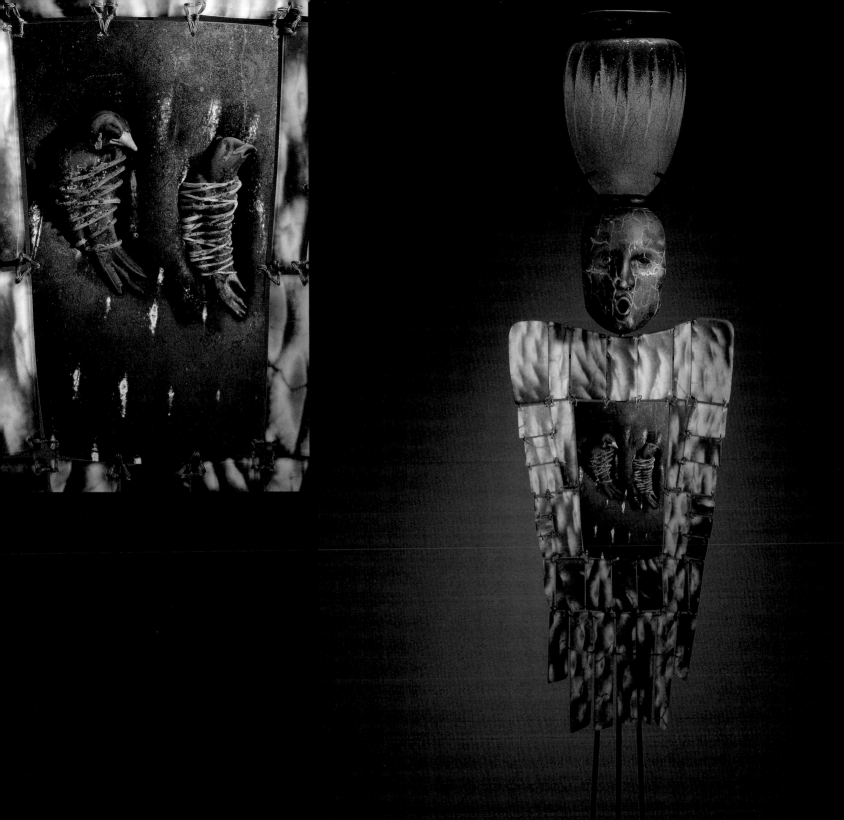

23
Maroon Singer
2001
80 × 17 × 16 in.
HI301.04.03

24
Indus Bird Hunter
2001
26 × 14 × 10 in.
HA601.01.07

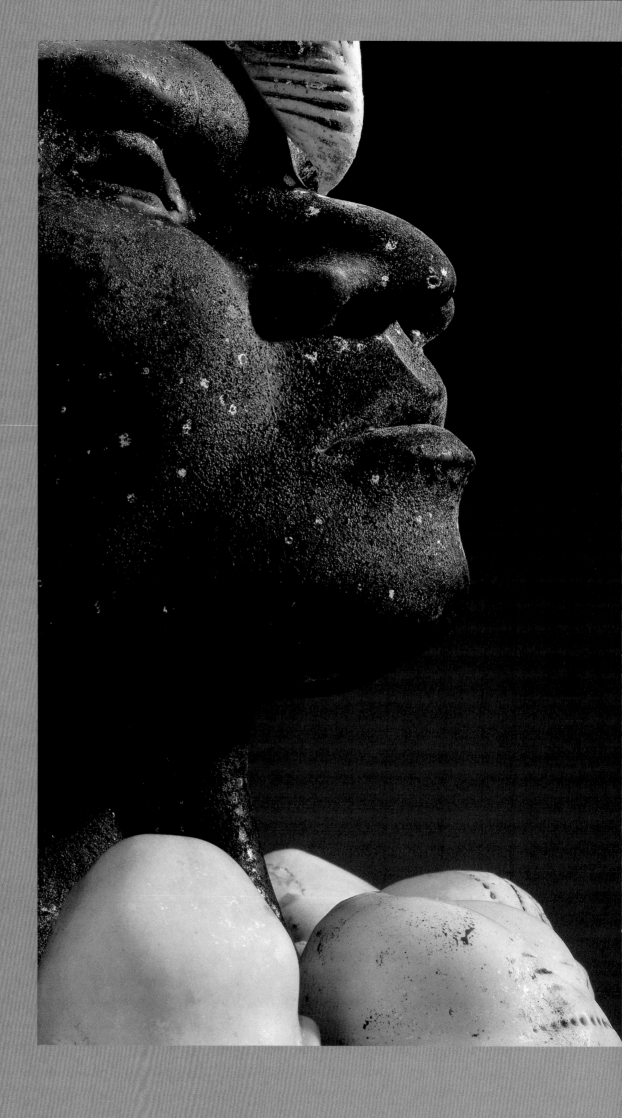

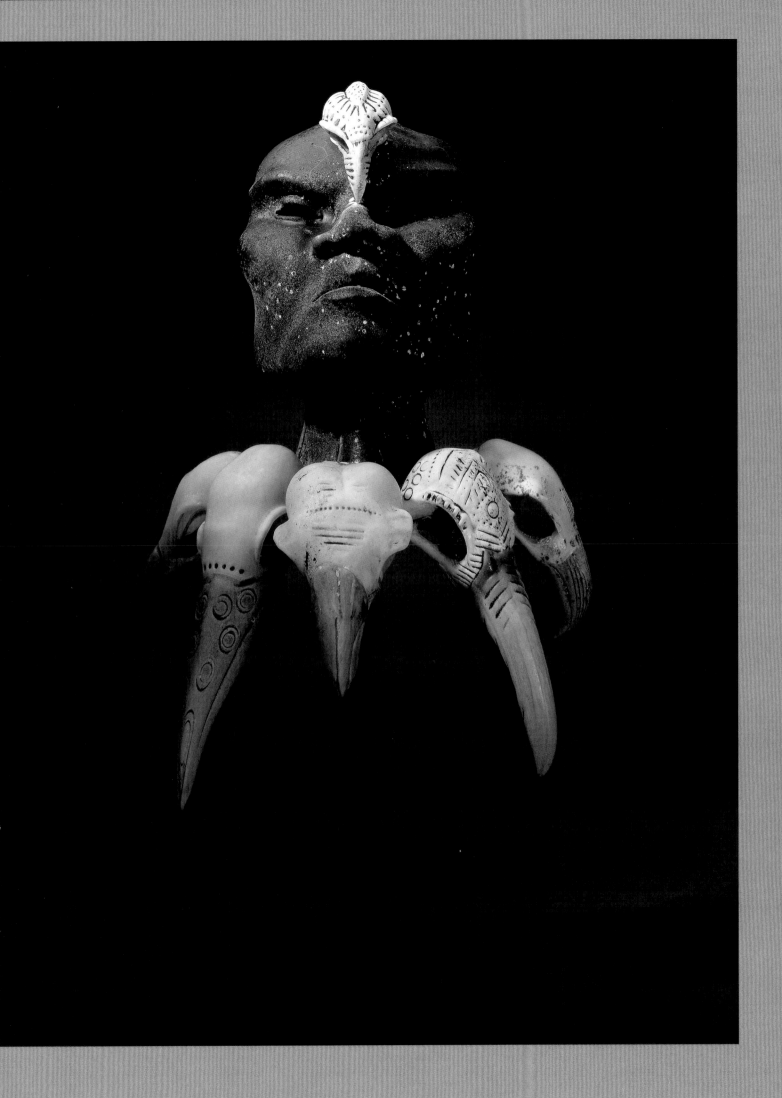

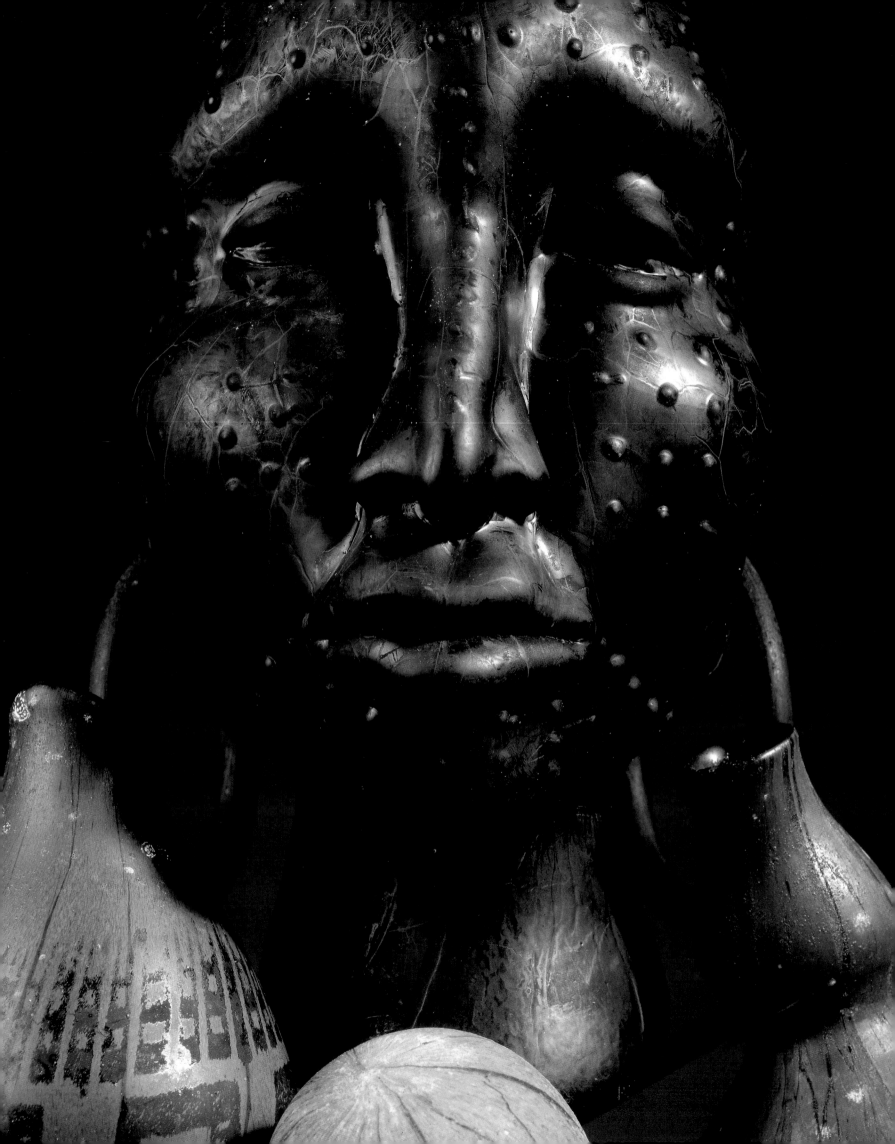

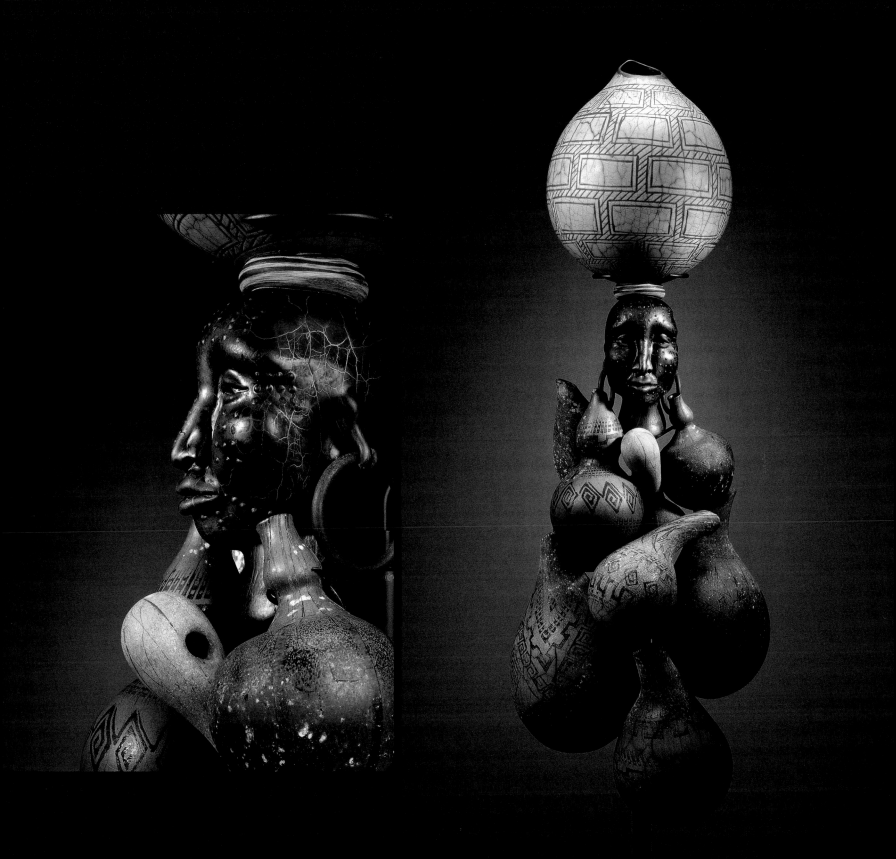

25

Nuba Woman I

2001

80 × 24 × 24 in.

HI301.05.12

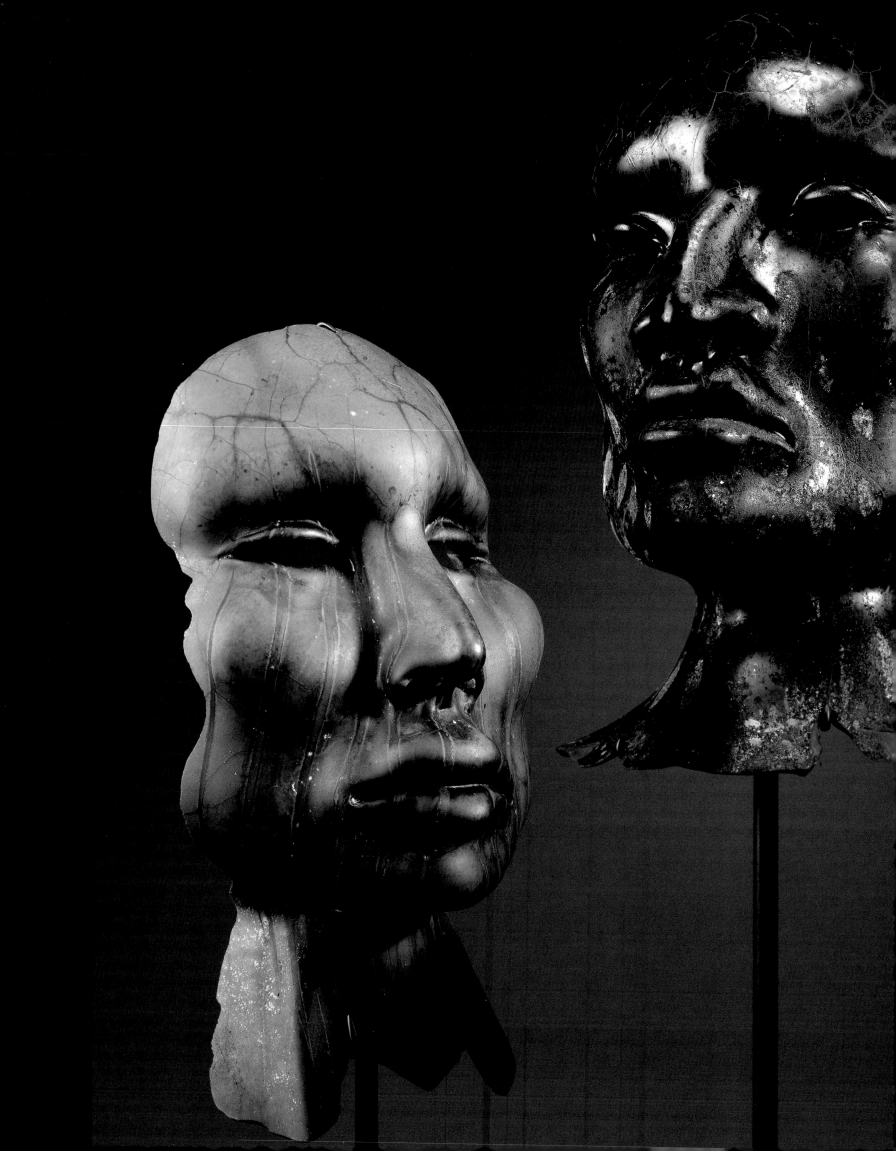

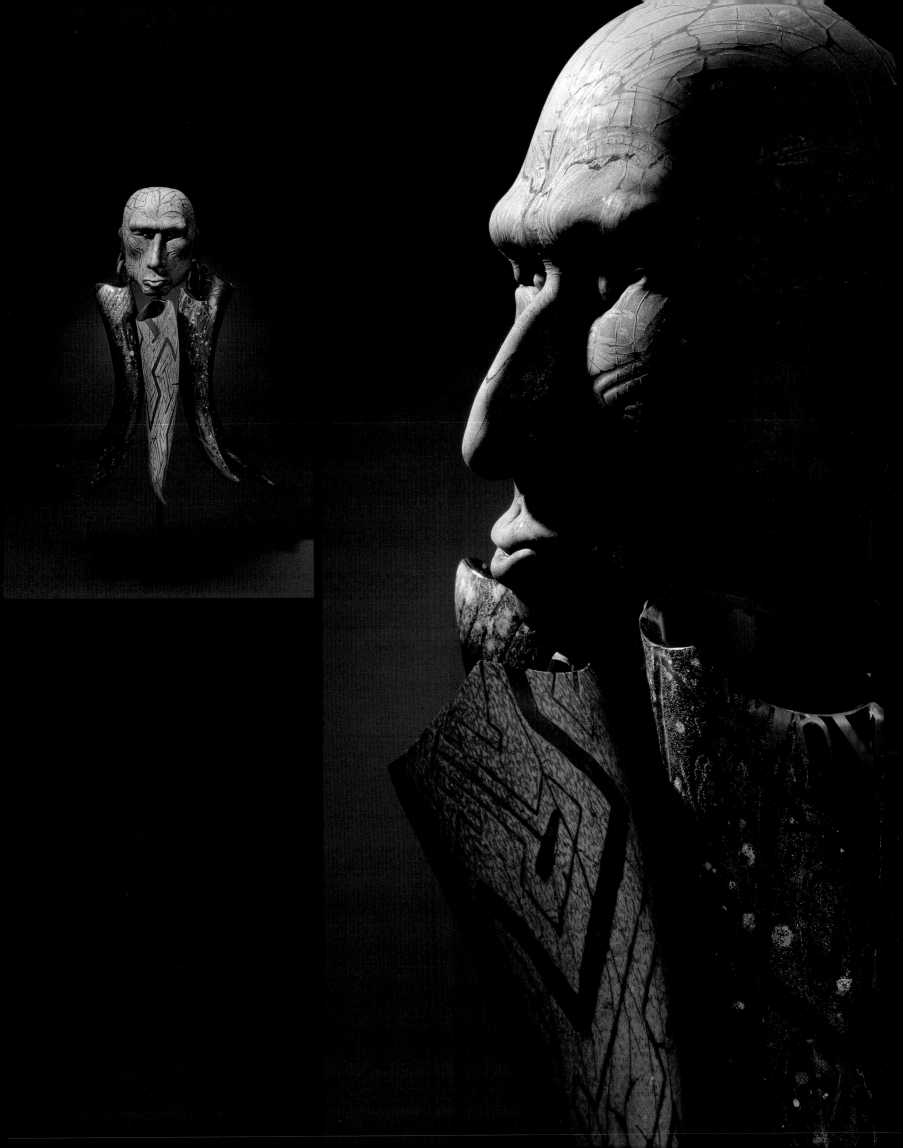

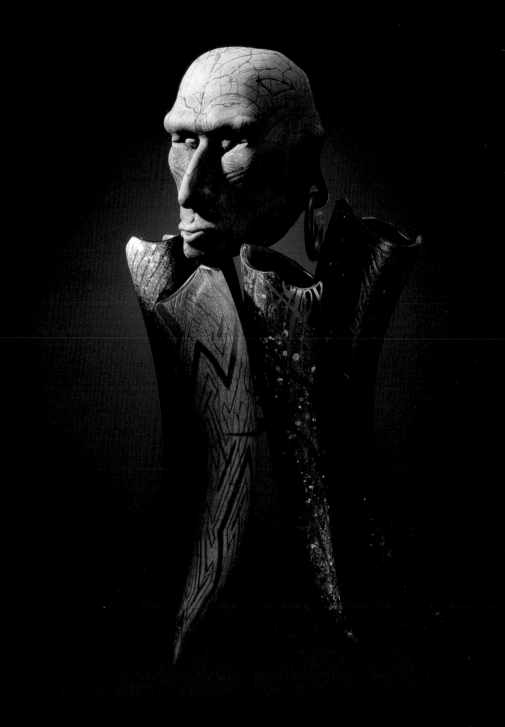

27

Laibon Man

2001

32 × 19 × 12 in.

HA601.03.09

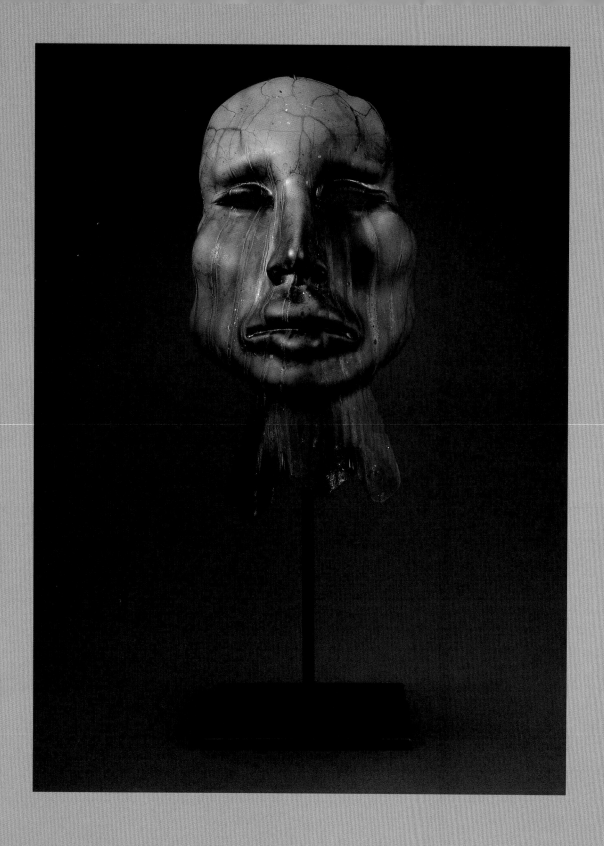

28

Karok Man

2001

19 × 7 × 7 in.

HA301.02.02

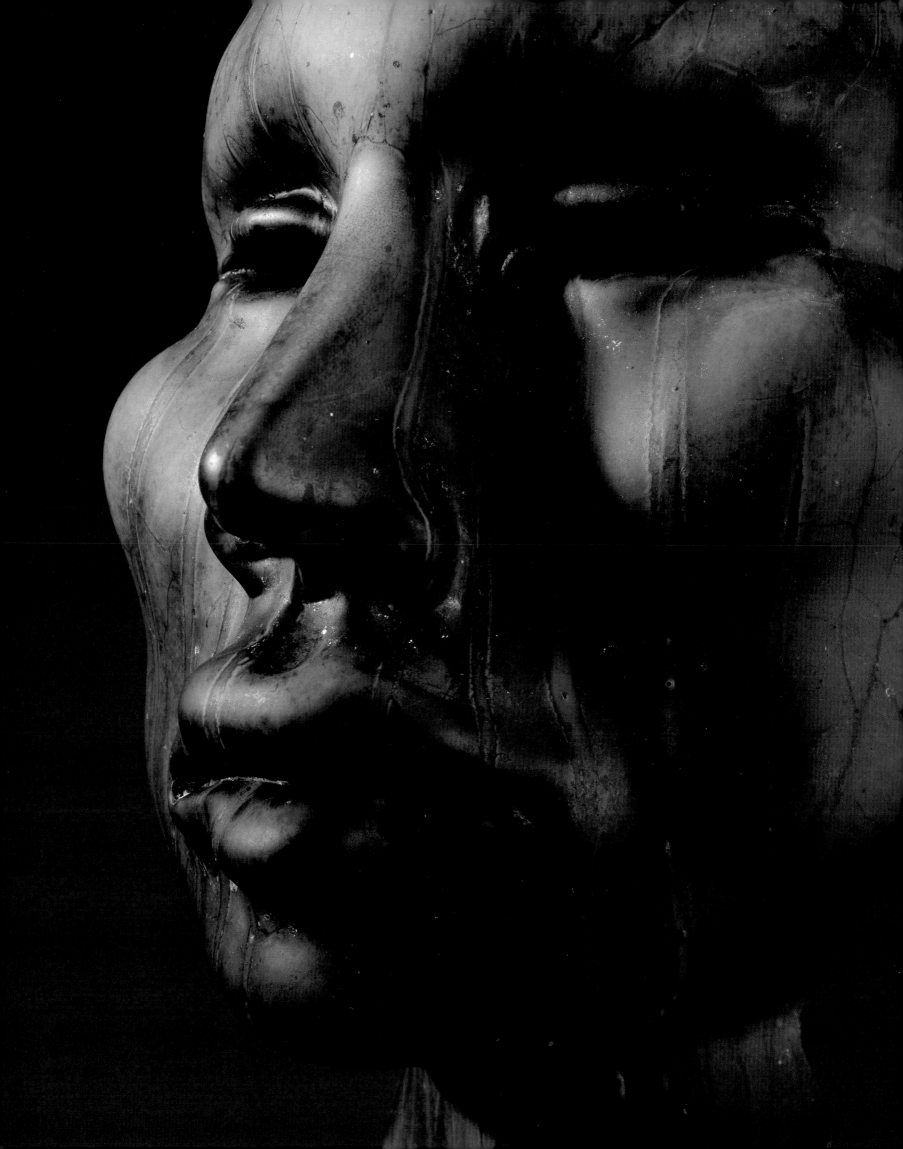

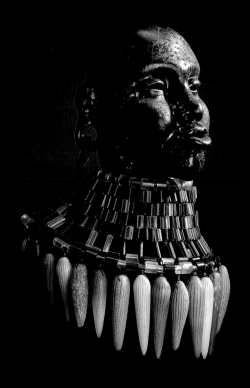 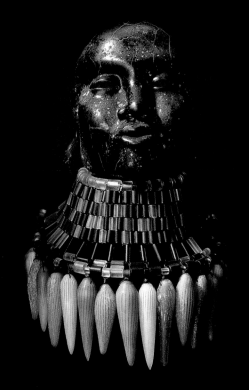

29

Turkana Woman

2001

26 × 12 × 9 in.

HA601.25.05

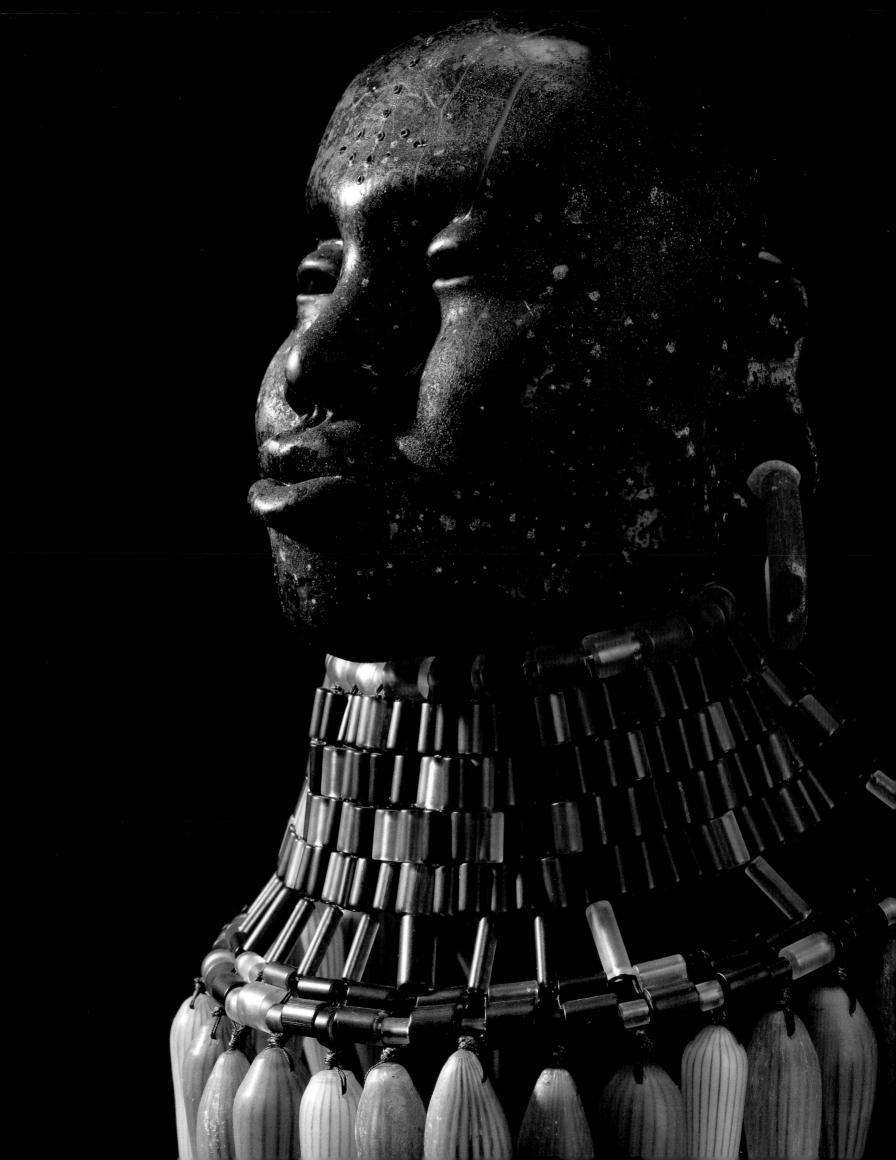

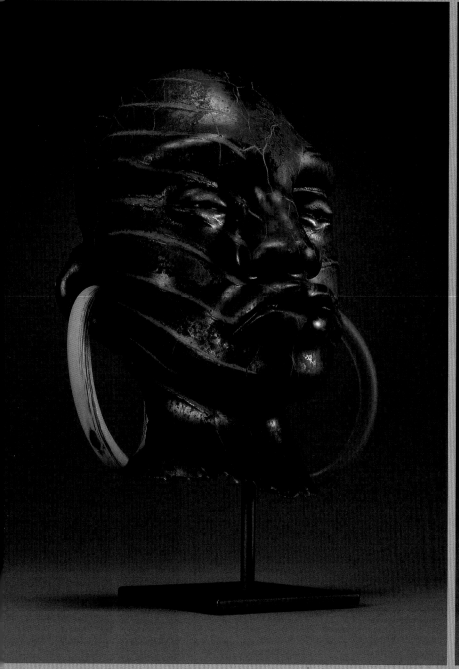

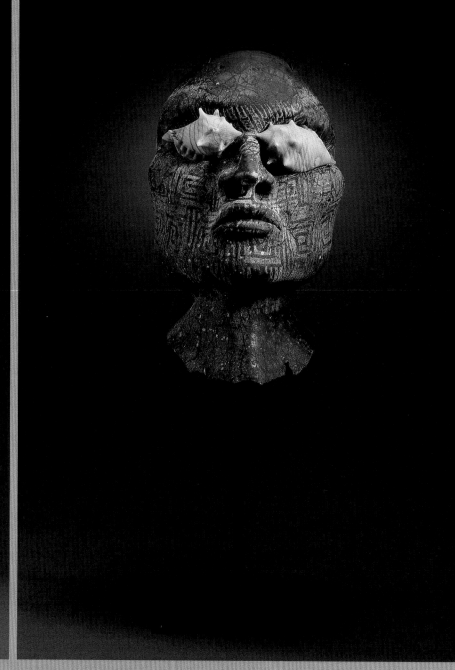

30

Surma Girl

2001

12 × 9 × 7 in.

HA301.14.04

31

Teotihuacan Man

2001

22 × 9 × 7 in.

HA601.05.02

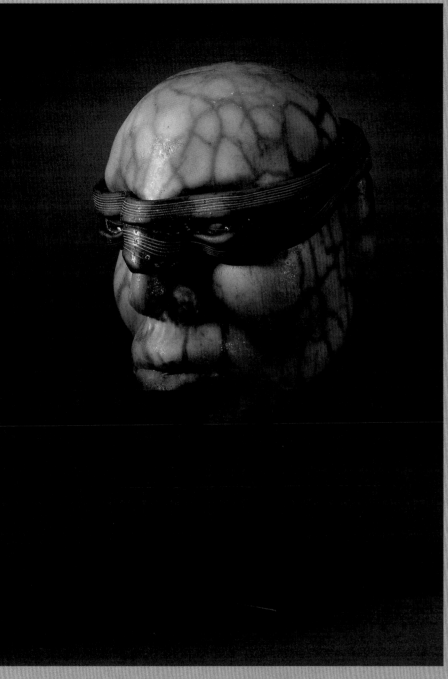

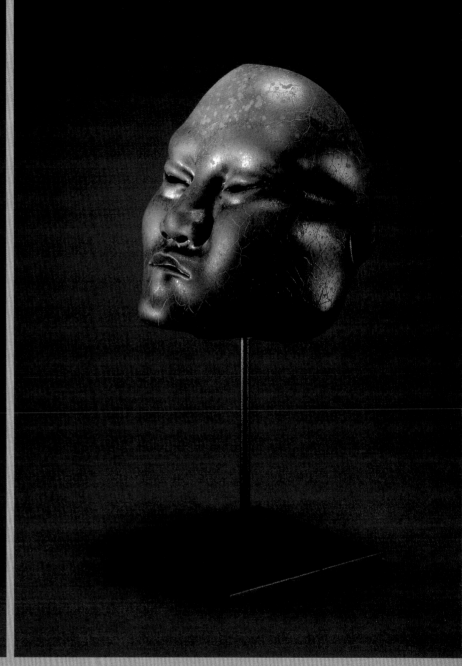

32

Blind Asmat Man

2001

14 × 8 × 9 in.

HA601.06.02

33

Kaesong Man

2001

15 × 7 × 7 in.

HA301.01.02

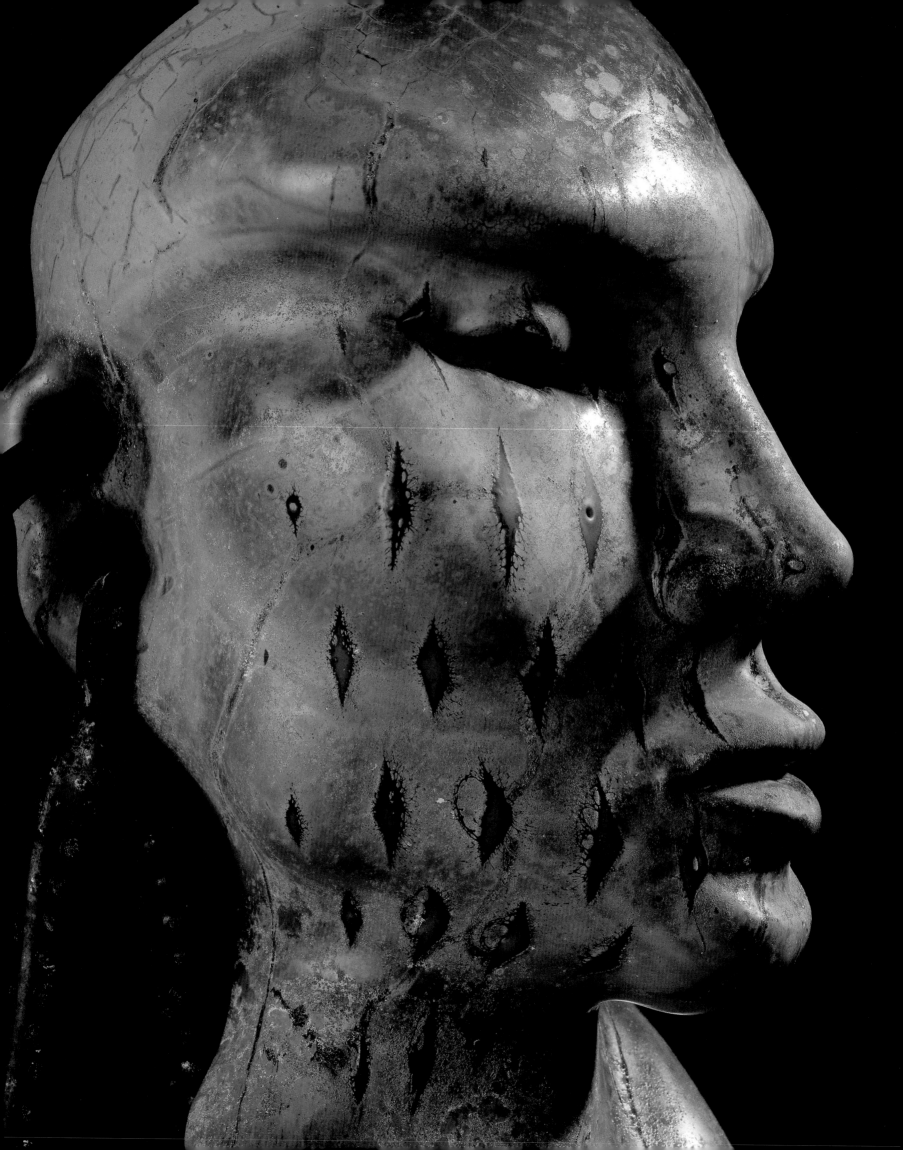

34
Rana Tharu Woman

2001
18 × 8 × 7 in.
HA301.09.04

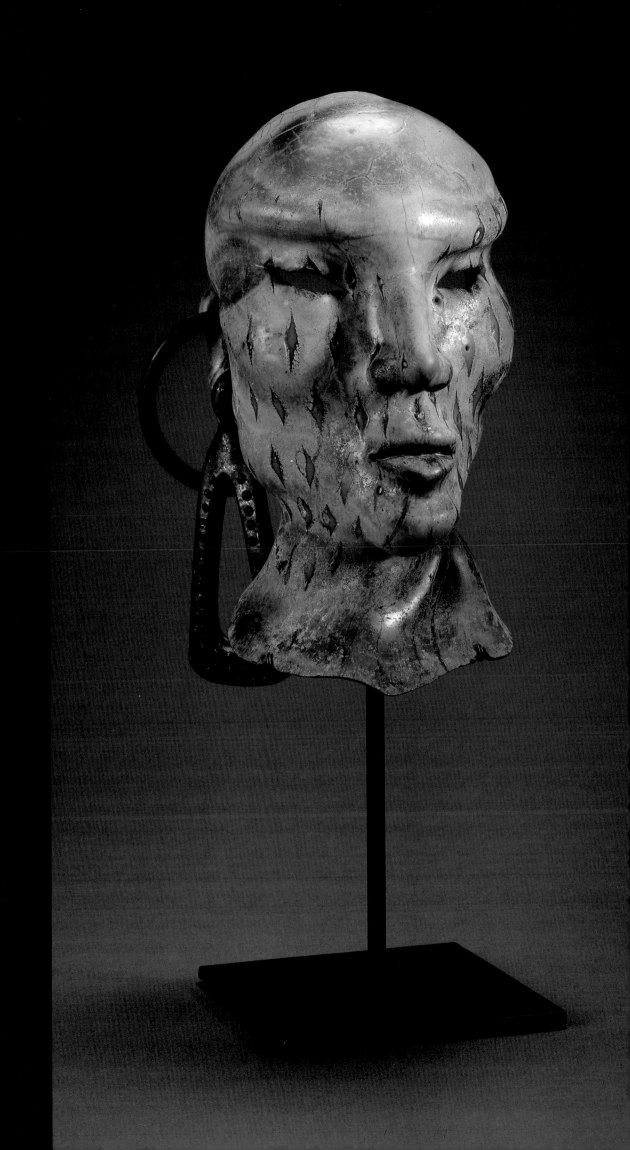

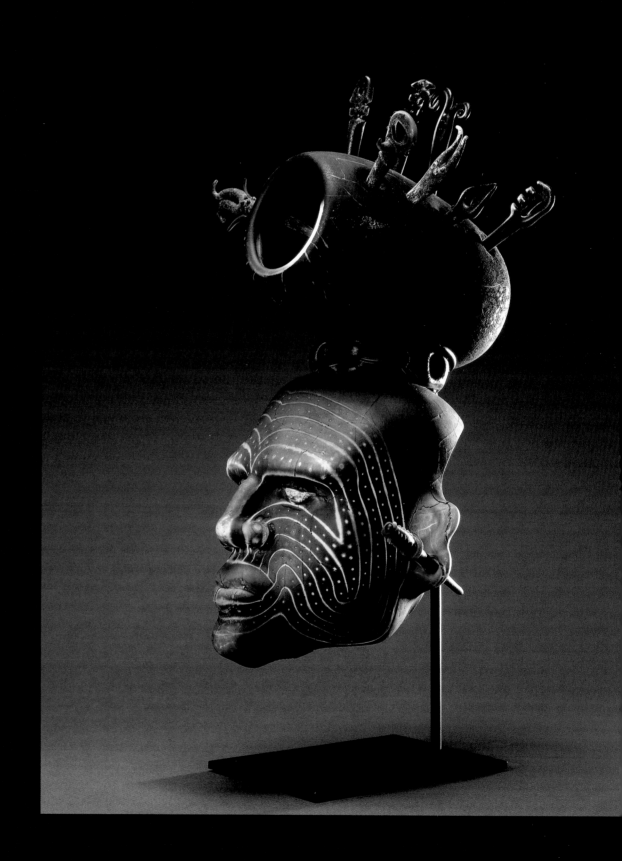

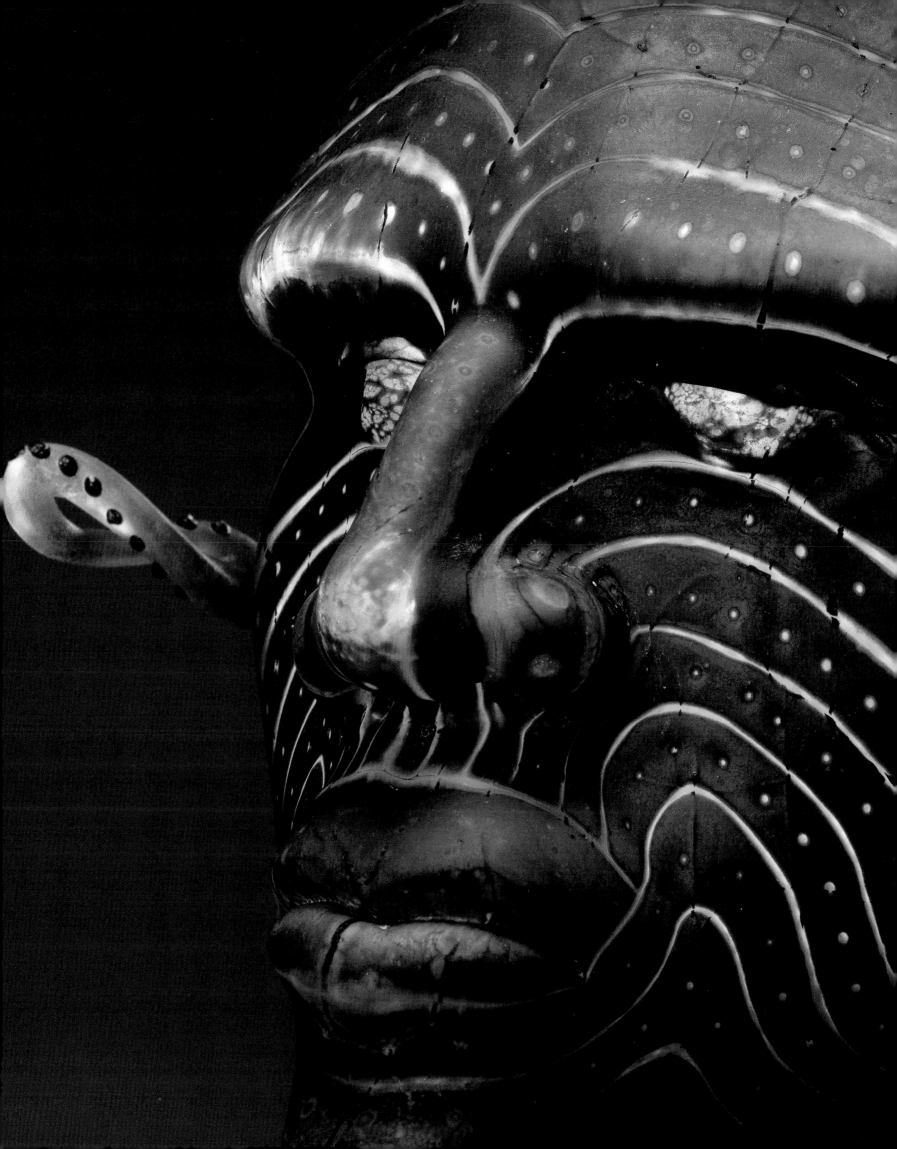

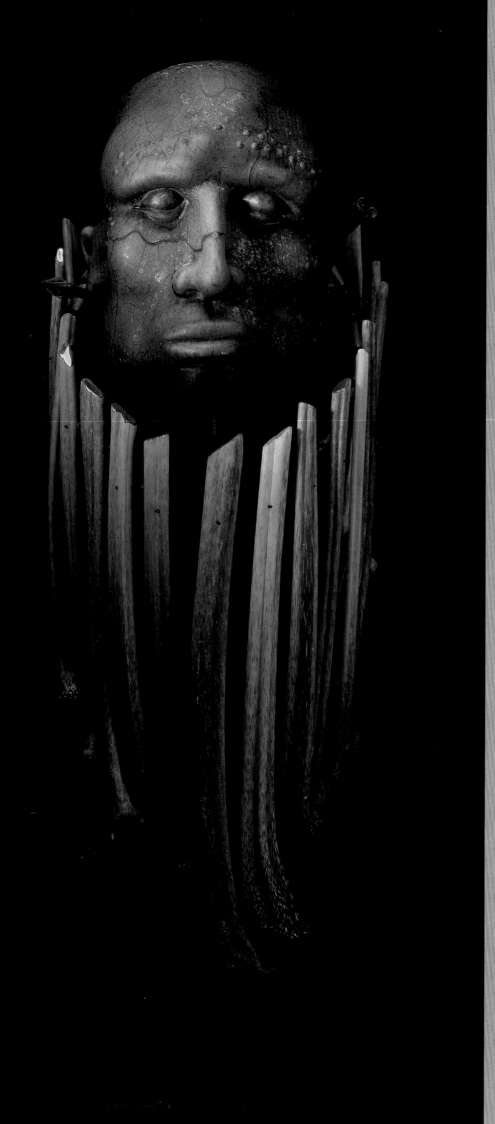

36

Peuhl Man

2001

28 × 10 × 9 in.

HA301.12.41

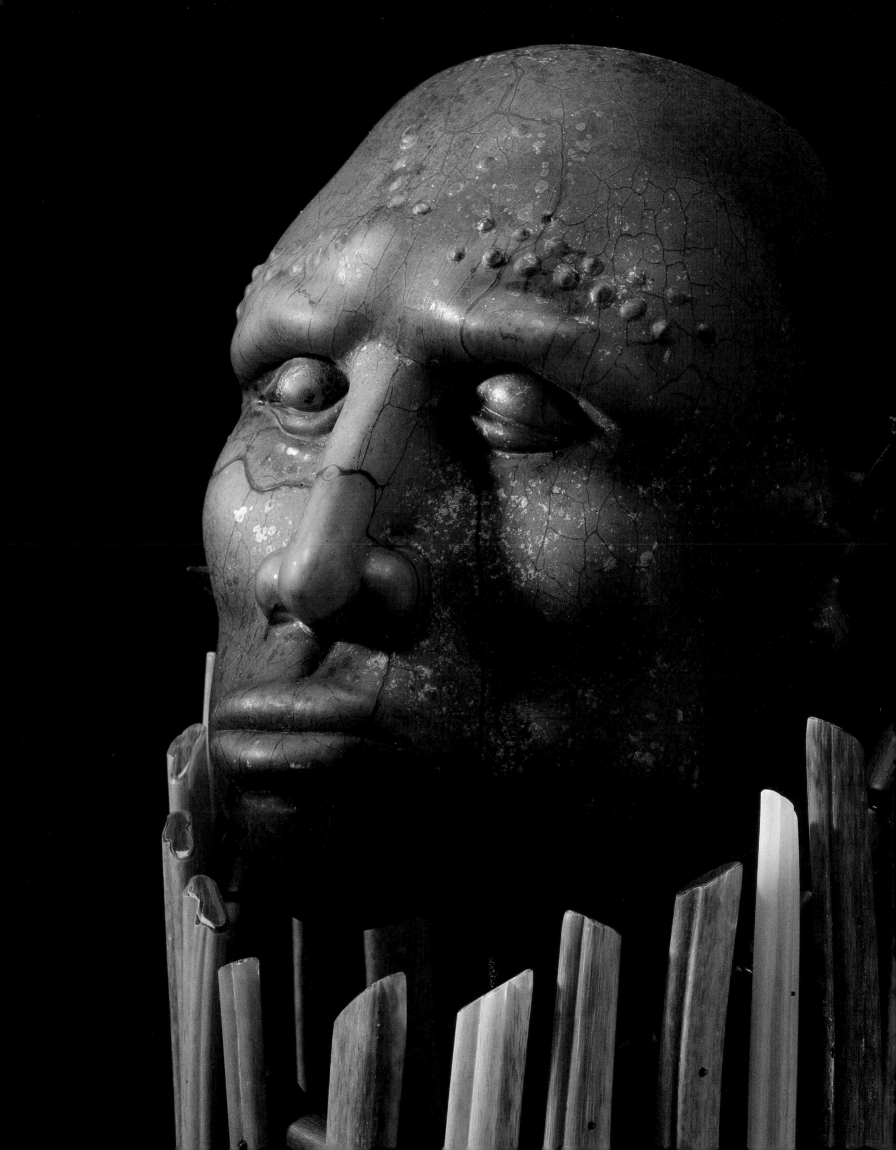

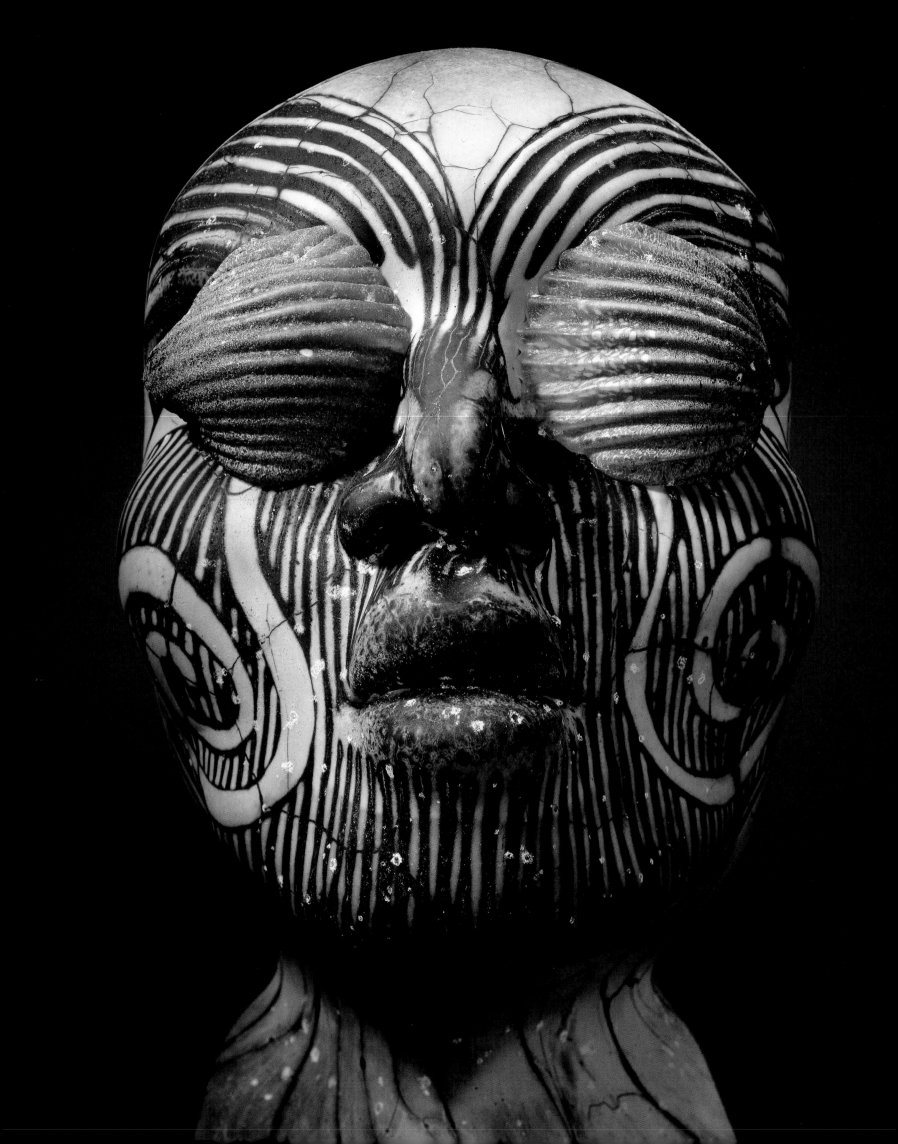

37

Maori Man

2001

24 × 7 × 10 in.

HA601.13.02

38
Hunter
2001
82 × 24 × 21 in.
HI601.04.09

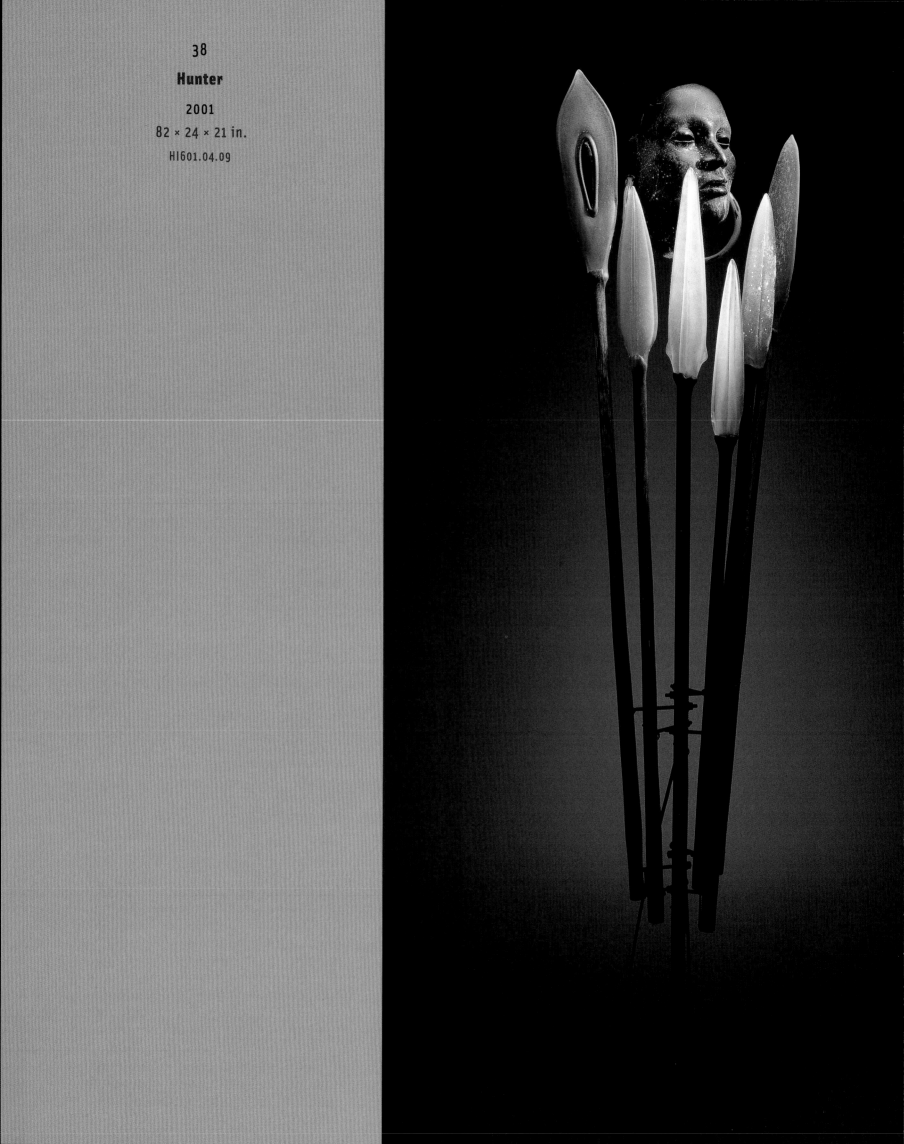

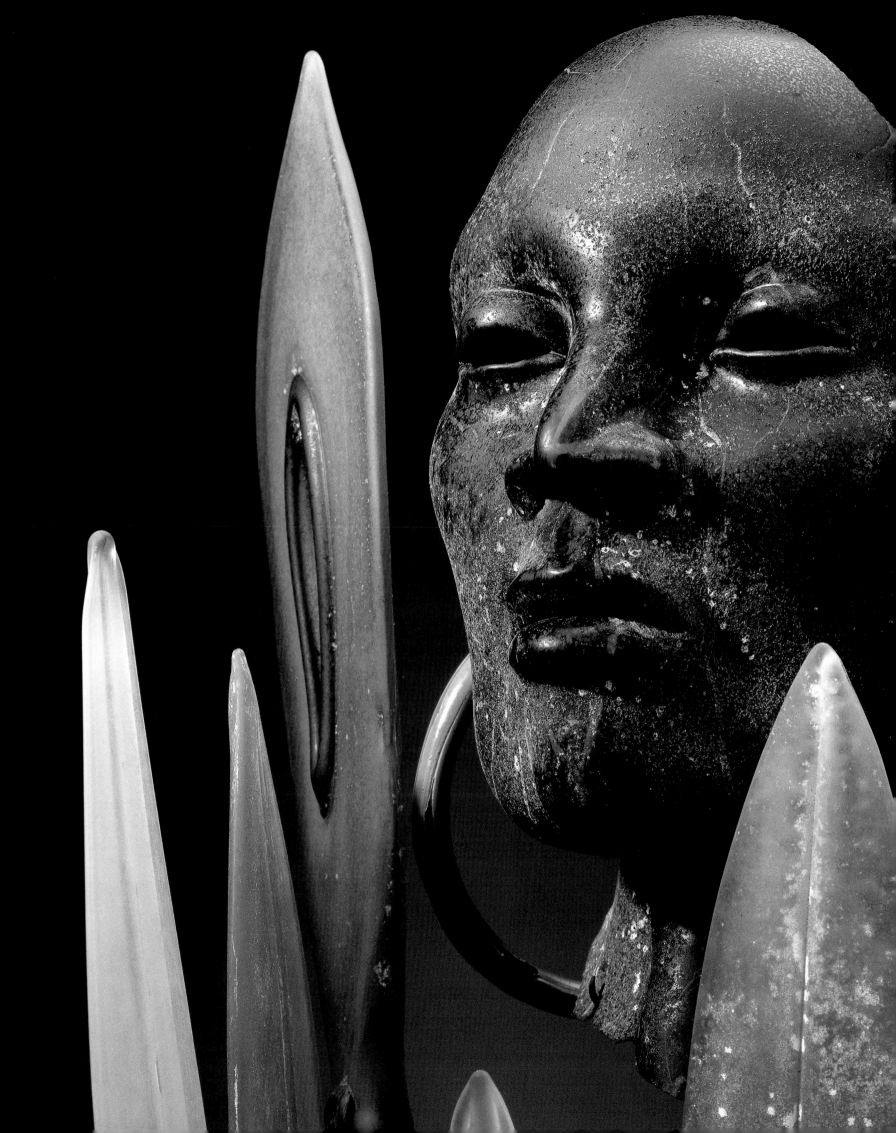

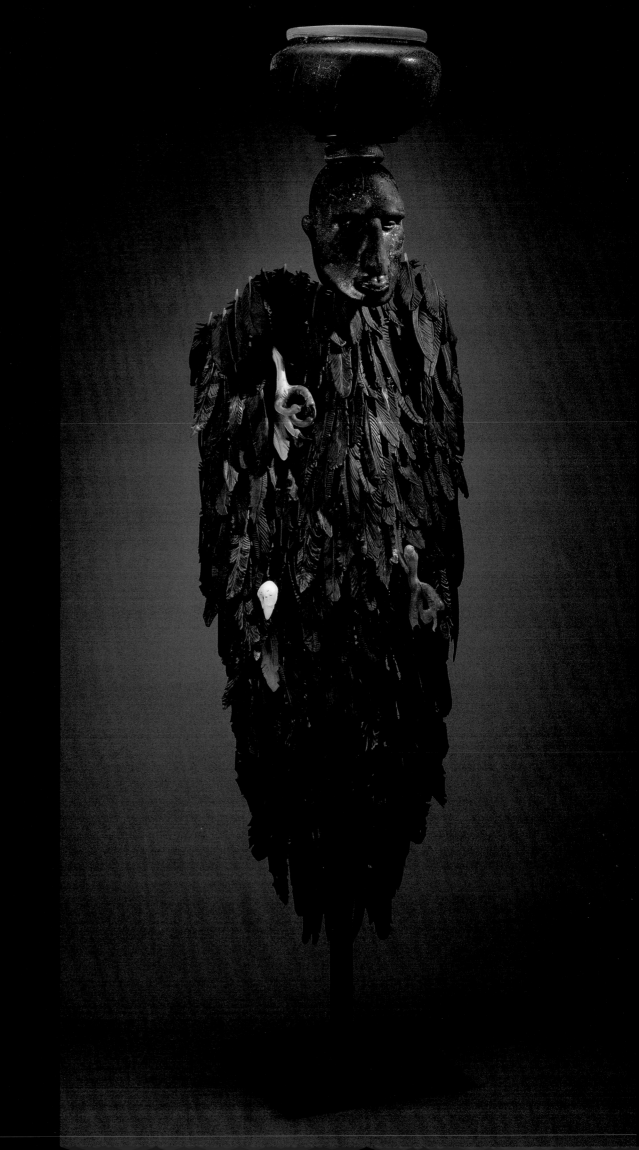

39

Hupa Shaman

2001

74 × 22 × 19 in.

HI301.03.03

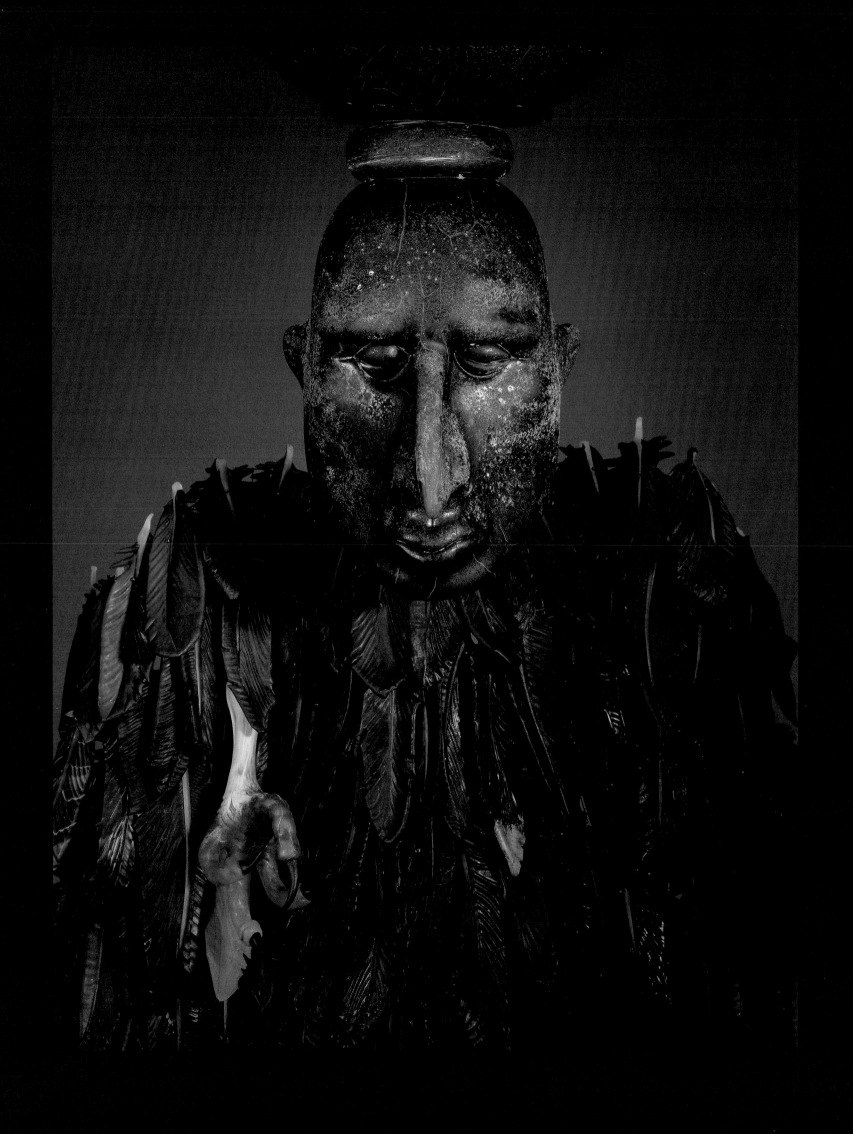

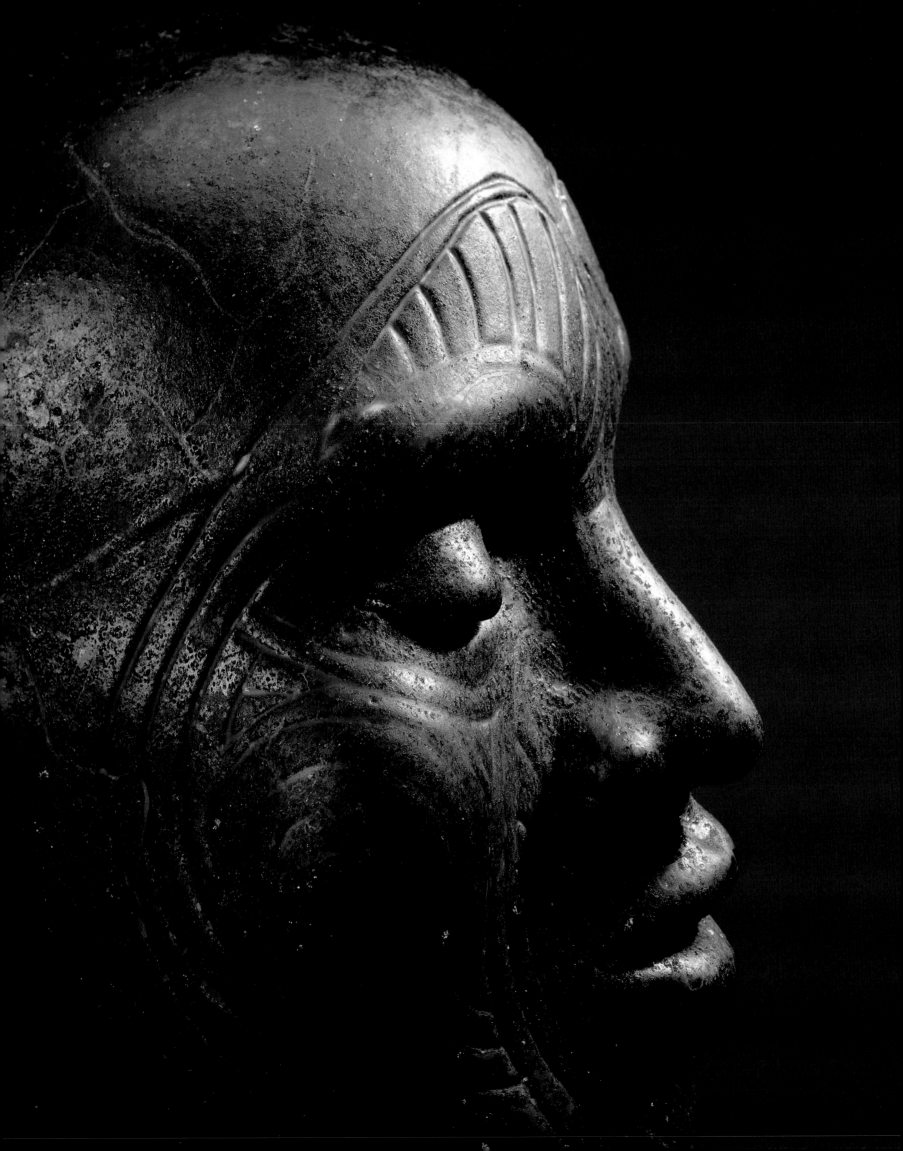

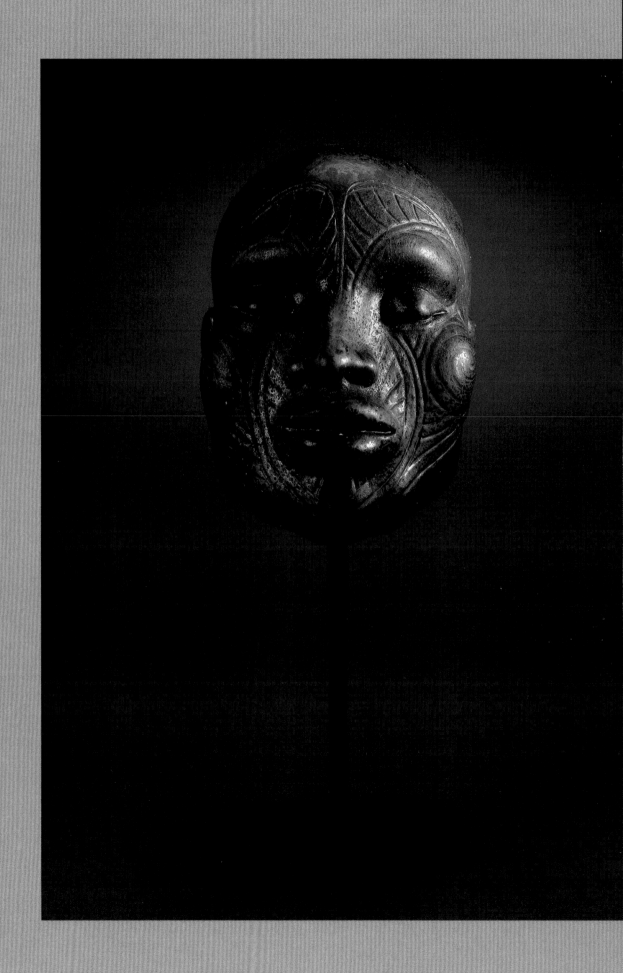

40

Nepalese Priest

2001

17 × 7 × 9 in.

HA601.15.02

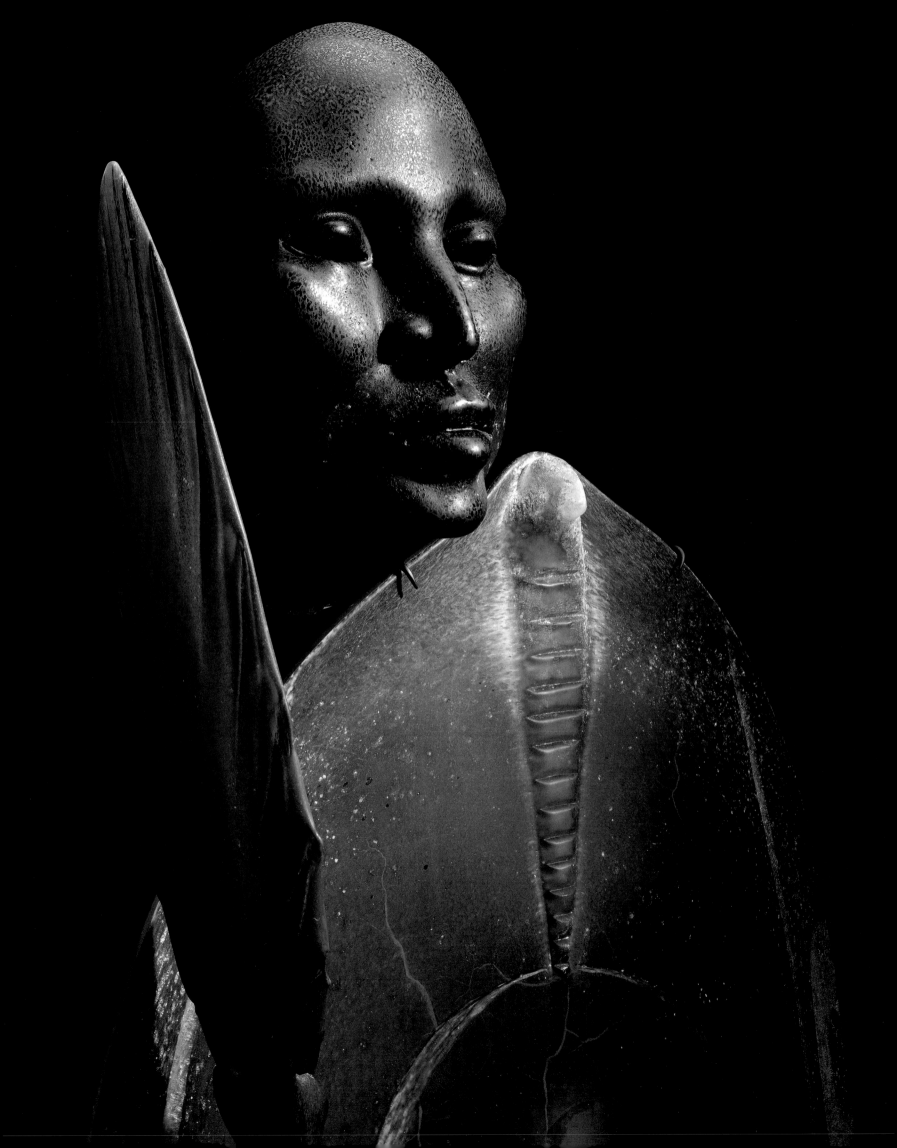

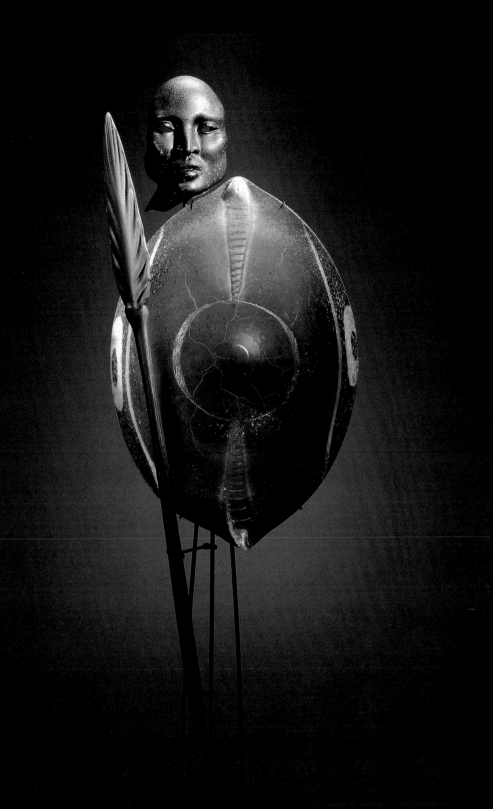

41

Warrior I

2001

71 × 26 × 16 in.

HI601.09.04

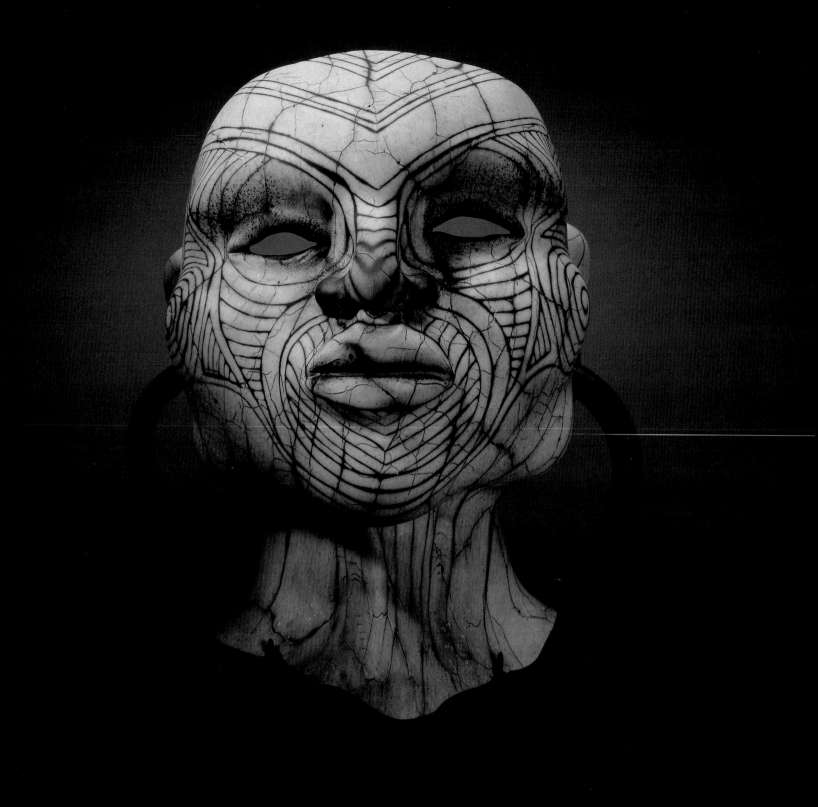

42

Maori Woman

2001

17 × 10 × 7 in.

HA601.12.04

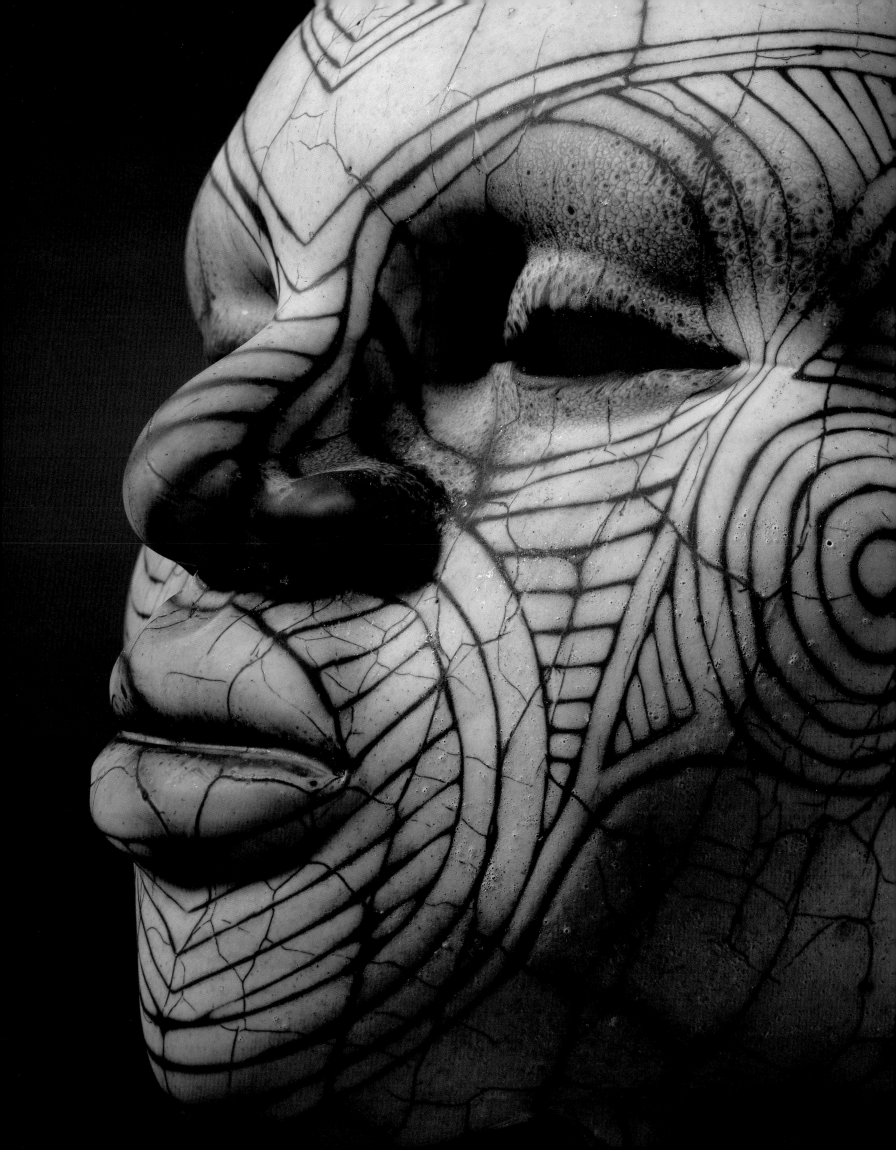

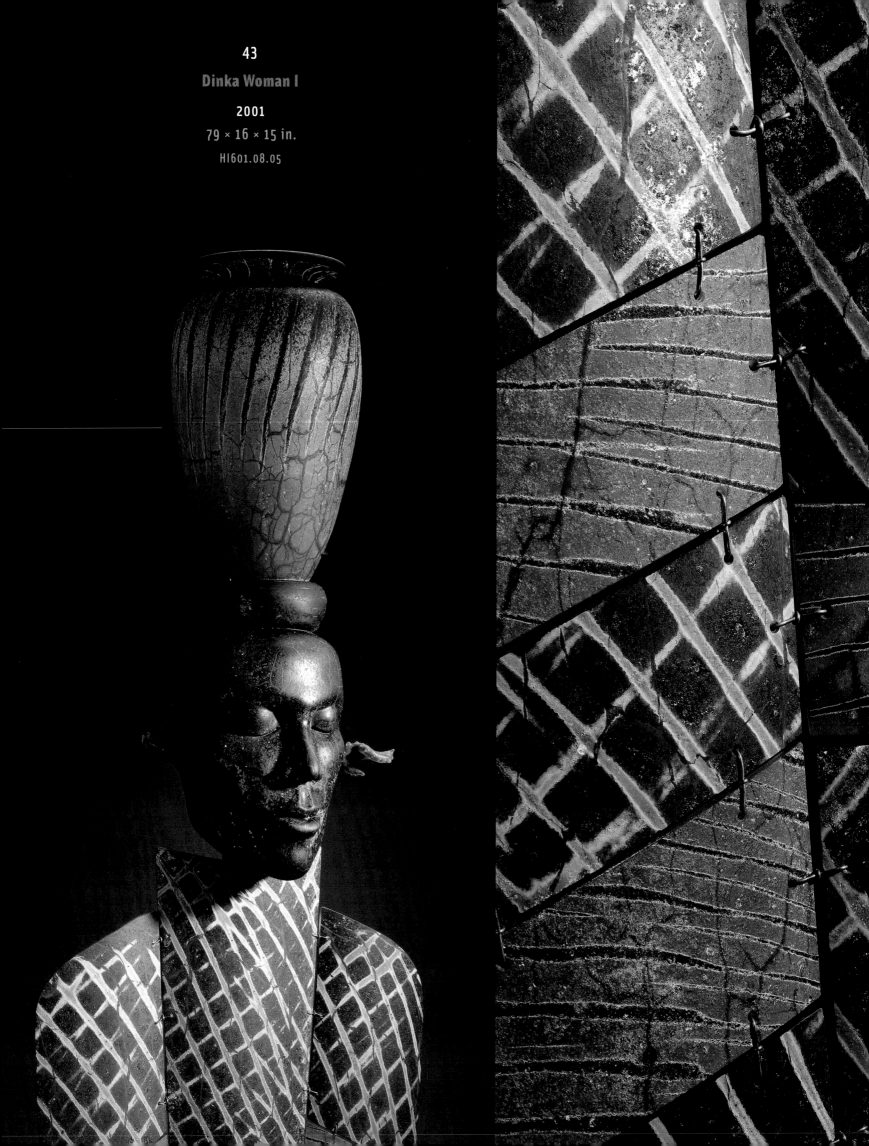

43
Dinka Woman I

2001
79 × 16 × 15 in.
HI601.08.05

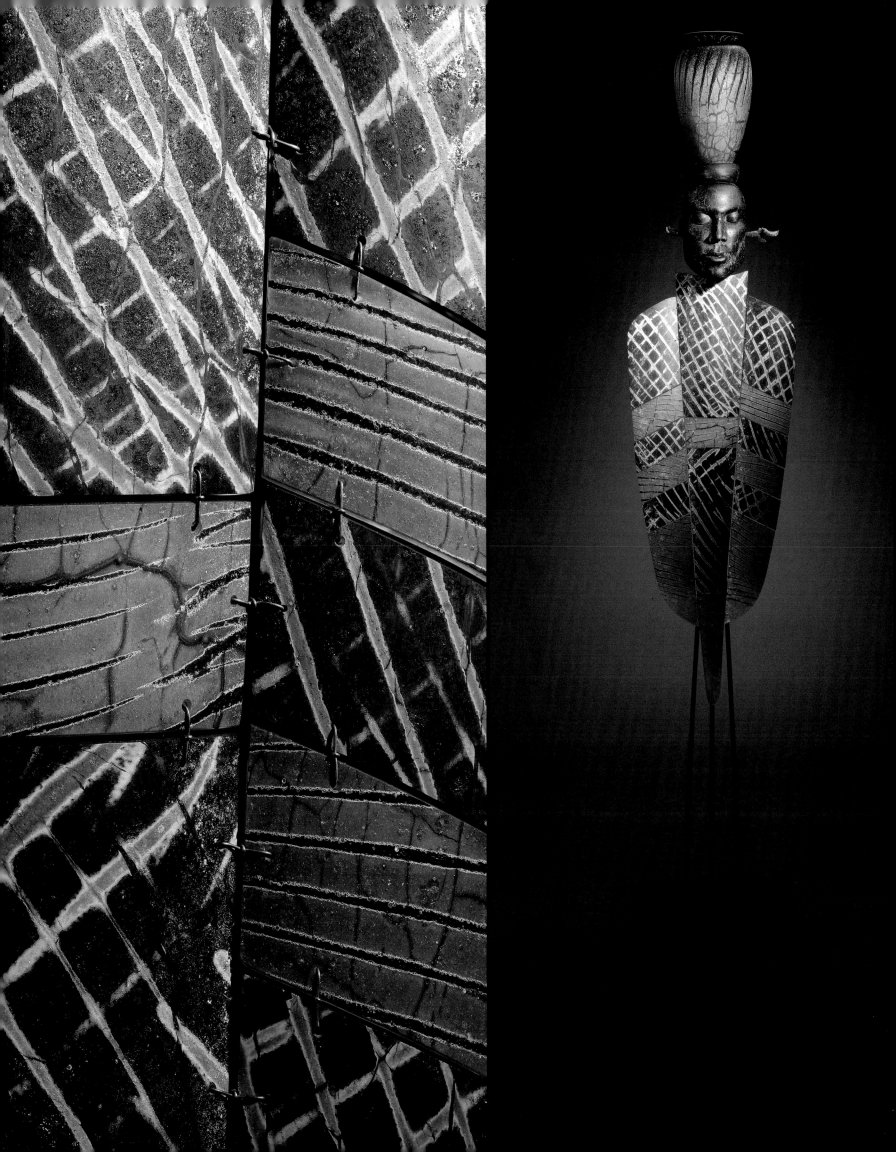

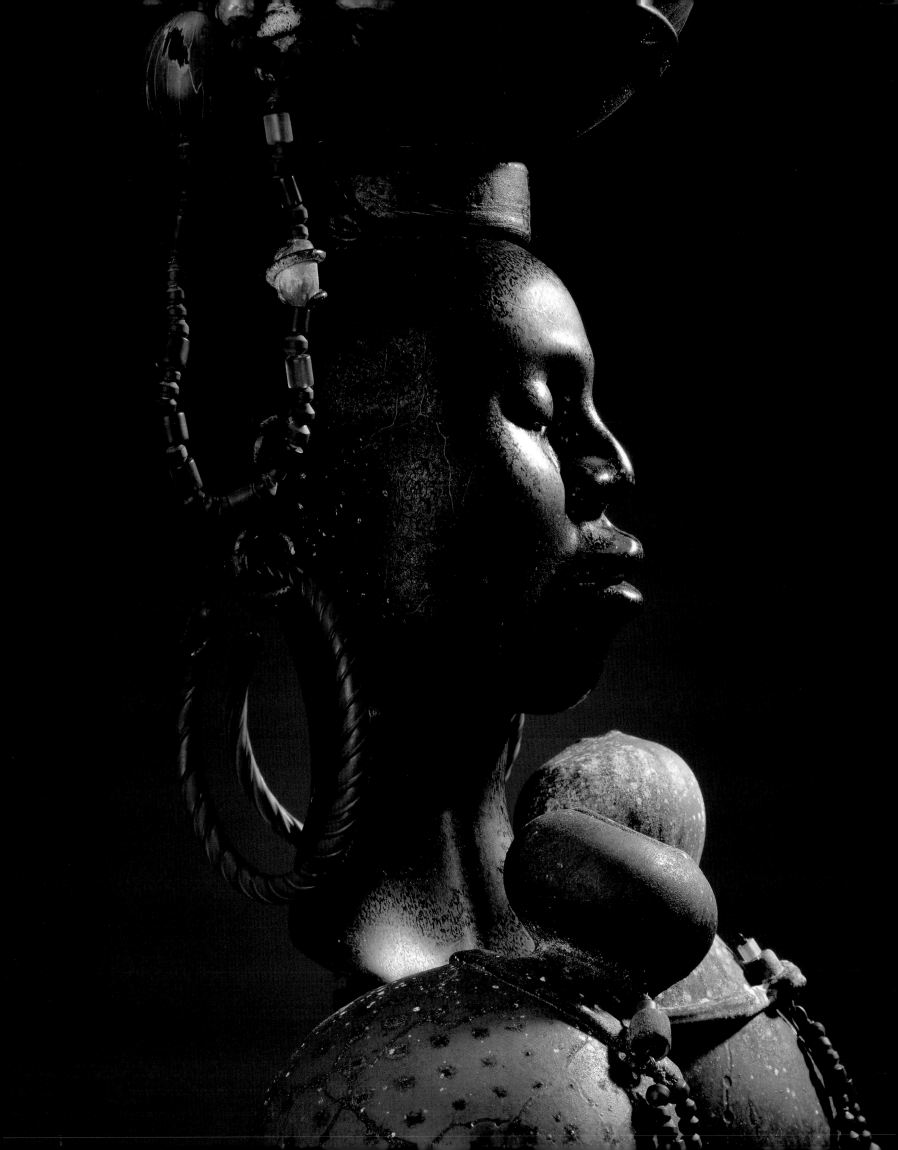

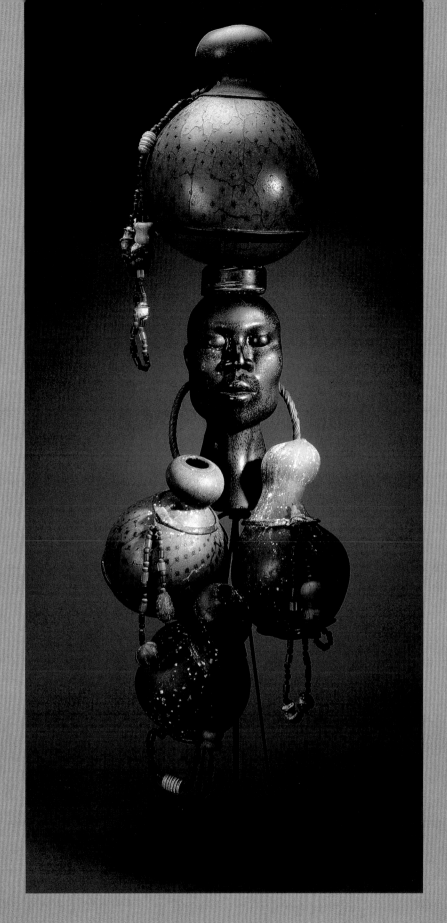

44

Nuba Woman II

2001

53 × 17 × 19 in.

HI601.07.12

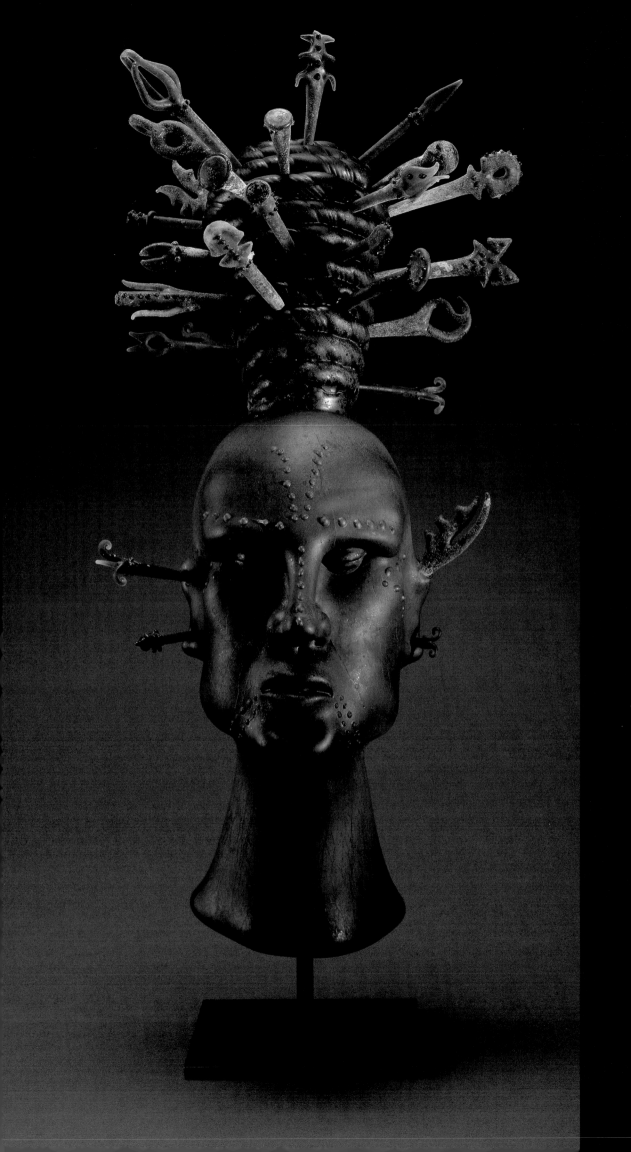

45
Mangbeta Woman
2001
26 × 12 × 10 in.
HA301.03.29

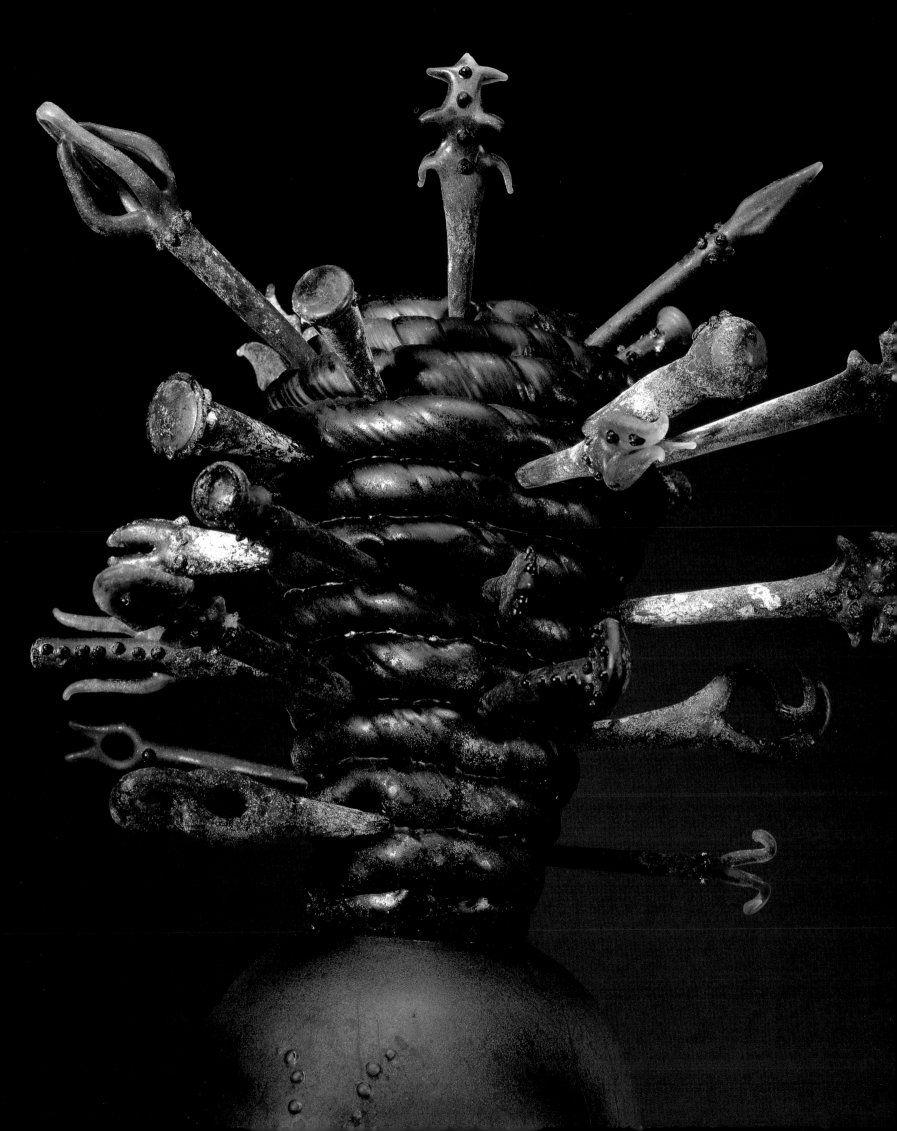

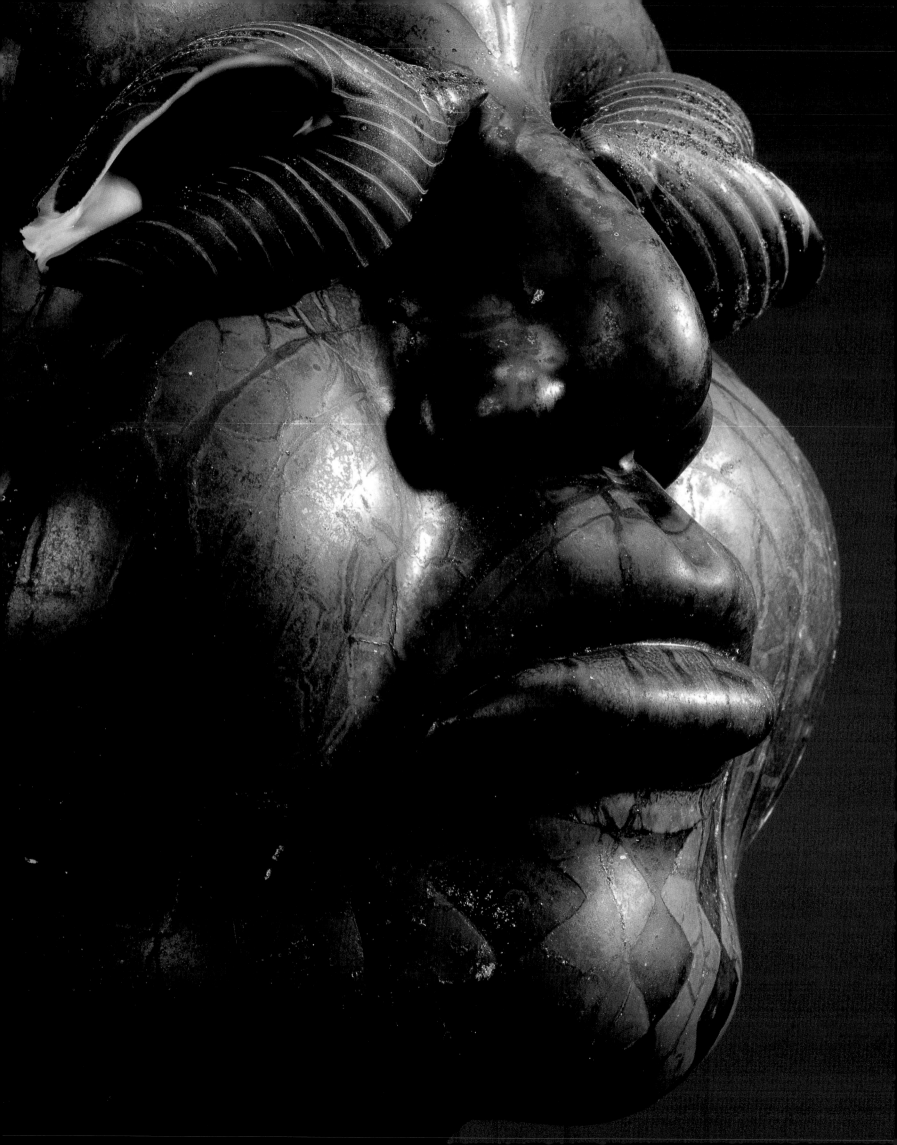

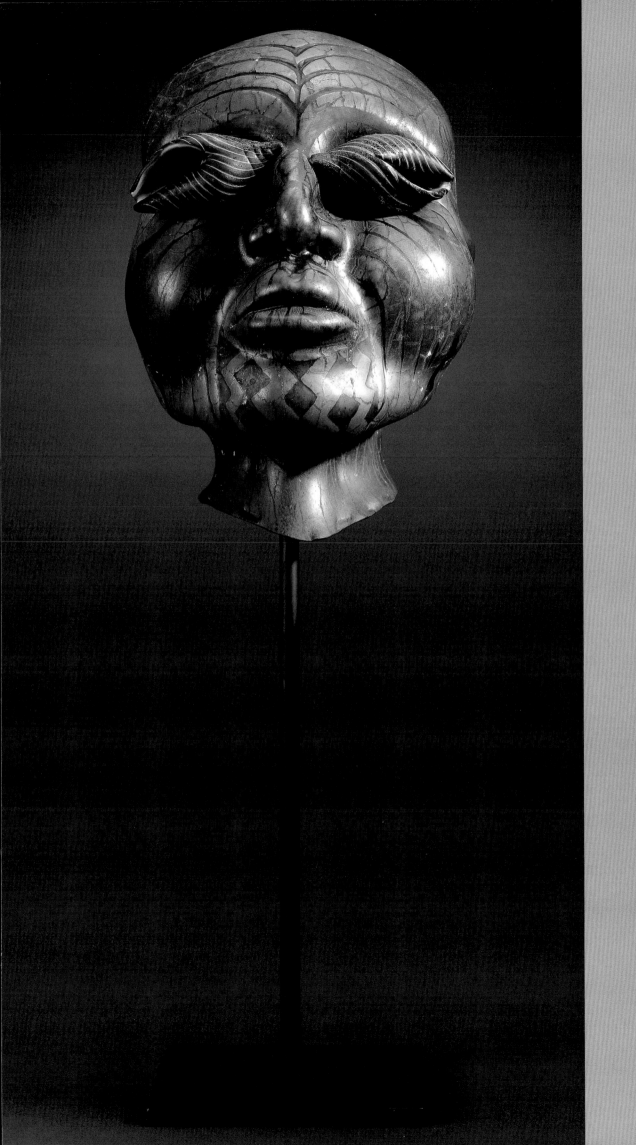

46
Samoa Man
2001
20 × 8 × 7 in.
HA601.11.02

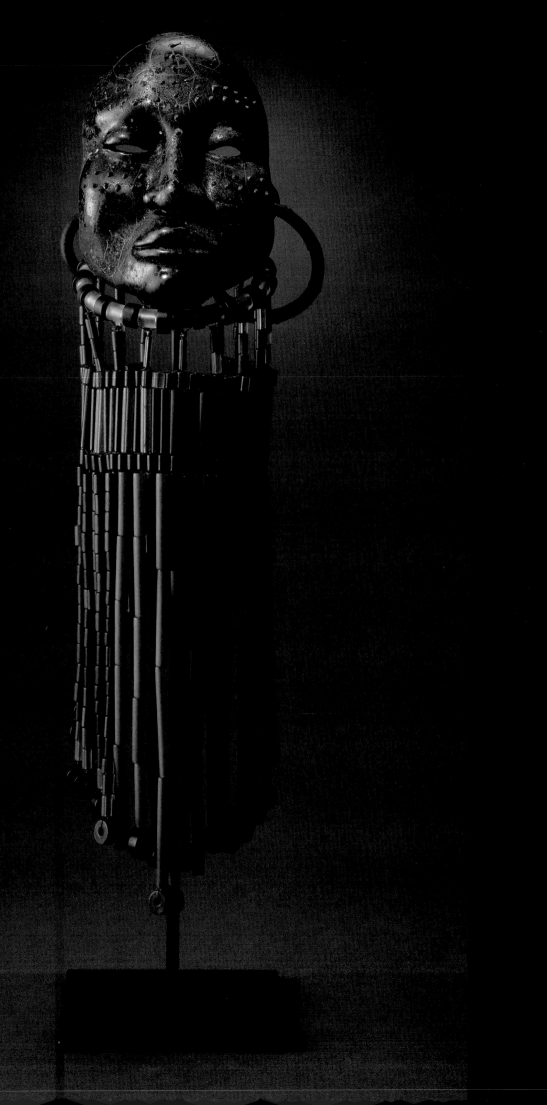

47

Rendille Woman

2001

32 × 9 × 8 in.

HA601.17.05

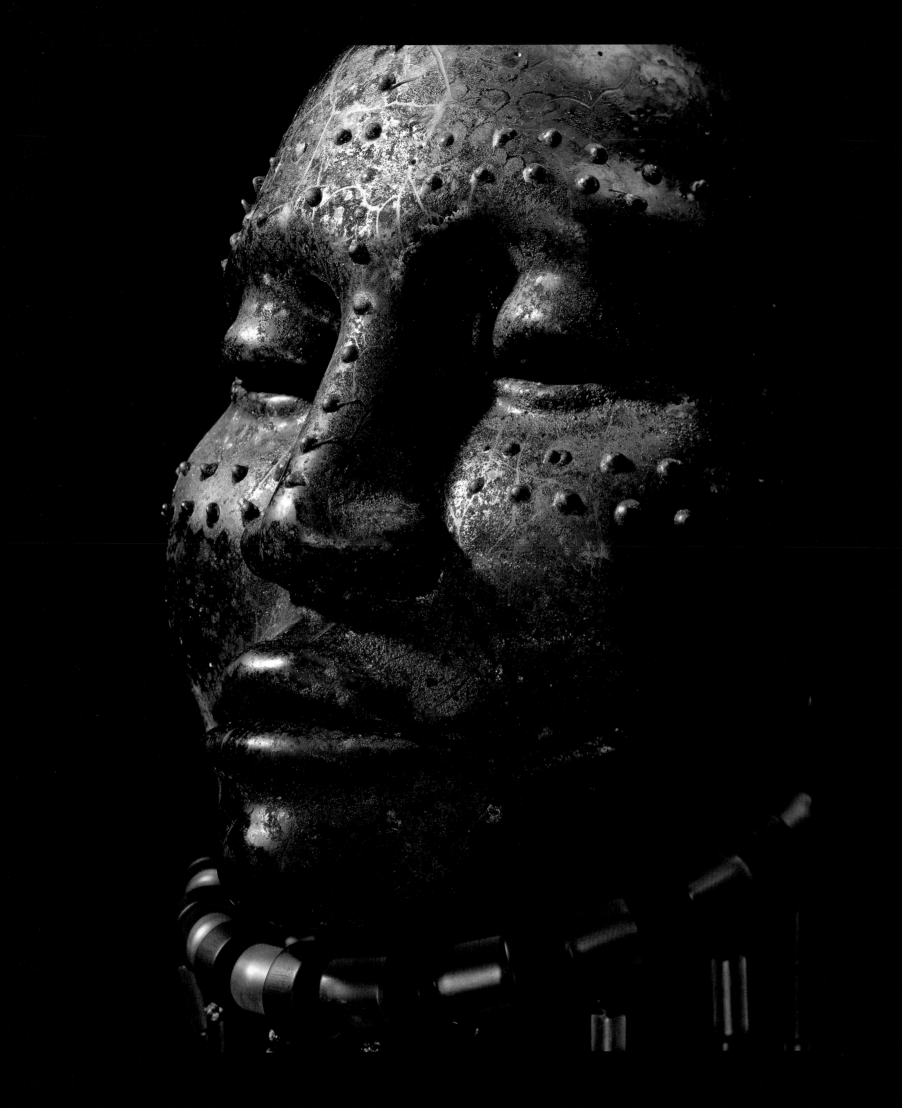

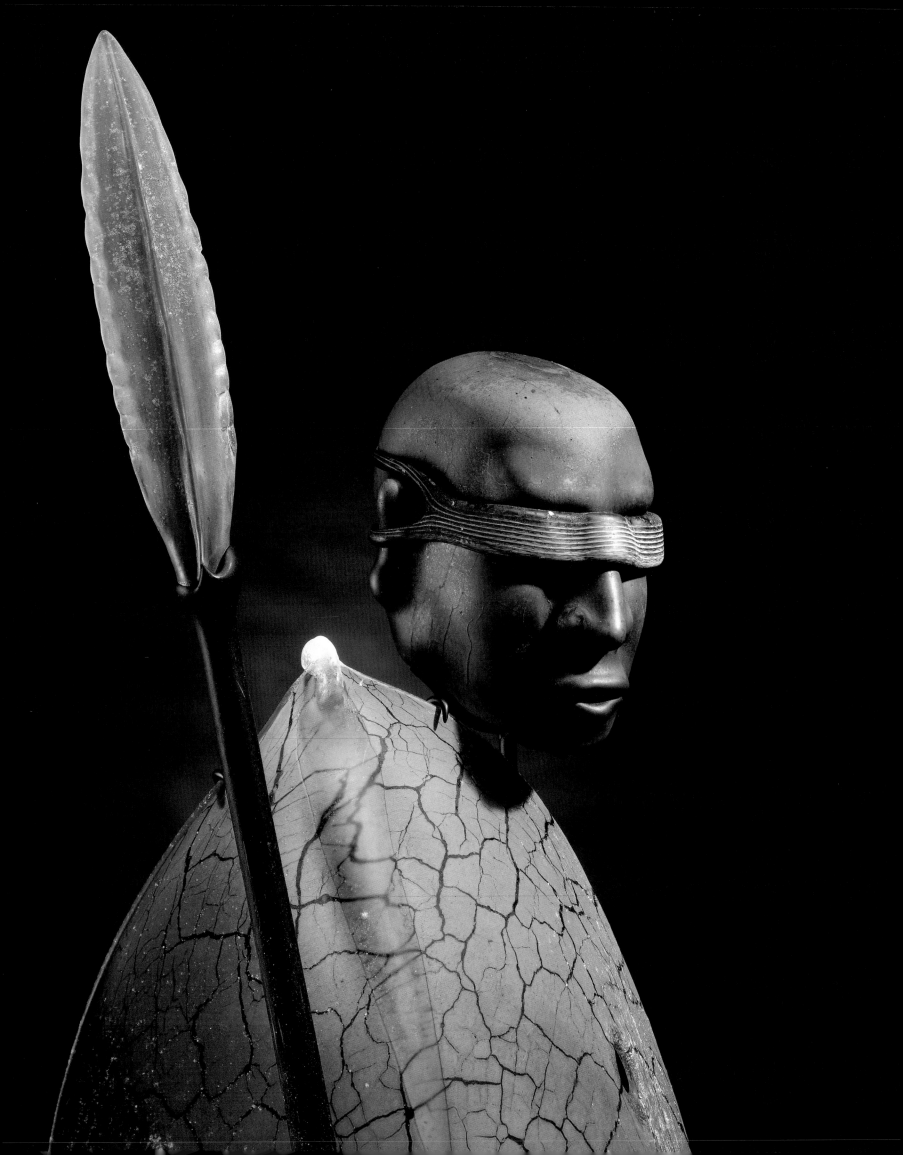

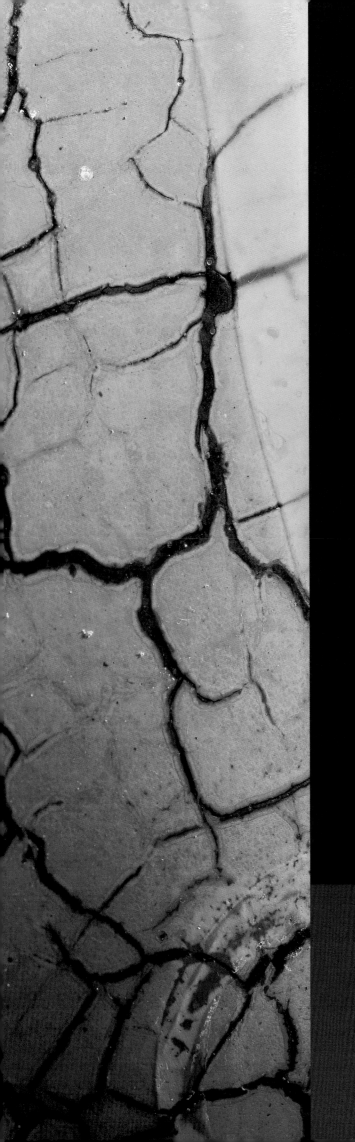

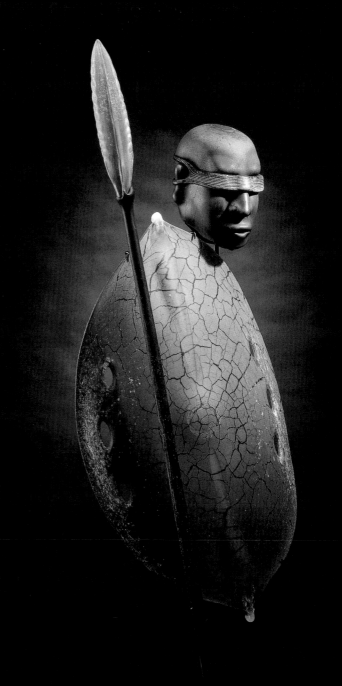

48

Warrior III

2001

67 × 20 × 14 in.

HI601.10.04

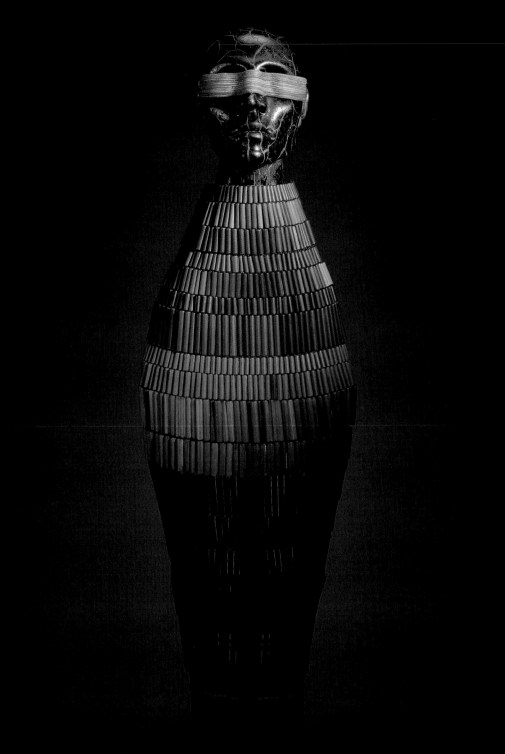
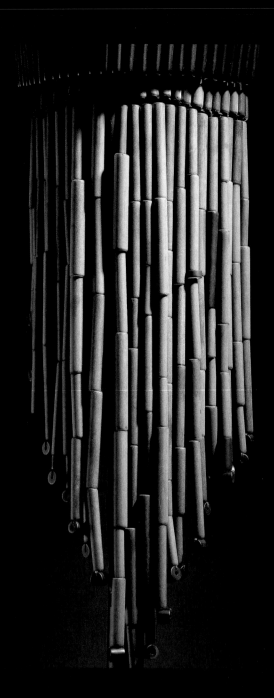

49

Natufian Woman

2001

64 × 15 × 14 in.

HI601.12.03

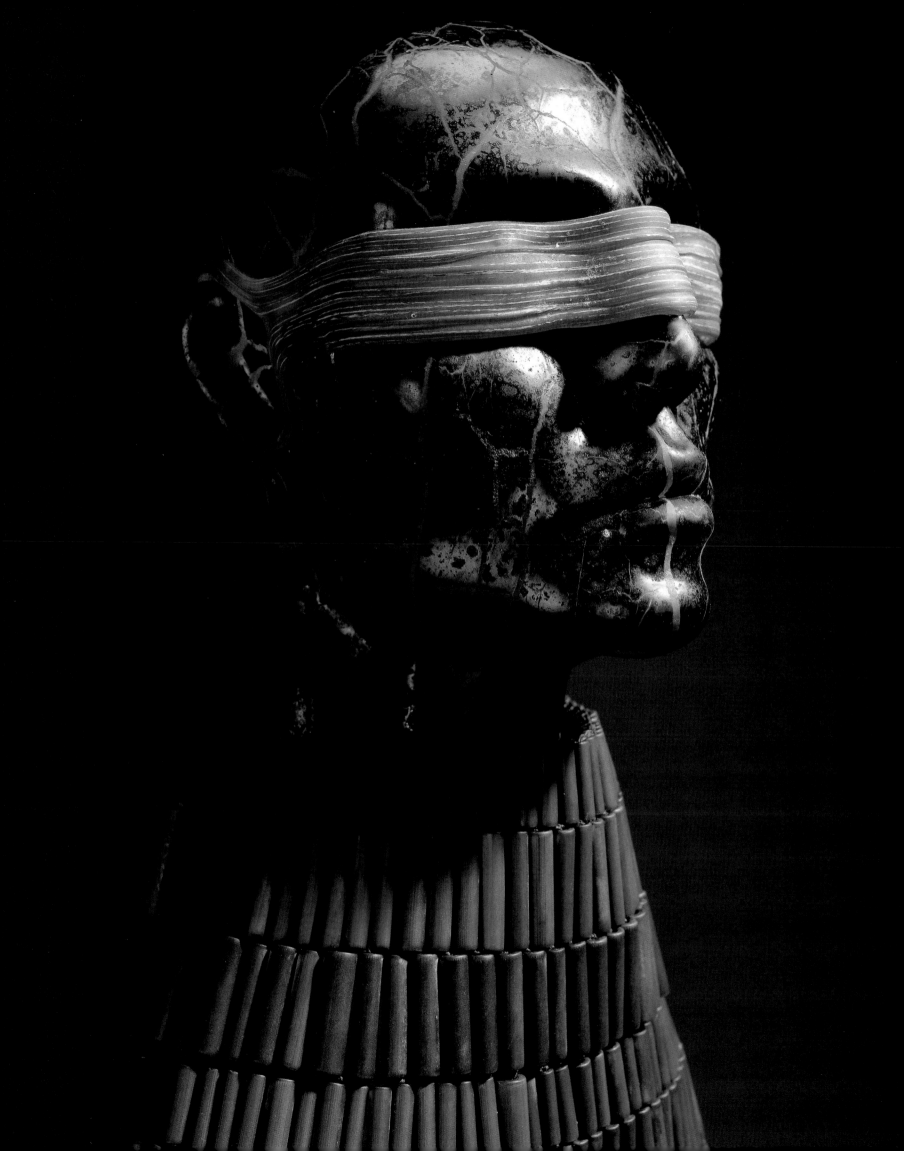

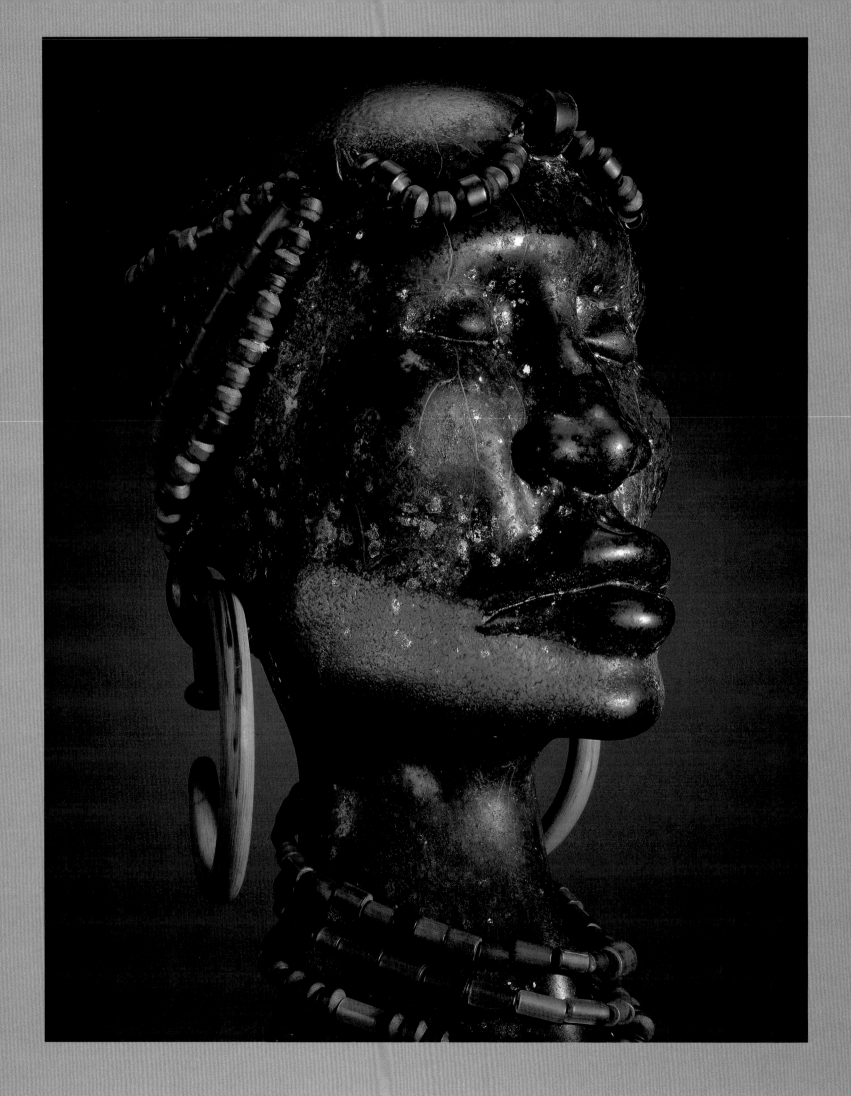

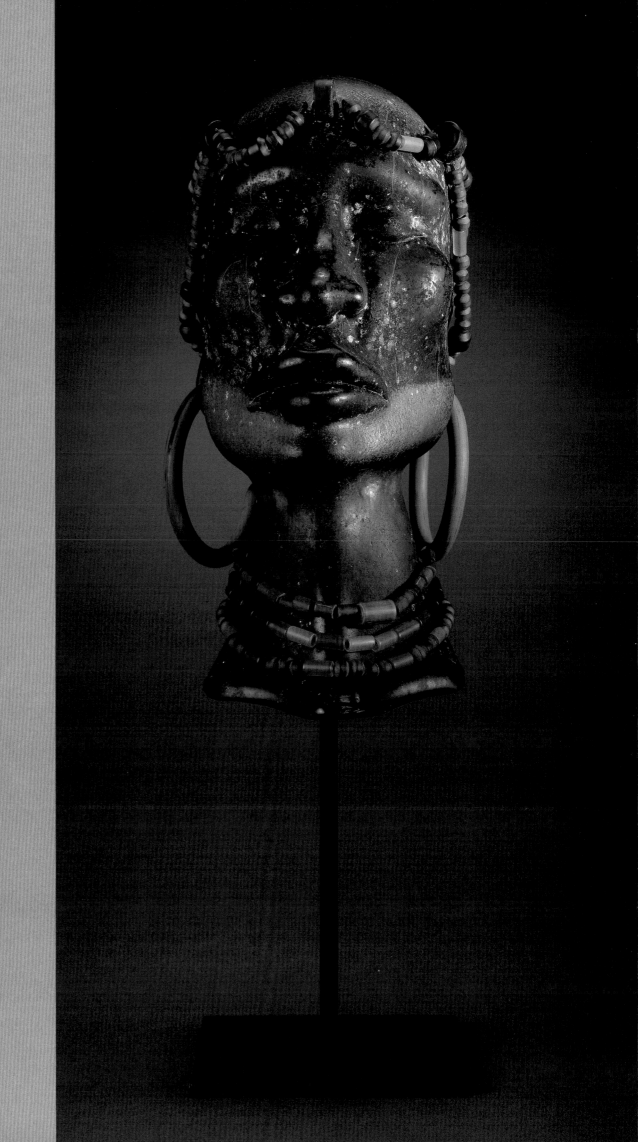

50

Dinka Woman II

2001

23 × 8 × 9 in.

HA601.19.07

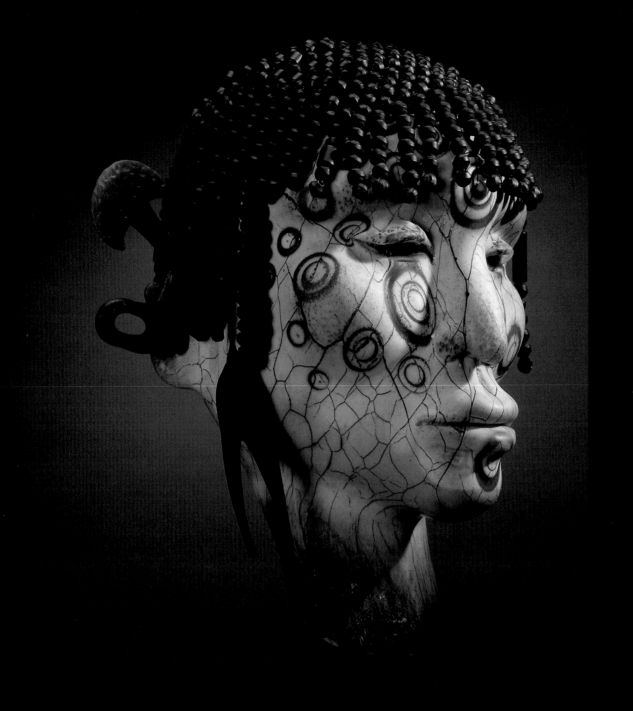

51

Wodaabe Woman

2001

24 × 10 × 9 in.

HA601.20.06

Marquesas Man

2001

19 × 9 × 10 in.

HA601.24.02

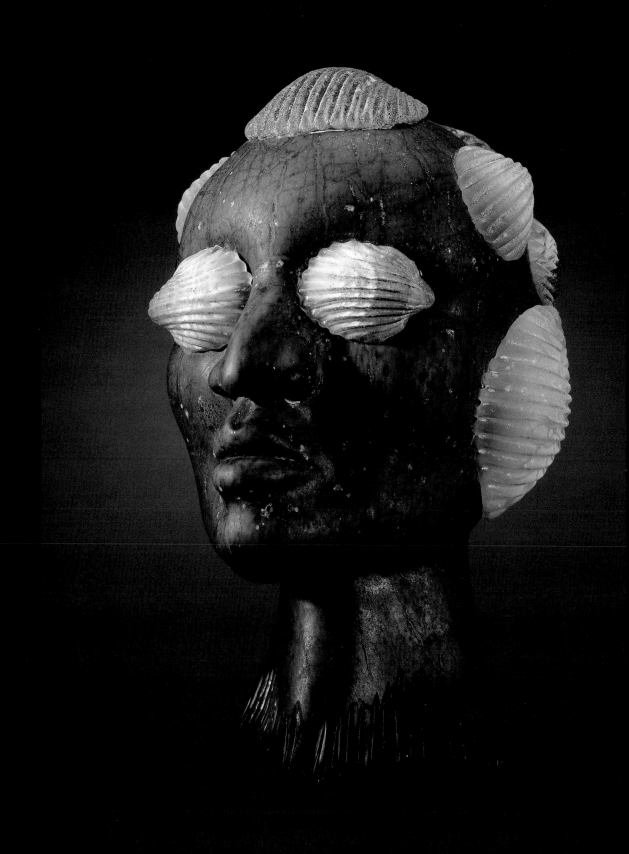

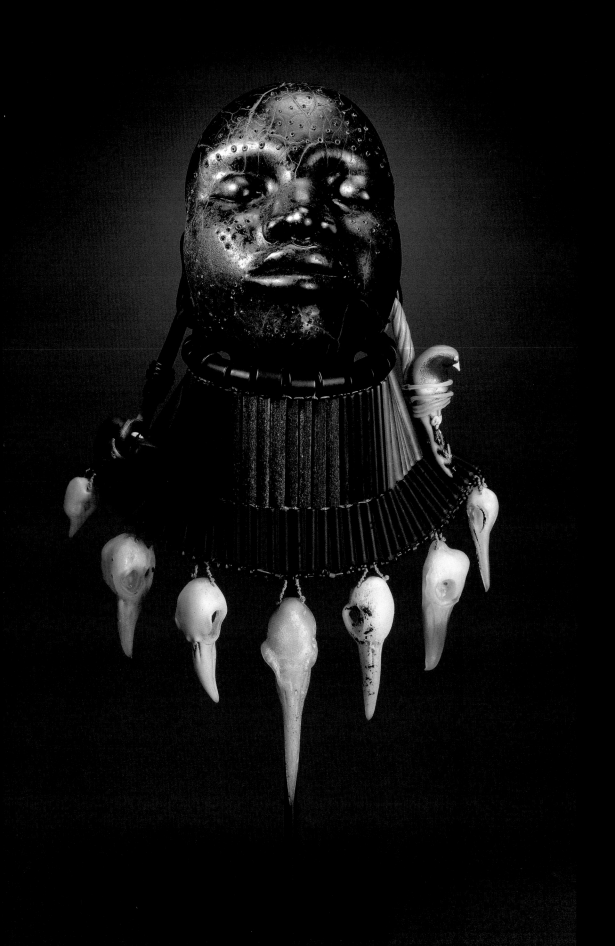

26 × 15 × 7 in.

HA601.16.05

53

Samburu Woman

2001

26 × 15 × 7 in.

HA601.16.05

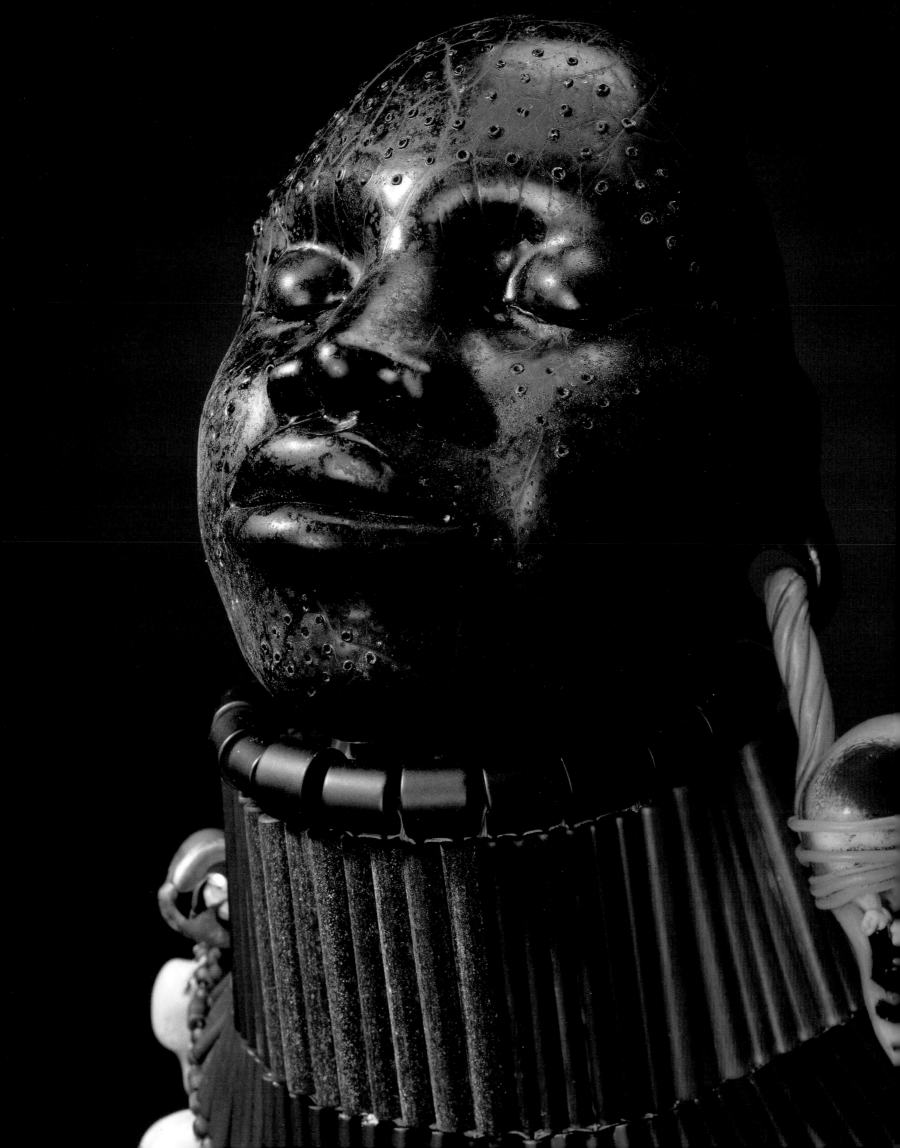

54

Kau Woman

2001

81 × 20 × 20 in.

HI601.06.09

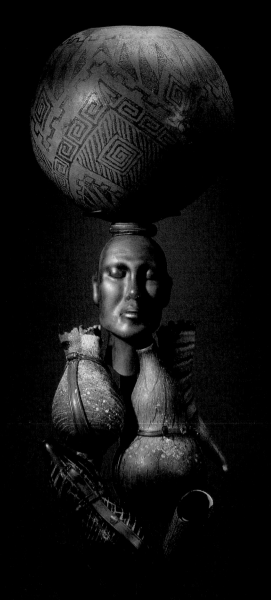

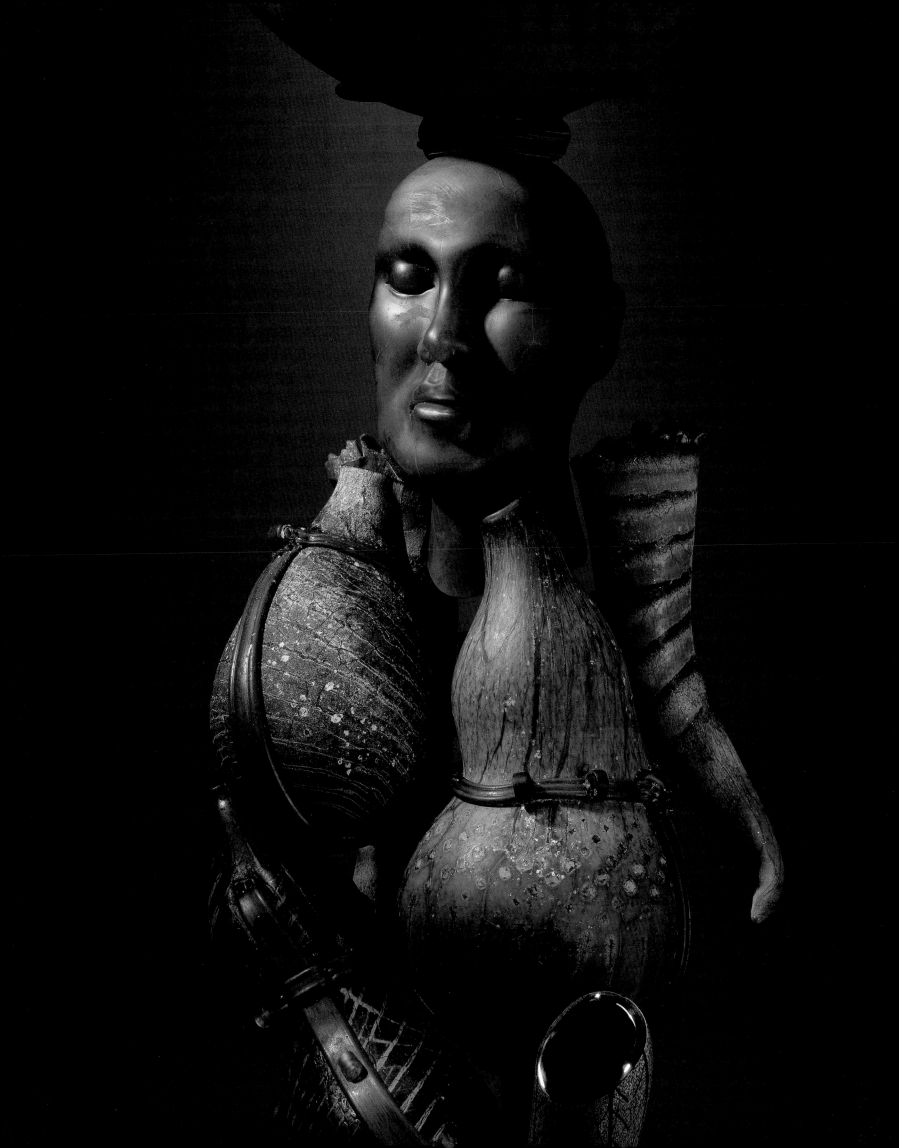

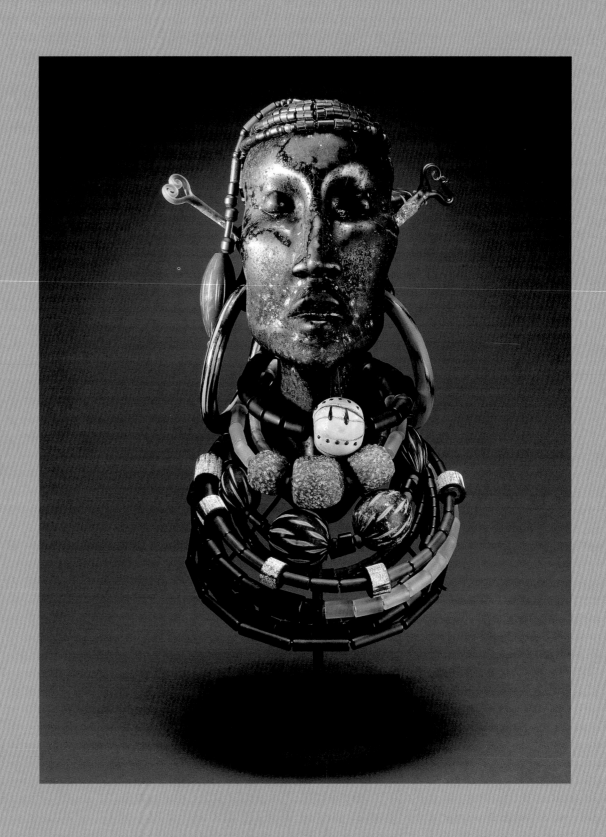

55
Beaded Woman

2001

25 × 11 × 12 in.

HA301.07.18

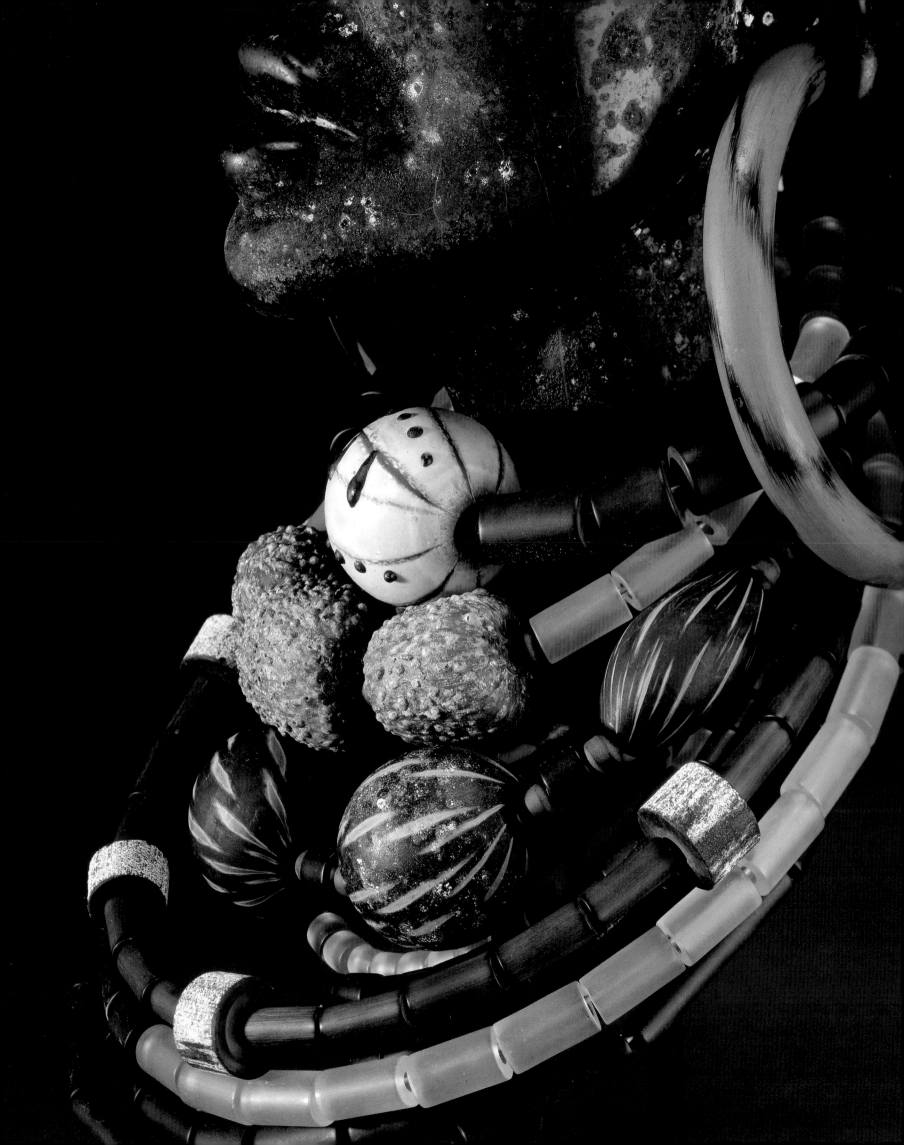

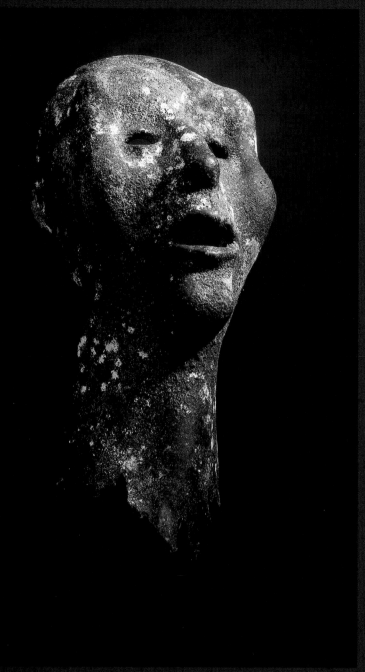

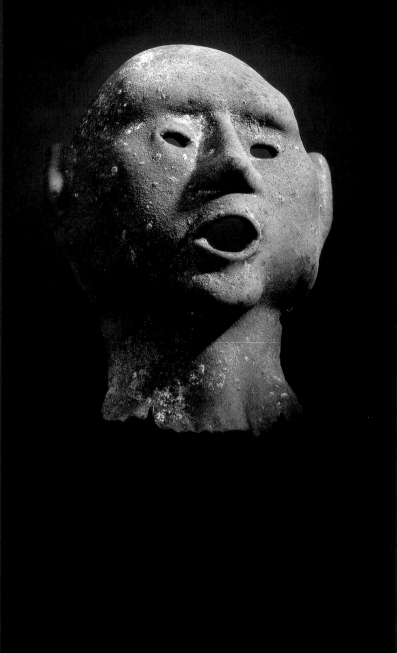

56

Untitled

2001

12 × 4 × 4 in.

HA601.27.02

57

Untitled

2001

12 × 7 × 5 in.

HA601.21.02

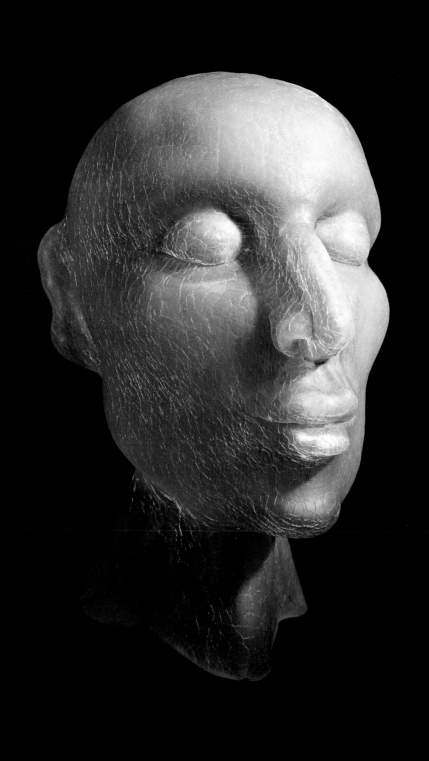

58
Untitled
2001
18 × 8 × 9 in.
HA601.08.02

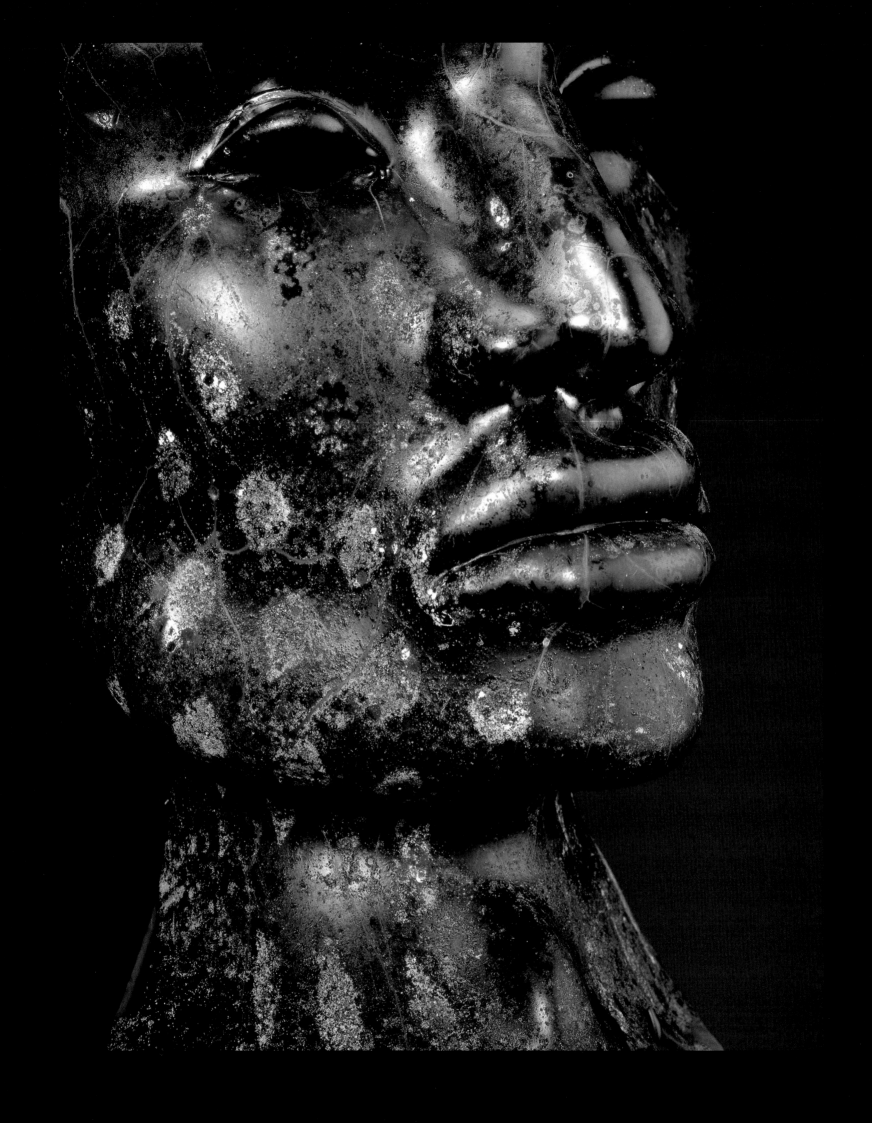

59

Nuba Man

2001

23 × 10 × 8 in.

HA301.13.03

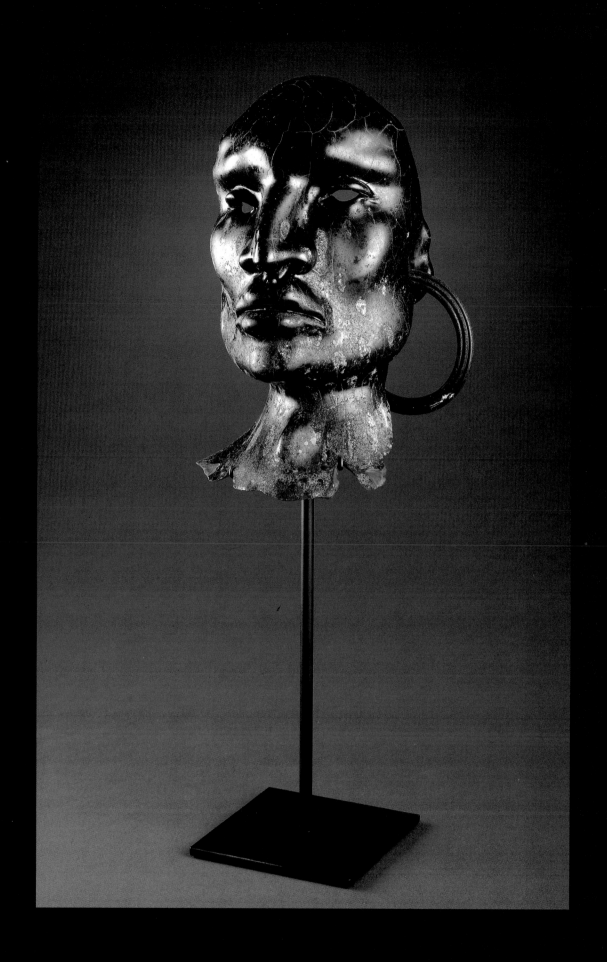

60

Berber Woman, Untitled

2001

20 × 10 × 9 in. (Berber Woman)

18 × 8 × 9 in. (Untitled)

HAGR.04

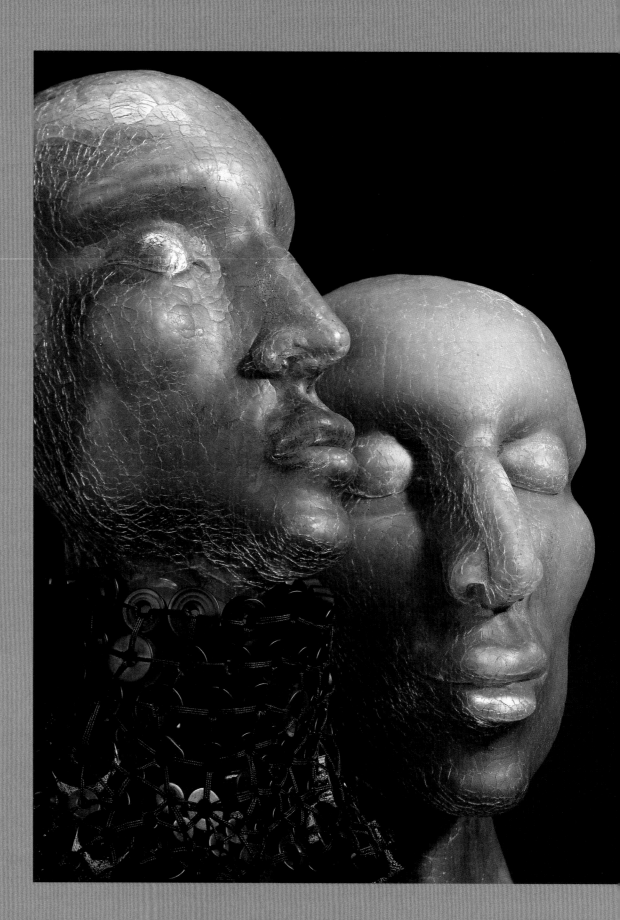

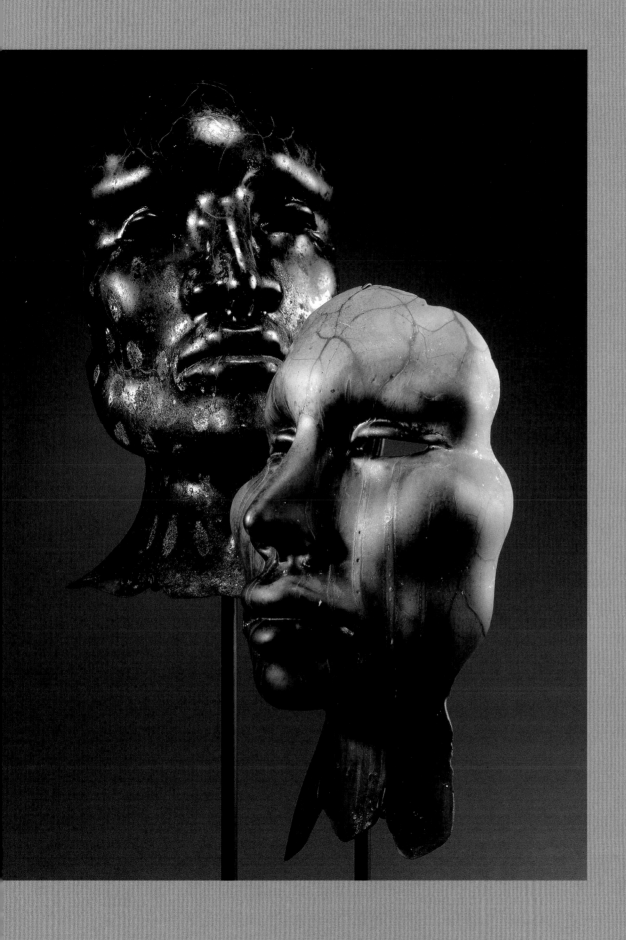

61

Nuba Man, Karok Man

2001

23 × 10 × 8 in. (Nuba Man)

19 × 7 × 7 in. (Karok Man)

HAGR.03

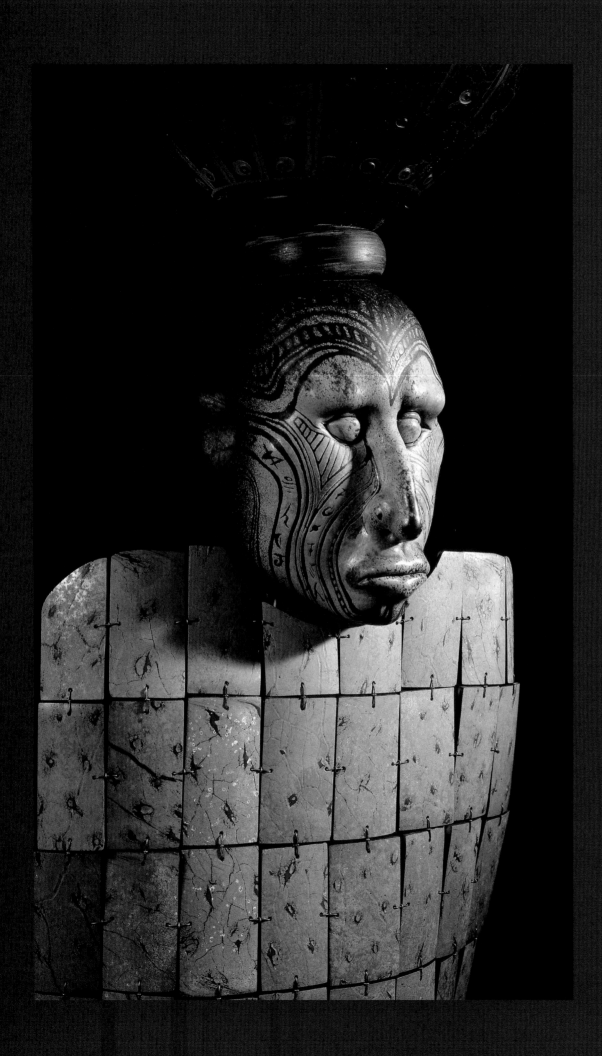

62

Zhejiang Man

2001

79 × 18 × 15 in.

HI301.01.03

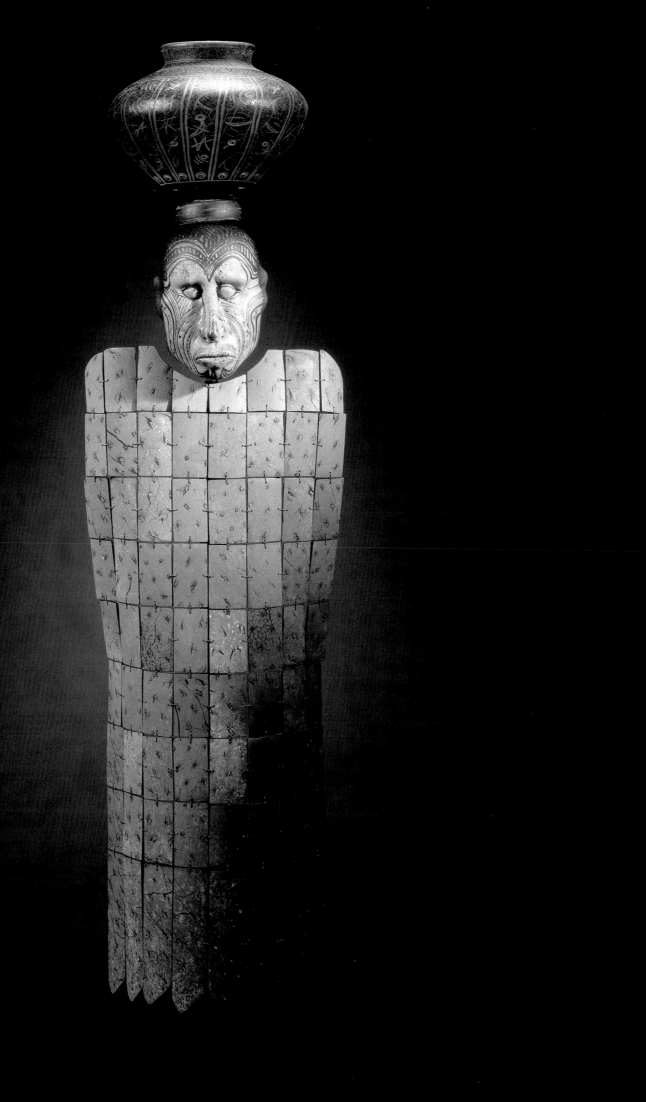

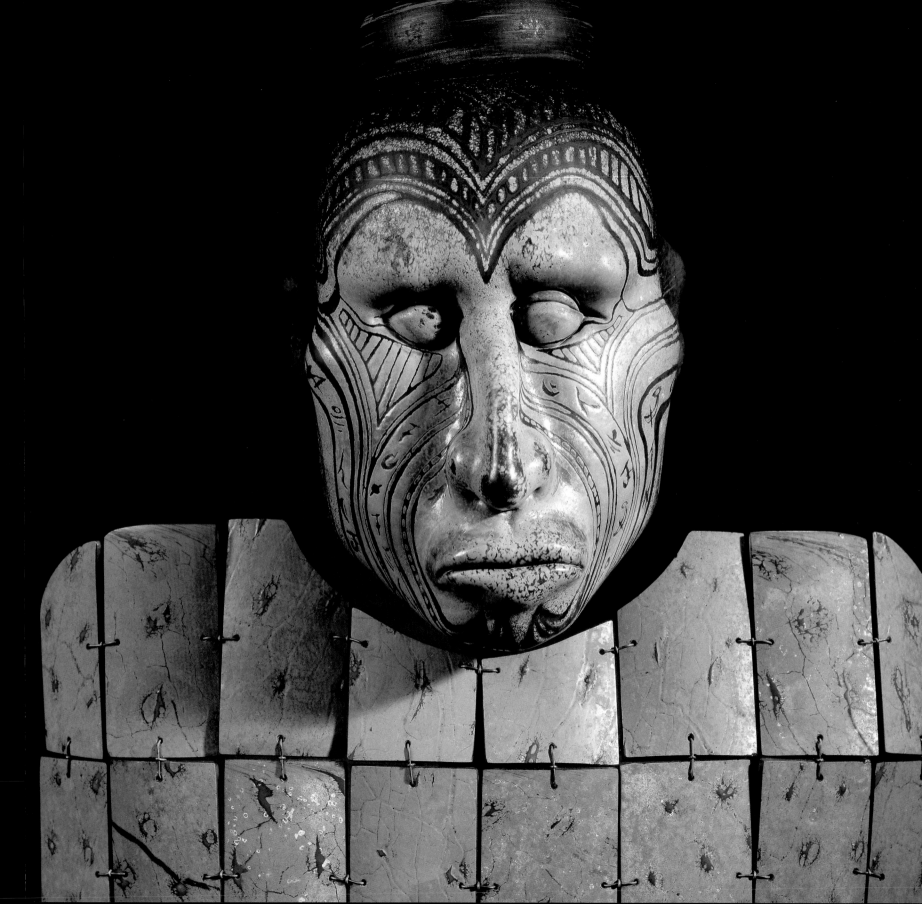

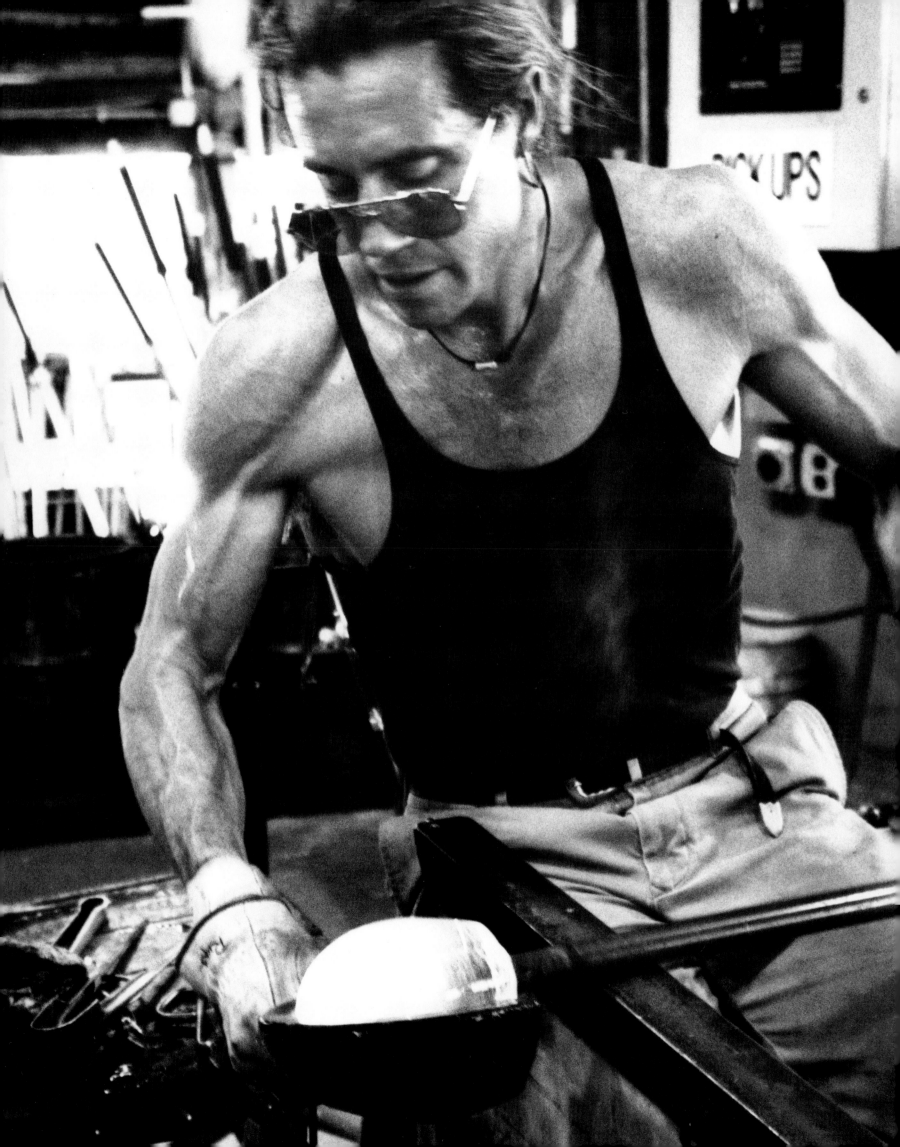

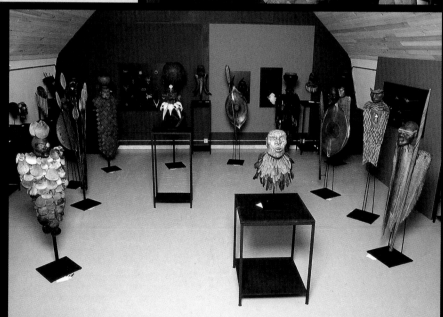

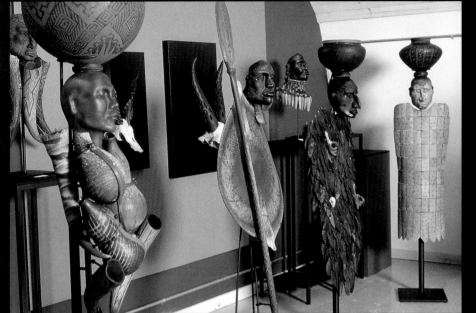
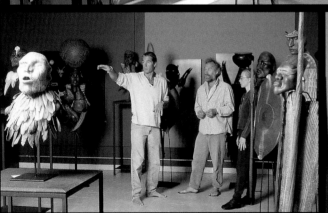
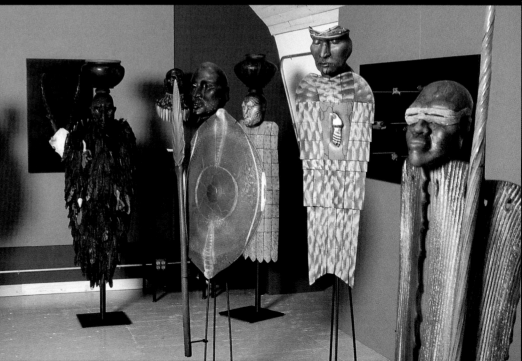

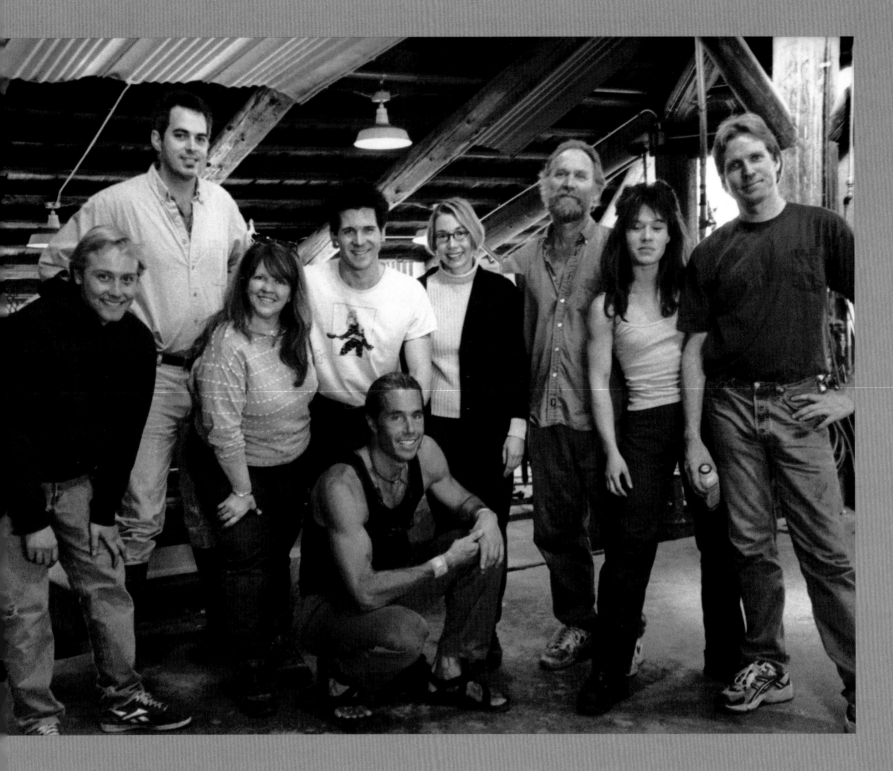

Center front: William Morris. Standing, left to right: Rahman Anderson, Rik Allen, Karen Willenbrink-Johnsen, Ross Richmond, Holle Simmons, Jon Ormbrek, Kimberley Haugh, and Randy Walker. Also part of the team but not pictured are Shelley Muzylowski Allen, Jeremy Bosworth, Graham Graham, Timothy Ringsmuth, and Veruska Vagen.

Born July 25, 1957, in Carmel, California

Education

California State University, Chico
Central Washington University, Ellensburg

Recent Awards

2001 Visionaries Award, American Craft Museum,
New York
1997 Distinguished Alumni Award, California State
University, Chico
Featured Artist, Chateau Ste. Michelle Winery
Artists Series
Outstanding Achievement in Glass, UrbanGlass
Third Annual Award Dinner, New York
1994 National Endowment for the Arts, Individual
Artist Grant

Solo Exhibitions

2001 *Myth, Object and the Animal*, Fort Wayne Museum of
Art, Ind.; The Philbrook Museum of Art, Tulsa,
Okla.; Akron Art Museum, Ohio; Mint Museum
of Craft + Design, Charlotte, N.C.
Heller Gallery, New York
Riley Hawk Gallery, Cleveland

2000 *Animals and Relics*, Guild.com online exhibition in
conjunction with the Heller Gallery, New York
Gerald Peters Gallery, Santa Fe, N.Mex.
Heller Gallery, New York
Maurine Littleton Gallery, Washington, D.C.
Susan Duval Gallery, Aspen, Colo.
University Art Gallery, California Polytechnic
State University at San Luis Obispo

1999 *Myth, Object and the Animal*, The Chrysler Museum
of Art, Norfolk, Va.; Yellowstone Art Museum,
Billings, Mont.; Fort Wayne Museum of Art, Ind.
Habatat Gallery, Boca Raton, Fla.
Imago Galleries, Palm Desert, Calif.
Lisa Sette Gallery, Scottsdale, Ariz.
Marx-Saunders Gallery, Chicago
Port Angeles Fine Arts Center, Wash.

1998 Foster/White Gallery, Seattle
Friesen Gallery, Sun Valley, Idaho
R. Duane Reed Gallery, St. Louis
Riley Hawk Gallery, Columbus, Ohio
Susan Duval Gallery, Aspen, Colo.

1997 Albers Fine Art Gallery, Memphis
Bush Barn Art Center, Salem, Ore.
Fay Gold Gallery, Atlanta
Habatat Gallery, Boca Raton, Fla.
Lisa Sette Gallery, Scottsdale, Ariz.
Maurine Littleton Gallery, Washington, D.C.
Museum of Northwest Art, La Conner, Wash.
Pittsburgh Cultural Trust, Wood Street Gallery,
Pittsburgh
Riley Hawk Galleries, Cleveland and Columbus,
Ohio

1996 Friesen Gallery, Sun Valley, Idaho
Habatat Gallery, Pontiac, Mich.
Heller Gallery, New York
Imago Gallery, Palm Desert, Calif.
Kennesaw State College Gallery of Art, Marietta,
Ga.; Meadows Museum of Art of Centenary
College, Shreveport, La.
Marx-Saunders Gallery, Chicago
Susan Duval Gallery, Aspen, Colo.

1995 Everett Center for the Arts, Wash.
Foster/White Gallery, Kirkland, Wash.
Foster/White Gallery, Seattle
Habatat Gallery, Boca Raton, Fla.
Lisa Sette Gallery, Scottsdale, Ariz.
Maurine Littleton Gallery, Washington, D.C.
Riley Hawk Galleries, Cleveland and Columbus,
Ohio

1994 Dorothy Weiss Gallery, San Francisco
Friesen Gallery, Sun Valley, Idaho
Habatat Gallery, Farmington Hills, Mich.

1993 Betsy Rosenfield Gallery, Chicago
Habatat Gallery, Boca Raton, Fla.
Heller Gallery, New York
Laura Russo Gallery, Portland, Ore.
Maurine Littleton Gallery, Washington, D.C.
Riley Hawk Galleries, Cleveland and Columbus,
Ohio
Susan Duval Gallery, Aspen, Colo.

1992 Betsy Rosenfield Gallery, Navy Pier, Chicago
Foster/White Gallery, Seattle
Friesen Gallery, Sun Valley, Idaho
Lisa Sette Gallery, Scottsdale, Ariz.

1991 Betsy Rosenfield Gallery, Navy Pier, Chicago
Charles Grant Gallery, Ketchum, Idaho
Helander Gallery, Palm Beach, Fla.
Maurine Littleton Gallery, Washington, D.C.
Riley Hawk Galleries, Cleveland and Columbus,
Ohio

1990 Betsy Rosenfield Gallery, Chicago
Foster/White Gallery, Seattle
Maurine Littleton Gallery, Washington, D.C.
Renwick Gallery, National Museum of American Art,
Smithsonian Institution, Washington, D.C.

1989 Brendan Walter Gallery, Santa Monica, Calif.
Riley Hawk Galleries, Cleveland and Columbus,
Ohio

1988 Brendan Walter Gallery, Santa Monica, Calif.
Foster/White Gallery, Seattle
Glass Art Gallery of Toronto
Maurine Littleton Gallery, Washington, D.C.
Skagit Valley College, Mt. Vernon, Wash.
University of Michigan, Dearborn, Mich.

1987 Heller Gallery, New York
Holsten Gallery, Palm Beach, Fla.

1986 Betsy Rosenfield Gallery, Chicago
Foster/White Gallery, Seattle
Glass Art Gallery of Toronto

Habatat Gallery, Miami
Holsten Gallery, Stockbridge, Mass.
Kurland/Summers Gallery, Los Angeles
Maurine Littleton Gallery, Washington, D.C.
Works Gallery, Philadelphia

1985 Betsy Rosenfield Gallery, Chicago
Holsten Gallery, Stockbridge, Mass.
Museum of Fine Arts, Missoula, Mont.

1984 Foster/White Gallery, Seattle
Heller Gallery, New York
Kurland/Summers Gallery, Los Angeles
Running Ridge Gallery, Santa Fe, N.Mex.

1983 Betsy Rosenfield Gallery, Chicago
Glass Art Gallery of Toronto
Green Gallery, Carmel, Calif.
Matrix Gallery, Austin, Tex.

1982 Foster/White Gallery, Seattle
Green Gallery, Carmel, Calif.
Heller Gallery, New York
Kurland/Summers Gallery, Los Angeles

1981 Galerie der Kunsthandwerker, Hamburg,
West Germany
Galerie Fischer, Augsburg, West Germany
Glass Art Gallery of Toronto
Green Gallery, Carmel, Calif.
Heller Gallery, New York
Running Ridge Gallery, Santa Fe, N.Mex.

1980 Foster/White Gallery, Seattle

Group Exhibitions

2001 *Contemporary Craft in the Museum of Fine Arts, Houston*,
Museum of Fine Arts, Houston
Lino Tagliapietra and His Friends, Fuller Museum of Art,
Brockton, Mass.

2000 *Creativity and Collaboration: Pilchuck Glass School's
30 Years*, Bumbershoot Glass Exhibition,
Seattle Center
18th Annual International Glass Invitational, Habatat
Gallery, Boca Raton, Fla.
*Fired with Enthusiasm: A Selection of Contemporary Studio
Glass*, The Columbus Museum, Ga.
Glass America, Heller Gallery, New York
Glass: Artist, Influence, and Evolution, Habatat
Gallery, Pontiac, Mich.
A Glass Invitational, Margo Jacobson Gallery,
Portland, Ore.
Millennium Glass: An International Survey of Studio Glass,
Kentucky Art and Craft Gallery, Louisville, Ky.
Pathways, TransAmerica Pyramid Lobby,
San Francisco
Shattering Precepts: The Fine Art of Contemporary Glass,
Dennos Museum Center, Traverse City, Mich.
*SOFA (The International Exposition of Sculpture Objects
& Functional Art)*, Chicago; represented by Riley
Hawk Galleries, Ohio
Sun Valley Winter Season Show, Friesen Gallery,
Sun Valley, Idaho

1999 *Art Glass of This Century*, Museum of Fine Arts–
St. Petersburg, Fla.

The Art of Craft: Works from the Saxe Collection, Fine Arts
Museums of San Francisco

The Art of Glass, Safety-Kleen Gallery One, Elgin
Community College; coordinated by Marx-
Saunders Gallery, Chicago

Glass! Glorious Glass!, Renwick Gallery, National
Museum of American Art, Smithsonian Institution,
Washington, D.C.

Holding Light, Laguna Gloria Gallery, Austin Museum
of Art, Tex.

International Glass Masters Invitational, Salem Art
Association, Ore.

Masters of Contemporary Glass, Jenkins Johnson Gallery,
San Francisco

17th Annual International Glass Invitational, Habatat
Gallery, Boca Raton, Fla.

Signature Exhibition, Albers Gallery, Memphis, Tenn.

SOFA, Chicago; represented by Riley Hawk
Galleries, Ohio

SOFA, New York; represented by Habatat
Galleries, Fla.

Studio Glass, From the Gerard L. Cafesjian Collection,
Scottsdale Museum of Contemporary Art,
Scottsdale, Ariz.

27th Annual International Glass Invitational, Habatat
Gallery, Pontiac, Mich.

1998 *American Glass, Masters of the Art*, circulated by
Smithsonian Institution Traveling Exhibition
Service (SITES)

Animal as Muse, Norton Museum of Art, West Palm
Beach, Fla.

Clearly Magic, Port Angeles Fine Arts Center, Wash.

A Collaboration, co-organized by the John Berggruen
Gallery (San Francisco) and Friesen Fine Art,
Sun Valley, Idaho

Fever, Lisa Sette Gallery, Scottsdale, Ariz.

Glass America, Heller Gallery, New York

International Movements in Glass, Auckland Museum,
New Zealand

*A Passion for Glass: The Aviva and Jack A. Robinson
Studio Glass Collection*, The Detroit Institute
of Arts

Pilchuck Show, Port of Seattle

16th Annual International Glass Invitational, Habatat
Gallery, Boca Raton, Fla.

SOFA, Chicago; represented by Riley Hawk
Galleries, Ohio

SOFA, New York; represented by Habatat
Galleries, Fla.

26th Annual International Glass Invitational, Habatat
Gallery, Pontiac, Mich.

1997 *Al Fin del Milenio*, Museo del Vidrio, Monterrey,
Mexico

Artfair Miami; represented by Fay Gold Gallery,
Atlanta

Blowing Hot, Cutting Cold, Lakeview Museum of
Arts and Sciences, Peoria, Ill.

Celebrating American Craft, The Danish Museum of
Decorative Art, Copenhagen

15th Annual International Glass Invitational, Habatat
Gallery, Boca Raton, Fla.

Four Acts in Glass, American Craft Museum,
New York

*Glass Today: American Studio Glass from Cleveland
Collections*, Cleveland Museum of Art

Glass Today by American Studio Artists, Museum of
Fine Arts, Boston

Heir Apparent, Bellevue Art Museum, Wash.

John Berggruen Gallery Second Annual Collaboration,
with Friesen Gallery, Sun Valley, Idaho

Mano Volante, Etherton Gallery, Tucson, Ariz.

Pilchuck Show, Port of Seattle

Recent Glass Sculpture: A Union of Ideas,
Milwaukee Art Museum

SOFA, Chicago; represented by Riley Hawk
Galleries, Ohio

SOFA, New York; represented by Habatat
Galleries, Boca Raton, Fla.

1996 *Almost Alchemy*, TransAmerica Corp., San Francisco

Artfair Seattle; represented by Habatat Gallery, Mich.

The Brillson Foundation, American Glass of the 1980s,
Charles A. Wustum Museum of Fine Arts,
Racine, Wis.

A Collaboration, John Berggruen Gallery, San Francisco
and Friesen Gallery, Sun Valley, Idaho

Craft at Gump's: The Helen Heninger Years, San Francisco
Craft and Folk Art Museum

Eight Concepts in Glass, Habatat Gallery, Miami, Fla.

14th Annual International Glass Invitational, Habatat
Gallery, Boca Raton, Fla.

Friesen Gallery Tenth Anniversary, Sun Valley, Idaho

Glass, The Fifth Invitational Exhibition, Hodges
Taylor Gallery, Charlotte, N.C.

Glass America, Heller Gallery, New York

*Glass Enchantment: An Exhibition of Contemporary Glass
Art in America*, sponsored by Rochester Children's
Theatre, Rochester, N.Y.

Holding the Past: Historicism in Northwest Glass Sculpture,
Seattle Art Museum

Hsinchu International Festival of Glass Art, Hsinchu
Cultural Center, Taiwan

Interior Images, Walter Anderson Museum of Art,
Ocean Springs, Miss.

Massiccio: A Tribute to Loredano Rosin, Philabaum Art
Glass, Tucson, Ariz.

19th Annual Pilchuck Exhibition, William Traver Gallery,
Seattle

Pilchuck Show, Port of Seattle

*A Powerful Presence: Pilchuck Glass School's
25 Years*, Bumbershoot Arts Festival, Seattle

SOFA, Chicago; represented by Riley Hawk
Galleries, Ohio

SOFA, Miami; represented by Habatat Galleries,
Boca Raton, Fla.

Studio Glass, The Metropolitan Museum of Art,
New York

Studio Glassmasters, Grand Central Gallery, Tampa,
Fla.

Triptique, Galerie Internationale du Verre, Biot, France

1995 *American Art Glass*, Halls Gallery, Hallmark Head-
quarters, Kansas City, Mo.

Breaking Barriers: Recent American Craft, Portland Art
Museum, Ore.

Contemporary Northwest Art, Coos Art Museum,
Coos Bay, Ore.

A Cosmic Fable, Molbak's display, Northwest Flower
and Garden Show, Seattle

Glass America, Heller Gallery, New York

Glass as Art, Blue Spiral 1, Asheville, N.C.

Glass Now 17, World Studio Glass Exhibition,
Hokkaido Museum of Art, Tokyo

International Survey of Contemporary Art Glass, Wood
Street Gallery and Concept Art Gallery,
Pittsburgh

Light Interpretations, The Jewish Museum
San Francisco

Northwest Glass: Part I, Museum of Northwest Art,
La Conner, Wash.

Past/Present/Past, Artifacts for Our Times, Hand
Workshop, Richmond, Va.

Pilchuck Show, Port of Seattle

Sculpture, Galerie Internationale du Verre, Biot,
France

SOFA, Chicago; represented by Riley Hawk
Galleries, Ohio

SOFA, Miami; represented by Habatat Galleries, Fla.

Taipei International Glass Exhibition, Taiwan

13th Annual International Glass Invitational, Habatat
Gallery, Boca Raton, Fla.

The Three Artists, The Azabu Museum of Arts & Crafts;
sponsored by Yamaha Corporation, Tokyo

A Touch of Glass, Explorers Hall, National
Geographic Society, Washington, D.C.

The 23rd Annual International Glass Invitational, Habatat
Gallery, Pontiac, Mich.

1994 *Birds and Beasts*, Seattle Art Museum

Breaking Barriers: Recent American Craft, American
Craft Museum, New York

Collective Brilliance: Contemporary Glass, Albany
Museum of Art, Ga.

*Form and Light: Contemporary Glass from the Permanent
Collection*, American Craft Museum, New York

Glass Invitational, Dorothy Weiss Gallery,
San Francisco

Glass Masters, Helander Gallery, Palm Beach, Fla.

Masterworks of Contemporary Glass, Habatat
Gallery, Farmington Hills, Mich.

1994 Northwest Glass Invitational, Lyons Matrix Gallery,
Austin, Tex.

Pilchuck Glass at the Monte Cristo, Everett Center for
the Arts, Wash.

Pilchuck Show, Port of Seattle

Ten Years, Ten Artists, Albers Fine Art Gallery,
Memphis, Tenn.

Trasparenze d'Arte a Venezia, Serge Gallerie Biot, Venice

The 22nd Annual International Invitational, Habatat
Gallery, Farmington Hills, Mich.

Verriales '94, Galerie Internationale du Verre, Biot,
France

World Glass Now, '94, Hokkaido Museum of Modern
Art, Sapporo, Japan (traveled in Japan)

1993 *Contemporary Glass*, Albers Fine Art Gallery,
 Memphis
 Contemporary Glass from South Florida Collections,
 Museum of Art, Fort Lauderdale, Fla.
 Formed by Fire, Carnegie Museum of Art,
 Pittsburgh
 Glass America, Heller Gallery, New York
 Glass Installations, American Craft Museum,
 New York
 Maximizing the Minimum, Museum of American Glass
 at Wheaton Village, Millville, N.J.
 Pilchuck Show, Port of Seattle
 SOFA, Chicago; represented by Betsy Rosenfield
 Gallery
 Storytelling in Northwest Craft, Bumbershoot Arts
 Festival and Washington State Convention and
 Trade Center, Seattle
 The 21st Annual International Invitational, Habatat
 Gallery, Farmington Hills, Mich.
 Verriales '93, Galerie Internationale du Verre, Biot,
 France
 Where Image Meets Form, Habatat Gallery,
 Boca Raton, Fla.
 Foster/White Gallery, Kirkland, Wash.
 Friesen Gallery, Sun Valley, Idaho

1992 *Artists from Pilchuck Glass School*, SeaTac International
 Airport, Seattle
 Brock, Mantano and Morris, Niki Glass Gallery, Tokyo
 Clearly Art: The Pilchuck Legacy, Whatcom Museum
 of History and Art, Bellingham, Wash. (traveled
 through 1996)
 Contemporary Glass Art, Brendan Walter Gallery, Santa
 Monica, Calif.
 *Contemporary Glass Sculpture: Innovative Form and
 Expression*, New Jersey Center for Visual Arts,
 Summit, N.J.
 *First International Exhibition of Contemporary Glass in Latin
 America*, Rufino Tamayo Museum, Mexico City,
 and the Marco, Monterrey, Mexico
 International Exhibition of Glass Kanazawa '92, Kanazawa,
 Japan
 Obscure Objects of Desire, Helander Gallery,
 New York
 Remains, Grove Gallery, University of California,
 San Diego
 Spirit of the West, West One Mobile Art Museum
 (traveled in Northwest region)
 Verriales '92, Galerie Internationale du Verre, Biot,
 France

1991 *Art Junction*, Galerie Internationale du Verre, Nice,
 France
 Artists at Work, Cheney Cowles Museum, Spokane,
 Wash., and Boise Art Museum, Idaho
 Artists from Pilchuck Glass School, SeaTac International
 Airport, Seattle
 Contemporary Glass: Seven Northwest Artists, Laura Russo
 Gallery, Portland, Ore.
 Focus Northwest, Old Pueblo Museum, Tucson, Ariz.
 Frozen Moments; Glass Artists of the Northwest, Bellevue
 Art Museum, Wash.
 Glass America '91, Heller Gallery, New York

Habatat International, Habatat Galleries, Farmington
 Hills, Mich., and Boca Raton, Fla.
Masters of Contemporary Glass, Philharmonic Center
 for the Arts Galleries, Naples, Fla.
Northwest Glass Masters, LewAllen Butler Fine Art,
 Santa Fe, N.Mex.
Out of the Fire, William Traver Gallery, Seattle
*Studio Glass: Selections from the David Jacob Chodorkoff
 Collection*, The Detroit Institute of Arts
Verriales '91, Galerie Internationale du Verre, Biot,
 France

1990 *Art Junction*, Galerie Internationale du Verre,
 Nice, France
 Verriales '90, Galerie Internationale du Verre,
 Nice, France
 Betsy Rosenfield Gallery, Chicago
 Nielsen Gallery, Stockholm Art Fair, Sweden

1989 *American Masters*, The Glass Art Gallery, Toronto
 Artful Objects; Recent American Craft, Fort Wayne
 Museum of Art, Ind.
 Documents Northwest: Figures of Translucence, Seattle Art
 Museum (three-person)
 Fantastic Crafts, The Albertson-Peterson Gallery,
 Orlando, Fla.
 New Art Forms Exposition at Navy Pier, Chicago;
 represented by Brendan Walter Gallery
 17th Annual Glass Invitational, Habatat Gallery, Detroit

1988 *A Generation in Glass Sculpture*, Florida State
 University, Tallahassee
 1988 Palm Beach Glass International, Holsten
 Gallery, Palm Beach, Fla.
 Pilchuck Annual International Glass Show, William Traver
 Gallery, Seattle
 Pilchuck School: The Great Northwest Glass Experiment,
 Bellevue Art Museum, Wash.
 16th Annual National Glass Invitational, Habatat Gallery,
 Lathrop Village, Mich.
 Splendid Forms 88, Bellas Artes, Santa Fe, N.Mex.
 Wita Gardner Gallery, San Diego

1987 *Annual Pilchuck International Glass Show*, Traver-Sutton
 Gallery, Seattle
 Contemporary Glass, Abilene Fine Arts Museum, Tex.
 Fifteenth Annual National Glass Invitational, Habatat
 Gallery, Lathrop Village, Mich.
 50th Annual Glass Exhibition, Contemporary Crafts
 Gallery, Portland, Ore.
 New Expressions with Glass, Hunter Museum of
 American Art, Chattanooga, Tenn.
 Thirty Years of New Glass, 1957–1987, The Corning
 Museum of Glass, New York; The Toledo Museum
 of Art, Ohio

1986 *Architecture of the Vessel*, Bevier Gallery, Rochester, N.Y.
 California Glass Today, Pacific Design Center,
 Los Angeles
 *Contemporary American and European Glass: The Saxe
 Collection*, Oakland Museum of California
 Craft Today: Poetry of the Physical, organized by
 American Craft Museum, New York. Traveled
 to Denver Art Museum; Laguna Art Museum,
 Laguna Beach, Calif.; J. B. Speed Art Museum,

Louisville, Ky.; Virginia Museum of Fine Arts,
 Richmond; San Diego Museum of Art
Fourteenth Annual National Glass Invitational, Habatat
 Gallery, Lathrop Village, Mich.
Glass, Contemporary Crafts Gallery, Portland, Ore.
Palm Beach Glass Invitational, Holsten Gallery, Palm
 Beach, Fla.
Pilchuck: The Creative Fire, Washington State Capital
 Museum, Olympia

1985 *Earth, Fire, and Light*, Kornbluth Gallery, Fairlawn, N.J.
 Glass, The Elements Gallery, Greenwich, Conn.
 Glass America '85, Heller Gallery, New York
 Habatat National, Habatat Gallery, Lathrop Village,
 Mich.
 *1985 Governor's Invitational Art Exhibition: Washington's
 Contemporary Glass Artists*, Washington State
 Capital Museum, Olympia
 Pilchuck Show, Traver-Sutton Gallery, Seattle
 Thirteenth Annual National Glass Invitational, Habatat
 Gallery, Lathrop Village, Mich.
 World Glass Now '85, Hokkaido Museum of Modern
 Art, Sapporo, Japan

1984 *Architectural Influences*, Three Glass Sculptors (Karl
 Schantz, William Morris, David Schwartz),
 Habatat Gallery, Fla.
 Crafts '84, Bellevue Art Museum, Wash.
 Evolution Resolution, Habatat Gallery, Lathrop
 Village, Mich.
 Glass: State of the Art 1983–1984, Concepts Gallery,
 Pittsburgh
 Glass National–International, Owens, Illinois,
 Art Center

1983 *American Glass Masters 1983*, Human Arts, Dallas
 Chibuly and Morris at The Works, The Works
 Gallery, Philadelphia
 Eleventh Annual National Glass, Habatat Gallery,
 Lathrop Village, Mich.
 Glass Now '83, Nippon Gakki, Japan
 Pilchuck Show, Traver-Sutton Gallery, Seattle
 Selected Works in Glass, Tempe Arts Center, Ariz.
 Sommerausstellung 1983, Galerie Hermann, Bayer Wald,
 West Germany

1982 *Americans in Glass; Evolution and Revolution*, The Morris
 Museum, Morristown, N.J.
 Americans Working in Glass, Butler Institute of
 American Art, Youngstown, Ohio
 Glass Now '82, Nippon Gakki, Japan
 Group Show, Bodega Court Gallery, Tacoma, Wash.
 Pilchuck Show, Traver-Sutton Gallery, Seattle
 Squibb Collection, Squibb Gallery, Princeton, N.J.
 The 3rd Concepts in Glass Exhibition, Habatat
 Gallery, Lathrop Village, Mich.

1981 *Americans in Glass*, Westlake Gallery, White Plains,
 N.Y.
 Dale Chibuly, William Morris Show, Hokin Gallery,
 Palm Beach, Fla.
 New Forms in Glass Invitational, Habatat Gallery,
 Lathrop Village, Mich.
 Ninth Annual National Invitational, Habatat Gallery,
 Lathrop Village, Mich.
 Pilchuck Glass, Traver-Sutton Gallery, Seattle

Teaching Experience and Lectures

1979– Artist in Residence, Pilchuck Glass School,
present Stanwood, Wash.

2000 Artist's Lecture, Portland Art Museum, Ore.

1999 Artist's Lecture, California Polytechnic State
 University at San Luis Obispo
 Artist's Lecture, The Chrysler Museum of Art,
 Norfolk, Va.
 Artist's Lecture, Scottsdale Museum of
 Contemporary Art, Ariz.
 Artist's Lecture, Yellowstone Art Museum,
 Billings, Mont.

1998 Artist's Lecture, *Artifacts of Common Ceremony*,
 Museum of Northwest Art, La Conner, Wash.
 Artist's Lecture, The Saint Louis Art Museum
 Guest Artist, *Pacific Light Conference*, Auckland,
 New Zealand

1997 Featured Speaker, G.A.S. Conference, Tucson, Ariz.
 Featured Speaker, National American Glass Club,
 The Chrysler Museum of Art, Norfolk, Va.
 Featured Speaker, *Passion Afire*, sponsored by the
 Pilchuck Glass School, City Centre, and
 Metropolitan Home magazine, Seattle

1996 Featured Speaker, *SOFA*, Miami

1995 Artist's Lecture, Memphis Brooks Museum of Art,
 Tenn.

1994 Featured Speaker, *The Art of Glass* seminar,
 The Bon Marché, Seattle
 Niijima Art Glass Center, Tokyo

1993 Demonstrating Artist, Glassweekend '93, Creative
 Glass Center of America, Wheaton Village,
 Millville, N.J.

1992 California College of Arts and Crafts, Oakland
 Niijima Art Glass Center, Tokyo

1991 University of Hawaii at Manoa

1988 Penland School of Crafts, Penland, N.C.

1987 Appalachian Center for Crafts, Smithville, Tenn.

1986 Canadian Glass Art Society Symposium, Toronto
 Creative Glass Center of America, Wheaton Village,
 Millville, N.J.
 New Zealand Society of Artists in Glass, Auckland
 Rochester Institute of Technology, New York

1985 Art Glass Academy, Vienna
 Haystack Mountain School of Crafts, Deer Isle,
 Maine
 New York Experimental Glass Workshop, New York

1984 Carnegie Mellon, Pittsburgh
 Rhode Island School of Design, Providence

1983 Fire Island, Austin, Tex.
 Haystack Mountain School of Crafts, Deer Isle,
 Maine
 New York Experimental Glass Workshop, New York
 Summervail Workshops, Vail, Colo.

1982 Appalachian Center for Crafts, Smithville, Tenn.
 Illinois State University, Normal
 Renaissance Glass, Austin, Tex.

1981 Harbor Front Studios, Toronto
 Haystack Mountain School of Crafts, Deer Isle,
 Maine
 New York Experimental Glass Workshop, New York

1980 Orrefors Glass Studio, Sweden
 Rhode Island School of Design, Providence

1979 Amsterdam College of Art
 Lobmyer Studio, Vienna
 Royal College of Art, London

1978 Alberta College of Art, Calgary

Selected Museums and Public Collections

American Craft Museum, New York

Auckland Museum, New Zealand

Birmingham Museum of Art, Ala.

Carnegie Museum of Art, Pittsburgh

Charles A. Wustum Museum of Fine Arts, Racine, Wis.

The Chrysler Museum of Art, Norfolk, Va.

Cincinnati Art Museum

The Corning Museum of Glass, Corning, N.Y.

Daiichi Museum, Nagoya, Japan

Davis Wright Tremaine, Seattle

Dayton Art Institute, Ohio

Delta Airlines, Portland, Ore.

The Detroit Institute of Arts

Edmonds Arts Commission, Wash.

First Union Bank, Charlotte, N.C.

Florida National Collection, Florida National Bank,
 Jacksonville

Hokkaido Museum of Modern Art, Sapporo, Japan

Hunter Museum of American Art, Chattanooga, Tenn.

IBM Corporation, Tulsa, Okla.

J. B. Speed Art Museum, Louisville, Ky.

The Jewish Museum San Francisco

Joslyn Art Museum, Omaha, Neb.

Los Angeles County Museum of Art

McDonald's Corporation, Oakbrook, Ill., and
 Bellevue, Wash.

Memorial Art Gallery of the University of Rochester, N.Y.

The Metropolitan Museum of Art, New York

Microsoft Corporation, Redmond, Wash.

Milwaukee Art Museum

Mobile Museum of Art, Ala.

Musée des arts décoratifs, Paris

Museum für Kunst und Gewerbe Hamburg, Germany

Museum of American Glass at Wheaton Village,
 Millville, N.J.

Museum of Art, Rhode Island School of Design,
 Providence

The Museum of Fine Arts, Houston

Museum of Fine Arts, Missoula, Mont.

Niijima Contemporary Glass Art Museum, Japan

Norton Museum of Art, West Palm Beach, Fla.

Pilchuck Collection, Stanwood, Wash.

The Pilchuck Glass Collection at City Centre and
 US Bank Center, Seattle

Port of Seattle

Portland Art Museum, Ore.

Rockefeller Center, New York

Royal College of Art, London

Safeco Insurance Company, Seattle

Seattle Art Museum

Seattle-First National Bank Collection

Seattle Repertory Theatre

Seattle-Tacoma International Airport, Permanent
 Installation

Security Pacific Collection, Security Pacific Bank, Seattle

Sheldon Memorial Art Gallery and Sculpture Garden/
 University of Nebraska, Lincoln

Sheraton Seattle Hotel and Towers Collection, Seattle

Shimonoseki City Art Museum, Japan

Renwick Gallery, National Museum of American Art,
 Smithsonian Institution, Washington, D.C.

State Foundation of Culture in the Arts, Honolulu

State of Oregon Public Services Building, Portland

The Toledo Museum of Art, Ohio

Toyota USA, Corporate Retreat, Hilo, Hawaii

United Airlines, San Francisco

University of Michigan, Dearborn

UPS Corporate Collection, Louisville, Ky.

U.S. News and World Report, Washington, D.C.

The Valley National Bank of Arizona, Tucson

Victoria and Albert Museum, London

Virginia Museum of Fine Arts, Richmond

Westin Hotel, San Francisco

Yellowstone Art Museum, Billings, Mont.

Books and Exhibition Catalogue

Adamson, Glen, ed. *Object Lessons*. Madison, Wis.: The Guild, 2001.

Carruth, Hayden. *Collected Shorter Poems*. Port Townsend, Wash.: Copper Canyon Press, 2001 (cover illus.).

Del Mano Gallery. *Glass Showcase*. Madison, Wis.: The Guild, 2001.

Klein, Dan. *Artists in Glass: Late Twentieth Century Masters in Glass*. London: Mitchell Beazley Miller's Octopus Publishing Group, 2001.

Cain, Michael L. *Discover Biology*. Sunderlund, Mass.: Sinauer Associates, 2000.

Yelle, Richard Wilfred. *Contemporary Art from UrbanGlass*. Atglen, Penn.: Schiffer Publishing Limited, 2000.

Yood, James, and Tina Oldknow. *William Morris: Animal/Artifact*. New York, London, Paris: Abbeville Press, 2000.

Burgard, Timothy Anglin. *The Art of Craft: Contemporary Works from the Saxe Collection*. San Francisco: Fine Arts Museums of San Francisco; Boston, New York, London: Bulfinch Press/Little, Brown and Company, 1999.

Franz, Susanne K. *Eleven Glass Sculptures*. Corning, N.Y.: Corning Museum of Glass, 1999.

Myth, Object and the Animal. Exh. cat. Norfolk, Va.: The Chrysler Museum of Art, 1999.

Yood, James. *Myth, Object and the Animal: William Morris Glass Installations*. Stanwood, Wash.: Morris Studio, in conjunction with the Chrysler Museum of Art, the Yellowstone Art Museum and the Fort Wayne Museum of Art, 1999.

Ellis, William S. *Glass, from the First Mirror to Fiber Optics: The Story of the Substance that Changed the World*. New York: Bard, an imprint of Avon Books, 1998.

William Morris. Exh. brochure. St. Louis, Mo.: R. Duane Reed Gallery, 1998.

William Morris: Crows and Ravens. Exh. brochure. Essay by Tina Oldknow. Columbus, Ohio: Riley Hawk Galleries, 1998.

Four Acts in Glass. Exh. cat. New York: American Craft Museum, 1997.

William Morris: Rhyton. Exh. brochure. Essay by Tina Oldknow. Columbus and Cleveland, Ohio: Riley Hawk Galleries, 1997.

Ancient Memories. Exh. cat. Essay by Gary Blonston. Marietta, Ga.: Kennesaw State College Gallery of Art; Shreveport, La.: Meadows Museum of Art of Centenary College, 1996.

The Animal. Exh. brochure. Essay by James Yood. Chicago: Marx-Saunders Gallery, 1996.

Blonston, Gary. *William Morris: Artifacts/Glass*. New York: Abbeville Press, 1996.

Grieder, Terence. *Artist and Audience*. 2d ed. Madison, Wis.: Brown and Benchmark, 1996.

Interior Images. Exh. cat. Ocean Springs, Miss.: Walter Anderson Museum of Art, 1996.

William Morris. Exh. brochure. Aspen, Colo.: Susan Duval Gallery, 1996.

Allan, Lois. *Contemporary Art in the Northwest*. Roseville East, Australia: Craftsman House, 1995.

Collective Brilliance: Contemporary Glass. Exh. cat. Albany, Ga.: Albany Museum of Art, 1994.

Galaxie. Exh. cat. Biot, France: Serge Gallerie Biot, 1994.

William Morris: Artifact Tooth Series. Exh. brochure. Seattle: Seattle Art Museum, 1994.

World Glass Now '94. Exh. cat. Sapporo, Japan: Hokkaido Museum of Modern Art, 1994.

Autrement. Exh. cat. Biot, France: Serge Gallerie Biot, 1993.

Contemporary Glass from South Florida Collections. Exh. cat. Fort Lauderdale, Fla.: Museum of Art, 1993.

Glass Installations. Exh. cat. New York: American Craft Museum, 1993.

Maximizing the Minimum: Small Glass Sculpture. Exh. cat. Millville, N.J.: Museum of American Glass at Wheaton Village, 1993.

All about Glass. Japan: Shinshusha Co., Ltd., 1992.

AZUR. Exh. cat. Biot, France: Serge Gallerie Biot, 1992.

Florilege. Exh. cat. Biot, France: Serge Gallerie Biot, 1991.

Miller, Bonnie. *Out of the Fire: Contemporary Glass Artists and Their Work*. San Francisco: Chronicle Books, 1991.

Biskeborn, Susan. *Artists at Work: 25 Northwest Glassmakers, Ceramists, and Jewelers*. Seattle: Alaska Northwest Books, 1990.

Elliot, Kate, ed. *William Morris: Artifact and Art*. Seattle: University of Washington Press, 1989.

25 Years: Glass as an Art Medium. Exh. cat. Lathrop Village, Mich.: Habatat Gallery, 1987.

Architecture of the Vessel. Exh. cat. Rochester, N.Y.: Rochester Institute of Technology, 1986.

Works: The 14th Annual National Glass Invitational. Exh. cat. Lathrop Village, Mich.: Habatat Galleries, 1986.

World Glass Now '85. (Exh. cat.) Sapporo, Japan: Hokkaido Museum of Modern Art, 1985.

Articles and Reviews

2001

Arney, Sarah. "Glossy New Book Documents Morris Rhytons." *Arlington Times/Marysville Globe*, March 7, 2001.

Carlton, William. "Look at Glass—Not Through It." *News Sentinel Newspaper*, March 23, 2001.

Cole, Tina. "Heat, Gravity and Motion: William Morris." *Sun Valley Guide*, summer 2001, pp. 34–39.

"Gant in Seattle." Gant catalogue, fall/winter 2001, p. 31.

Kangas, Matthew. "Public Glasswork." *Public Art Review*, spring/summer 2001, pp. 5–9.

2000

Gangelhoff, Bonnie. "A Coastal Collection." *Southwest Art*, May 2000, pp. 96–99, 152–53.

Gragg, Randy. "Wings of Desire." *Sunday Oregonian*, August 20, 2000.

Wichert, Geoff. Review of Morris's permanent installation at the Portland (Ore.) Art Museum. *Glashause*, March 1999.

1999

Cowan, Ron. "Glass, Color, Fusion." *Statesman Journal* (Salem, Ore.), June 17, 1999.

Dorsey, Catherine. "Off the Wall Glass." *Port Folio Weekly* (Norfolk, Va.), April 13–19, 1999.

Erickson, Mark St. John. "Glorious Glass." *Norfolk Daily Press*, April 18, 1999.

"Glass Sculpture Gleams with Prismatic Viewpoints." *The Monitor* (Austin, Tex.), September 1999.

"May Treasure of the Month." *Mosaic* (Museum of Fine Arts–St. Petersburg, Fla.), April–June 1999.

McKig, Jean. "Glass Master Expertly Explores Tension Between Nature and Man." *Desert Sun* (Palm Desert, Calif.), May 9, 1999.

O'Sullivan, Michael. "Masters of Accessible Arts." *Washington Post Weekend*, October 22, 1999.

Robinson, Rebecca. "Glass Paradox." *Art & Antiques*, December 1999, pp. 72–81.

Ryan, Emily K. "An Exhibit for the Spirit." *Elite Home and Lifestyle*, November/December 1999.

Van Ryzin, Jeanne Claire. "Frozen in Glass." *Austin American-Statesman*, October 14, 1999.

1998

Daniel, Jeff. "Lost Cultures Haunt the Art of William Morris." *St. Louis Post Dispatch*, May 24, 1998.

Dugan, Dana. "William Morris." *Sun Valley Art*, summer 1998.

Edgar, Blake. "William Morris: Glimmers of the Past." *Vetro*, premier issue, 1998, pp. 33–37.

"Glass Grows Up." *Museums New York* 3:5, 1997–98.

Hall, Jacqueline. "Crows and Ravens Might Ruffle Feathers." *Columbus Dispatch*, December 13, 1998.

Masters, Catherine. "World-Class Glass Guru Blows Away Audience." *New Zealand Herald*, January 30, 1998.

Reed, Claudia. "Elton John Visits Glass Artist." *Stanwood/Camano (Wash.) News*, February 17, 1998.

Tennant, Donna. "Washington Wrap-up." *Southwest Art*, January 1998, p. 116.

1997

Cowan, Ron. "Ancient Obsessions." *Statesman Journal* (Salem, Ore.), May 1, 1997, p. D1.

Kaplan, Morton A. "William Morris Spirited Forms." *The World & I*, fall 1997, pp. 152–56.

Leonard, Pamela Blume. "Fragile Glass Meets Savage Force." *Atlanta Journal*, March 28, 1997.

Litt, Steven. "The Roots of Man in Glass." *Plain Dealer* (Cleveland), April 11, 1997.

Melrod, George. "Ah, Wilderness." *Art & Antiques*, April 1997, p. 27.

"Passion Afire." *Metropolitan Home*, May 1997.

"Renowned Glass Artists Explain Their Craft." *Daily Break* (Norfolk, Va.), May 10, 1997.

Rosenberg, Larry. "Death Awareness." *Tricycle*, fall 1997, pp. 32, 33.

"Show Puts Glass on the Cutting Edge." *Milwaukee Journal Sentinel*, September 14, 1997.

Small, Meredith F. "Read in the Bone." *Natural History Magazine*, June 1997, pp. 14–17.

Tennant, Donna. "Best of the West." *Southwest Art*, June 1997, p. 28.

1996

"Ancient Memories: Glass Sculpture at the Meadows Museum." *The Times* (Shreveport, La.), May 16, 1996.

Chambers, Karen S. "Studio Glass Collection Showcased at New York's Metropolitan Museum of Art." *Neues Glas*, January 1996, p. 41.

Colby, Joy Hakanson. "A Glass Affair." *Detroit News*, March 28, 1996.

Crocket, Lane. "Touch of Glass." *Sunday Living in the Times* (Shreveport, La.), March 24, 1996.

Dyett, Linda. "Multifaceted Glass." *House Beautiful*, April 1996, p. 4.

Giles, Charlotte. "Artist Focuses on Primitive." *Ketchum (Idaho) Times*, January 1996.

Harris, JoAnne. "Glass Sculptures on Exhibit are Unusual, Clearly Masterful." *The Times* (Shreveport, La.), March 31, 1996.

Hughes, Ginger. "Glass with a Past." *Marietta (Ga.) Daily Journal*, February 9, 1996.

Kangas, Matthew. "William Morris." *Sculpture Magazine*, March 1996, p. 60.

Leonard, Pamela Blume. "Looking Through the Glass— at Death." *Atlanta Journal*, February 2, 1996.

Updike, Robin. "The Met's Glass Art Show Looks Very Seattle." *Seattle Times*, June 24, 1996.

1995

Blonston, Gary. "Fire, Gravity, Chance." *American Way Magazine*, March 1995, pp. 62, 67.

Bullard, Cece. "Out of Past, Perspective & Prologue." *Richmond Times*, July 25, 1995.

"Glass Movement Celebrated in WSU 'Clearly Art' Display." *Moscow (Idaho)-Pullman (Wash.) Daily News*, August 24, 1995.

Glowen, Ron. "William Morris: Glass Installation." *The Herald* (Everett, Wash.), October 5, 1995.

Goss, Lee. "Visions of Fire and Glass." *Eastside Week* (Bellevue, Wash.), January 18, 1995.

Hall, Jacqueline. "Translucence Gives Glass Elusive Spirituality." *Columbus Dispatch*, July 2, 1995.

Hallinan, Michael. "The Northwest's Glass Menagerie." *The Herald* (Everett, Wash.), April 9, 1995.

Huntington, Rebecca. "A Touch of Glass." *Lewiston (Idaho) Morning Tribune*, September 29, 1995.

Kangas, Matthew. "Glass Art." *ARTnews*, January 1995, pp. 49–78.

Loyle, Donna. "Ageless Imagery in a Modern World." *American Style*, premier issue, winter 1995, pp. 28–30.

Marsh, Ann. "Louis Comfort Tiffany, Meet Dale Chihuly." *Forbes*, June 1995, p. 269.

"Seattle's Glass Menagerie." *ARTnews*, May 1995, p. 104.

Shinoda, Satoka, ed. "William Morris." *Glass & Art Magazine*, no. 8, 1995, pp. 42–51.

Takada, Akemi. "Glass from the Past." *Alaska Airlines Magazine*, July 1995, p. 15.

Tarzan, Deloris. "In New Home, Museum of NW Art Expands Mission." *Seattle Times*, October 29, 1995.

Updike, Robin. "Art in the Craft." *Seattle Times*, January 17, 1995.

Updike, Robin. "Glass Explorer." *Seattle Times*, January 24, 1995.

Updike, Robin. "Pilchuck Puts Seattle on the Map, Capital of Glass." *Seattle Times*, August 27, 1995.

Wright, Diane. "Glass Menagerie." *The Herald* (Everett, Wash.), October 3, 1995.

1994

Boltz, Diane. "The Refined Art of Studio Crafts." *Smithsonian*, October 1994, p. 36.

Kangas, Matthew. "Paleoglass." *Glass Magazine*, spring 1994, pp. 20–29.

Powell, Todd. "Collective Works." *Horizon Air*, August 1994, pp. 20–25.

Russell, Lucille. "The Brilliance of Glass." *Albany (Ga.) Herald*, January 23, 1994.

1993

Blonston, Gary. "Through a Glass Artfully." *Art & Antiques*, December 1993, pp. 58–63.

Cotter, Holland. "Glass Sculptors Whose Work Transcends Craft." *New York Times*, June 18, 1993.

Failing, Patricia. "William Morris Glass Remains." *American Craft*, February/March 1993, pp. 49–51.

Hall, Jacqueline. "Glass Struggle." *Columbus Dispatch*, June 2, 1993.

Kaplan, Morton A. "Primal Instincts." *The World and I*, January 1993, pp. 212–21.

Louie, Elaine. "Glass That Flickers and Plays Tricks." *New York Times*, April 15, 1993.

Myer, Joe. "Talent Is Transparent in Artists' Glass Works." *Desert Sun* (Palm Desert, Calif.), December 26, 1993.

Netzer, Sylvia. "William Morris." *New Glass*, March 1993, pp. 12–21.

Pagano, Penny. "Exploring The Glass Frontier." *Washington Post*, September 16, 1993.

1992

Alaska Airlines Magazine, July 1992, illust. p. 24.

Downey, Roger. "Sacred Bone Yard." *Seattle Weekly*, October 21, 1992.

Hackett, Regina. "Celebrating with Glass." *Seattle Post Intelligencer*, May 16, 1992.

1990

Ament, Deloris Tarzan. "Some Glass Acts." *Seattle Times*, December 6, 1990.

Daniels, Mary. "Glass Artifacts; An Artist's Works Reflect Archeology." *Chicago Tribune*, September 2, 1990.

Glowen, Ron. "Visual Arts Review." *The Herald* (Everett, Wash.), December 21, 1990.

Hackett, Regina. "A Glass Act." *Seattle Post-Intelligencer*, December 19, 1990.

1988

The Herald (Everett, Wash.), August 25, 1988, illust. p. B1.

The Herald (Everett, Wash.), September 19, 1988, illust. p. D1.

Marks, Ben. "William Morris; Brendan Walter Gallery, Santa Monica." *New Work*, no. 35, fall 1988, pp. 32–33.

1987

Basa, Lynn. "William Morris." *New Work*, winter 1987, pp. 8–9.

1986

Marlacher, Patricia. "Earth, Fire and Light in Glass and Clay." *New York Times*, March 17, 1985, p. 24.

"A Natural History Magazine of Glass." The Asaki (Japan) newspaper, May 1986.

Turner, Priscilla. "Giving in to Glass." *Alaska Airlines Magazine*, March 1985, p. 24.

"Who's Who In the South." *FDQ Design South Magazine*, 1985.

1985

Hampson, Ferdinand. "A Collector's Guide to Contemporary American Glass." *Insight*, 1985.

Metropolitan Home, April 1985, p. 129.

1984

"All That Glitters Is Glass." *Gold Coast Life*, June 1984, pp. 10–13.

Architectural Digest, October 1984, illust. p. 143.

Cody, Dan. "A Story in Glass." *Town and Country*, January 1984, pp. 80–90.

Cody, Dan. "A Story in Glass." *Sky* (Delta Airlines magazine), p. 81.

"Corning Museum of Glass." *New Glass Review*, May 1984, p. 18.

Morris, William. "Designing, Constructing and Blowing into Wooden Molds," *Glass Art Society Journal*, p. 50.

1983

Wall, C. Edward. "Adventures in Glass." *Arizona Arts and Travel*, September/October 1983, pp. 19–22.

1981

Von Shack, Katherine. "Glass Comes Into Its Own." *Vancouver*, November 1981, pp. 61–69.

Other Media

"Myth, Nature and Art: William Morris Glass Blower," *Ovation*, The Arts Network, Program Guide (cable TV), July/August 2001.

Distributed by
University of Washington Press
P.O. Box 50096
Seattle, WA 98145

Library of Congress Catalog Control Number: 2001 135502
ISBN: 0-295-98184-9

Page 1: Detail from *Hupa Shaman*, 2001, Collection of
Ronald and Susan Crowell (no. 39, HI301.03.03)

Page 3: Detail from *Zhejiang Man*, 2001 (no. 62,
HI301.01.03)

Pages 4–5: Detail from *Rendille Woman*, 2001, private
collection, Cleveland (no. 47, HA601.17.05)

Pages 6–7: Detail from *Colima Shaman*, 2001 (no. 17,
HI601.01.03)

Pages 8–9: Detail from *Beaded Woman*, 2001, Collection
of Leonard and Lois Schnitzer (no. 55, HA301.07.18)

Pages 10–11: Detail from *Nuba Woman II*, 2001 (no. 44,
HI601.07.12)

Page 12: Detail from *Turkana, Rendille, & Samburu Women*,
2000 (HAGR.09)

Page 16: Detail from *Warrior I*, 2001 (no. 41, HI601.09.04)

Page 33: Detail from *Warrior I*, 2001 (no. 41, HI601.09.04)

Collection credits:

Hohokam Man, 2001 (no. 9, HI601.02.03) and *Rendille
Woman*, 2001 (no. 47, HA601.17.05) are from a private
collection in Cleveland.

Untitled, 2001 (no. 19, HA301.05.02) is from the collec-
tion of Anne and Marvin Cohen.

Maroon Singer, 2001 (no. 23, HI301.04.03) and *Nuba
Woman I*, 2001 (no. 25, HI301.05.12) are from the collec-
tion of Dr. and Mrs. Gerald Dorros, Scottsdale, Arizona,
and Jackson Hole, Wyoming.

Hupa Shaman, 2001 (no. 39, HI301.03.03) is from the
collection of Ronald and Susan Crowell.

Beaded Woman, 2001 (no. 55, HA301.07.18) is from the
collection of Leonard and Lois Schnitzer.

Project Manager and Editor: Holle Simmons

Designed by Susan E. Kelly and Jeff Wincapaw

Photographs of William Morris and crew by Amy Herd

Produced by Marquand Books, Inc., Seattle
www.marquand.com

Color separations by iocolor, Seattle

Printed and bound by CS Graphics Pte., Ltd., Singapore